Impressionists and Politics

Impressionists and Politics is an accessible introduction to the current debates about impressionism. How revolutionary were the impressionists? Is the term "impressionism" itself a good word for the movement that took the mid-nineteenth century art world by storm?

By providing an historical background and context, this book places impressionism's roots in wider social and economic transformations and explains its militancy, both aesthetic and political.

Impressionists and Politics is a concise history of a major art movement, from its youthful inception in the 1860s, through to its final years of recognition and then crisis.

Philip Nord is Professor of History at Princeton University

Historical Connections

Series editors

Tom Scott *University of Liverpool*
Geoffrey Crossick *University of Essex*
John Davis *University of Connecticut*
Joanna Innes *Somerville College, University of Oxford*

Titles in the series

Impressionists and Politics

Art and Democracy in the
Nineteenth Century

Philip Nord

London and New York

First published 2000
by Routledge
2 Park Square, Milton Park, Abingdon, Oxon, OX14 4RN

Simultaneously published in the USA and Canada
by Routledge
270 Madison Ave, New York NY 10016

Routledge is an imprint of the Taylor & Francis Group

Transferred to Digital Printing 2005

Typeset in Galliard and Gill Sans by Taylor & Francis Books Ltd

British Library Cataloguing in Publication Data
A catalogue record for this book is available from the British Library

Library of Congress Cataloging in Publication Data
Nord, Philip G., 1950-
Impressionists and politics: art and democracy in the nineteenth century
Philip Nord.
p. cm. – (Historical connections series)
Includes bibliographic references and index.
1. Painting, French. 2. Painting, Modern–19th century–France.
3. Impressionism
(Art)– France. 4. Art–Political aspects–France. I. Title. II. Series.
ND547.5.I4 N67 2000
759.4'09'034–dc21

99-047640

ISBN 0–415–07715–x (pbk)
ISBN 0–415–20695–2 (hbk)
Printed and bound by Antony Rowe Ltd, Eastbourne

for my Mother and my Father

Contents

Plates

Series editors' preface

Historical Connections is a series of short books on important historical topics and debates, written primarily for those studying and teaching history. The books offer original and challenging works of synthesis that will make new themes accessible, or old themes accessible in new ways, build bridges between different chronological periods and different historical debates, and encourage comparative discussion in history.

If the study of history is to remain exciting and creative, then the tendency towards fragmentation must be resisted. The inflexibility of older assumptions about the relationship between economic, social, cultural and political history has been exposed by recent historical writing, but the impression has sometimes been left that history is little more than a chapter of accidents. This series will insist on the importance of processes of historical change, and it will explore the connections within history: connections between diffent layers and forms of historical experience, as well as connections that resist the fragmentary consequences of new forms of specialism in historical research.

Historical Connections will put the search for these connections back at the top of the agenda by exploring new ways of uniting the different strands of historical experience, and by affirming the importance of studying change and movement in history.

Geoffrey Crossick
John Davies
Joanna Innes
Tom Scott

Acknowledgments

A first thanks is owed to Geoff Crossick. He asked me if I would like to write a book for Routledge and did not blanch when I proposed an art historical subject, not my area of expertise. Many years have passed since that moment, and Geoff has stuck with the enterprise throughout.

I owe a debt no less profound to Anne Higonnet, Daniel Sherman, and Paul Hayes Tucker. They made time in busy schedules to read this manuscript in its entirety, offering guidance and commentary that was much needed and always constructive. I am fortunate to have friends and colleagues so giving of themselves.

I have had a chance to present or publish portions of this work in other venues and formats. Early chapters were discussed at the Princeton Seminar on Metropolitan Culture, hosted by Christine Stansell, who has been a supporter and sympathetic critic of this project from the beginning. I first tried out what is now Chapter 3 at a conference convened in 1994 on the centenary of Alfred Dreyfus's conviction. Zeev Sternhell was the organizer, and a version of these remarks was later published thanks to the kind exertions of Vinni Datta and Willa Silverman. Mark Antliff, John House, Patricia Leighten, Theodore Reff, and Richard Thomson were generous with assistance that helped me to negotiate the unfamiliar terrain of art history. Arno Mayer provided no-nonsense advice of the sort that only a friend and mentor of long-standing can give. When doubts accumulated or problems grew murky, my wife Deborah came to my aid with wise counsel and clarifying criticism. No one knows better than she what I am about.

I dedicate this book to my parents, Del Nord and Henry Nord, lovers of art both, who have passed on their enthusiasm to me. It would not have been written without their example.

Introduction

The impressionists, according to standard interpretation, worked a revolution in the artworld of mid-nineteenth-century France. In this account, the artists are cast as embattled innovators who challenged and overthrew the institutional and aesthetic orthodoxies of the day.[1] The premier venue for the public exhibition of paintings in mid-century France was the annual Salon, run until 1863 by the Academy of Fine Arts and thereafter by a mix of state appointees and elected representatives, most of them in fact Academy members. The coterie of bureaucrats and academicians who administered the Salon favored conventional genres, historical landscapes and classical nudes. The impressionists, so the story goes, fought to break into this world and, in so doing, broke it open altogether. The Salon was undermined and bypassed. A new art regime, "modern" in its contours, took the place of the old. Painters, once hamstrung by the oligarchical exhibition practices of the Salon, now reached out to a wider art-buying public through an independent network of dealers and galleries. And they appealed to that public in a new aesthetic idiom. Gone were the bituminous canvases of yesteryear, so over-refined in execution, so encumbered by allusion to the great masters of the past. Instead, artists turned to contemporary themes drawn from everyday life, and they painted them in a sketchy, "impressionist" style ablaze with luminous color.

This version of the new painting's origins, what might be called the heroic legend of impressionism, has been subjected to heavy criticism in recent art historical literature. Alternative stories have been proposed, three of which will be canvased here.

The first, much favored by Francophone art historians, questions just how revolutionary the impressionists were. In the 1860s, it is pointed out, when the movement was still in its infancy, the painters were far from advocating the overthrow of all existing art.[2] Edgar Degas revered Ingres.

Delacroix's death in 1863 moved Henri Fantin-Latour to paint a collective portrait of the artist's young admirers: the *Hommage à Delacroix* (1864) depicted the group, Edouard Manet prominent among them, gathered around a picture of the deceased master. Nor was it just to the dead and aging that the new painters turned for inspiration. They cultivated ties to like-minded older contemporaries, to Gustave Courbet and the landscapists of the Barbizon school, who reciprocated with advice and friendship. With the backing of such mentors, the impressionists took on the Salon system with results that were not so disappointing as legend would have it. There were setbacks to be sure, but the impressionist record at the Salon, it is suggested, was more uneven than negative. And however mixed the impressionists' fortunes in the 1860s and 1870s, the picture cleared in the century's concluding decades. Impressionist painting found its market, and even the State adopted a more forthcoming attitude, bestowing honors on many of the painters and exhibiting their work as part of the national patrimony.[3] Looked at this way, impressionism appears less a rupture with the past than an extension of it. The new painters took up where Ingres, Delacroix, and Courbet left off, carrying forward France's great tradition into the modern era.[4]

From a second perspective, the crucial issue is not impressionism's fit into a particular national tradition but its embeddedness in the culture of its own time. Robert Herbert's work may be taken as exemplary of this point of view.[5] The middle decades of the nineteenth century, Herbert argues, witnessed the genesis of a new form of society that extended the pleasures of the marketplace – commodities and leisure time – to widening circles of consumers. Paris and the humanized landscapes of its near suburbs were focal points of the transformation, and it was this new world that the impressionists sought to fix on canvas. They went at the task with an inventive gusto, innovating in subject matter, style, and even marketing technique. The painters may not have been skilled businessmen, but they were by no means unworldly, casting about for new ways to attract the attention of potential buyers via advertising, independent group shows, and gallery retrospectives.[6] Impressionism stood in symbiotic relationship with a world of market-based leisure, which explains in part the art's enduring appeal to present-day denizens of consumer society.

As Herbert himself acknowledges, this vision of impressionist painting, benign and generous-spirited, comes with a hint of nostalgia. He attributes the sentiment to the contemporary museum-going public, but, I suspect, shares in it himself up to a point. The market and its advance have been mixed blessings, disseminating pleasure, yet cheapening it, such that

pleasure today is no longer taken with the same grace and ease it once was. No wonder the canvases of the impressionists inspire such delight. Paintings like Auguste Renoir's *Ball at the Moulin de la Galette* (1876) or *Luncheon of the Boating Party* (1881) evoke a world of leisured harmonies that is still familiar to us but now almost vanished.

It is possible, however, to take an altogether more somber view of impressionist painting. Such is T.J. Clark's point of departure.[7] Yes, the impressionists wanted to paint "modern life," but what modernity meant (and still means) is a dark business. It means first and foremost capitalism which disenchants as it goes, grinding down hierarchies of value, leaving behind a landscape made flat and featureless. The painters of modern life faced a triple set of problems when confronted with such a world. Conventional techniques of representation no longer had purchase on a modernity which drained such conventions of meaning. This was a world of pleasure but of a class-bound pleasure, often taken with a blank, pleasureless stare. Most serious of all, this was a world which denied redemption, thwarting the artist who sought to wrest from it a saving remnant of transcendent value. From this angle, the new painting appears a tortured enterprise: its practitioners at grips with inadequate modes of representation, hard-pressed to capture a reality at once spectacular and expressionless, ever on the hunt for an elusive place of grace.

In Clark's view, it is Manet's art – discordant, ironic, and searching – that is most expressive of the tensions which define the painting of modern life. But Manet is not the sole artist in Clark's scheme to qualify for the title. There are others, and it is no accident that two of them, Courbet and Camille Pissarro, had more than a glancing connection to radical politics. Courbet served as an official on Paris's revolutionary Commune in 1871; Pissarro became a committed anarchist in the final decades of his life. A serious modernism, Clark seems to suggest, implies an oppositional stance to the existing social order, a stance that tends to spill over into a politics of resolute anti-capitalism.[8]

Clark's work places center-stage the relationship between impressionism and politics, which forms the subject of the present volume. It is important, though, to be precise about what I mean here by politics, which is not altogether identical to what Clark means. The impressionists worked in an institutional environment dominated by the Academy and the Salon, and how they positioned themselves in relation to such powerful institutions had political consequences. Art critics, both well-intentioned and hostile, came at impressionism with agendas of their own, interpreting the painting in vocabularies freighted with barely concealed political meaning. Institutional contests and critical rhetorics spun impressionist

painting into the agonistic realm of partisan struggle, and what a variegated realm that was. Insurrectionism and anarchism were not the sole choices available to artists of a dissident temperament. There were liberal and democratic options as well. The range of choices, moreover, did not remain fixed but metamorphosed at the century's close, as new forms of commitment – extreme nationalism, feminism, etc. – became available. The approach adopted here then emphasizes institutions, rhetorics, and a complex understanding of political alternatives. It is reasonable to ask, though, just what such an approach might add to our understanding of the impressionist phenomenon.

THE ORIGINS OF THE NEW PAINTING

It will help first to explain the circumstances of the movement's coming into being. The term "impressionism" is a neologism invented in the 1870s. It conjures up visions of an out-of-doors painting, of light-soaked canvases depicting the passing effects of seasons and times of day. The description might well apply to the work of Claude Monet, Renoir, or Pissarro, but not to that of Manet and Degas. Neither made frequent use of the luminous palette which was a hallmark of the true impressionist. Manet experimented in the impressionist mode in the 1870s, but many of the pictures for which he is best known, the *Déjeuner sur l'herbe* (1863) and the *Olympia* (1863), were studio paintings, and Degas almost never worked *en plein air*. When he cast about for a word to identify the collective effort of which he felt himself a part, he settled on "realist," a referent with a long-standing and charged history.[9] In a celebrated pamphlet of 1876, the art critic Edmond Duranty (who was close to Degas) eschewed "impressionism" as a descriptive label, proposing instead a more inclusive and less precise tag, "the new painting." Both terms, impressionism and the new painting, will be used here as synonyms, but the issue of labeling does point to a larger question of genuine importance. If the new painting made room for an assortment of artistic currents, realist as well as impressionist, what gave the movement, so disparate in appearance, its coherence?

Common generational experience provides a partial answer. The new painting first affirmed its identity in the 1860s. Pissarro, the oldest of the artists involved, was born in 1830, and Pissarro's earliest comrades – Manet (b. 1832), Degas (b. 1834), Monet (b. 1840), Renoir (b. 1841) – were not far removed in age. The movement was joined in the 1870s by a troop of younger painters, Mary Cassatt and Gustave Caillebotte among them, but the newcomers were not that much younger. Cassatt was born

in 1844, Caillebotte in 1848. The new painters were on occasion referred to as the *jeune école*, and when they started out, a youthful ardor was a quality they held in common.

They also shared a deep antipathy toward France's Academy of Fine Arts. The Academy in the mid-nineteenth century enjoyed extensive institutional prerogatives. Until 1863, it administered the School of Fine Arts and, as already noted, the Salon. The Academy lost formal control of both the School and the Salon at that date. The former was henceforth governed by a state-appointed board, the latter by an organizing jury which consisted in part of state nominees, in part of elected members.[10] Elections (a brief period of liberalization apart in the late 1860s) were conducted under circumstances of restricted franchise, which excluded most artists from participating. In practice, however, the Academy continued to enjoy considerable informal authority in the artworld. The professors appointed to conduct the teaching workshops at the School of Fine Arts were academicians. In 1875, the three principal ateliers were run by Alexandre Cabanel, Jean-Léon Gérôme, and Henri Lehmann, Academy-members all. As for Salon elections, voters tended to cast ballots for the masters who had trained them (with certain notable exceptions). Cabanel was a perennial victor, and he wielded his power to punishing effect against painters judged out of sympathy with the academic aesthetic he believed in. To be sure, the Academy harbored artists of varied artistic persuasions, and in this sense it is exaggerated to speak of a single, academic aesthetic. Nevertheless, on certain points there was a modicum of agreement. A painter worthy of the name drew his inspiration from a thematic repertoire founded in the classics of history, literature, and antiquity. And he painted in a style with sufficient surface finish such that coloring and facture did not distract from content.[11] This was the institutional and aesthetic setting in which the new painting crystallized.

The new painters railed against the tyranny of the Salon system; they spurned, and from the very outset, the outworn thematics and stylish good manners of academic art, devoting themselves instead to a painting of modern life that was often rough and unfinished in its execution. The revolt they conducted was a collective and not just an individual effort. No doubt over the course of time, each artist elaborated a signature style. This was above all the case from the 1880s, when the new painters began to lose touch with one another, parting ways in pursuit of more individualized careers. But for a period in the 1860s and 1870s, a robust if oftentimes contentious camaraderie reigned among the artists. They shared rooms and painted side by side; they frequented the same salons and cafés; and they exhibited together. Between 1874 and 1886, the

jeune école mounted eight independent Salons. Not every new painter took equal part in these various manifestations of collective identity. Cassatt and Berthe Morisot (b. 1841), as women of breeding, were excluded from joining in the boisterous good fellowship of the café. Manet, heartset on making his name at the official Salon, declined to take part in the new painters' independent exhibitions. But all three had occasion to demonstrate their loyalty to the common enterprise by other means and in other venues. Membership in the group was fixed in part by aesthetic affinity but also by ongoing participation in a particular network of sociability and collective action.

Generational affiliation, a common aesthetic and institutional project, and a commitment to group endeavor: these were among the defining attributes of the new painting. But I would like to make the additional claim that politics too had a hand in framing the movement's identity. In a sense, how could it be otherwise? The generation the new painters belonged to was one scarred by political cataclysm. The oldest among them had witnessed first-hand the collapse of the Second Republic. The youngest grew to maturity under the imperial regime of Louis-Napoleon Bonaparte (1851–70). And all were of an age to perform military service during the Franco-Prussian war, to absorb as adults the buffets of military defeat and of the civil strife that followed.

A history so turbulent and disturbing did not leave the new painters untouched. Monet met Georges Clemenceau (b. 1841) in the 1860s, and the two remained lifelong friends. Renoir judged Léon Gambetta (b. 1838) "the simplest and most courteous man I have ever met."[12] Manet in 1879–80 painted the portrait of Henri Rochefort (b. 1830). Clemenceau, Gambetta, Rochefort: a more notorious trio of political troublemakers would be hard to find. They first made names for themselves as uncompromising enemies of Louis-Napoleon's Second Empire and with equal zeal battled the clerical and crypto-monarchist governments of "Moral Order" that came to power in the mid-1870s (1873–7). Their militancy did not diminish until a new Republic had been founded, France's Third, and even then Rochefort, the most intransigent of the lot, remained implacable in his oppositionism. The generation that spawned the new painting was the same that shepherded in the Third Republic. The painters and politicians involved in the two enterprises knew and, to a lesser extent, admired each other.

What will be argued here is that such parallels and connections had a formative impact on the new painting. In the 1860s, as the movement began to take shape, it was taken up by a band of critics who couched their praise in an idiom charged with political formulas and catchphrases.

The maneuver was not just rhetorical, for the critics themselves were more often than not republicans. Philippe Burty (b. 1830), Théodore Duret (b. 1838), and Emile Zola (b. 1840) are all cases in point. The new painting's critic friends cast it as an aesthetic analogue to republicanism in politics. The artists, it was claimed, were bent on a democratization of France's exhibition system, all the better to bring to the public a modern art which, in its celebration of the pleasures of the everyday, was accessible to the common run of humanity in a secularizing age. No more the Salon of old run by a handful of accredited masters. No more an outdated visual culture which presupposed audiences versed in the classic texts, both sacred and profane, of western civilization.

The *jeune école* did not bridle at such characterizations, but then again, they too tended to a republican politics. It was an allegiance that would deepen in the wake of the disasters of 1870–1, *l'année terrible*. As the decade of the 1870s wore on, the new painters more and more made a home for themselves in republican society, camping out in its salons and feeding off its social and journalistic resources. The attachment may have been transient, as it was for Degas, or opportunistic, as it seems to have been for Renoir, but an attachment there was; and in the cases of Manet and Monet it was sincere and enduring. Indeed, for a portrait of the republican milieu, its interiors and inhabitants, there is no better place to look than the painting of the *jeune école*. The Vichy regime of Maréchal Philippe Pétain railed against the political class of the Third Republic as a cabal of Protestants, Freemasons, and Jews. It was in just such circles that the new painters travelled; and it is just these faces, in unprecedented number, who peer out from the canvases they painted.

THE END OF IMPRESSIONISM

Commonalities of age, project, and milieu made possible the crystallization of the new painting, but so too did a common political purpose. As the century wound down, however, that purpose weakened. Gambetta died in 1882. Clemenceau remained a staunch republican, but Rochefort took a sharp rightward turn. The two squared off against each other at the time of the Dreyfus Affair, Clemenceau taking the Jewish captain's part, Rochefort standing against. And so it would be with the new painters. Politics had a hand in impressionism's rise and would play a part no less significant in its break-up.

The impressionist movement fragmented in the 1880s and 1890s. Aging and a ration of success had something to do with its disintegration.

Illness claimed Manet's life in 1883 at fifty-one. The new painters who survived began to hit middle age, which brought with it health worries as well as, for many of them, a taste of public recognition. The now not so young *jeune école* were no longer in a position to imagine themselves quite as beleaguered. Numerous second-rank artists had taken to imitating their experiments, and the stodgy old-timers against whom they had once measured themselves counted for less. Old enemies had begun to fade, and old causes as well. The Third Republic democratized the Salon system in 1880, placing organization of the event in the hands of the artists themselves. The Salon lost much of its former cachet and ceased to occupy a dominant place in the artistic scheme of things.[13] As the old external pressures waned, the ties binding the movement slackened. The artists drifted apart, settling into new social niches often far distant from the republican circles of younger days.

All of them in the process experienced bouts of personal crisis. Such crises, though, did not unfold in isolation but were played out against a larger backdrop of cultural and political transformation. An old and familiar order had begun to pass, giving way to a new and agitated modernity: a France of automobiles and electricity, populated by a disturbing array of novel types – feminists, socialists, Jews, and intellectuals. The painters wrestled through the difficulties they found themselves in, working out personal visions as distinct as Degas' tubwomen and Monet's water-lilies. And they worked toward a new politics as well, each in his or her own way. It was in the 1880s that Pissarro embraced the anarchist creed and in the decade following that Degas became an anti-semite. At the time of the Dreyfus Affair, the two, once so full of mutual admiration, ceased to speak to one another.

THE NEW PAINTING AND RADICAL POLITICS

Placing the new painting in a political frame is not meant to reduce it to a para-political phenomenon. The artists involved were first and always artists, men and women laboring with the brush, crayon, or etcher's needle, immersed in problems of composition and execution. They rummaged in the works of the past to find models for themselves and, more and more with the passing of years, laid claim (some more than others) to an honored rank of their own in the great tradition. The aim of all such effort was to create masterworks of enormous power and beauty.

To leave the story at that, however, is to slight the fractious character of the new painting. The artists were determined to set aside prevailing conventions of representation. They exploded them in bursts of pictoral

irony, as was Manet's stock-in-trade in the 1860s. They sabotaged the illusions of three-dimensional space, manipulating perspective, calling attention to how paintings were made – the brushwork, the application of paint, the framing of subjects. And they wanted to paint, without anecdote or sermonizing, themes of modern life hitherto neglected or deemed unworthy of attention. All this in itself might have sufficed to incense the tradition-minded. But as the new painting reached maturity, it pitched toward intersection with a republican movement then gaining in strength. It acquired in the process an oppositional political charge which redoubled the outrage of its opponents. The rapprochement, although provisional, was not accidental but sought out to varying degrees on both sides. The republican connection helps to explain the new painting's initial, troubled reception and even, to an extent, its later success. Republicans in growing numbers acceded to political office in the closing decades of the century, and as they took over management of the state, so the state became more generous to impressionism, extending to the movement a measured, first dose of public patronage.

From this perspective, the heroic legend of impressionism does not appear altogether without foundation. The movement defined itself as an artistic opposition. To be sure, the artists did not all suffer in consequence. Most had earned a degree of public acceptance before old age set in, and as the painters grew older, a number began to worry less about standing against tradition than about staking out a place within it. The impressionists painted – and often did so in flattering tones – a social world in the making that was middle-class and commercial. It should be remembered at the same time that this milieu and its inhabitants were not neutral subjects. To paint portraits of Clemenceau and Rochefort, as Manet did, was to paint modern life, but it was also to make a political statement. That statement did not signify a fundamental rejection of capital or a commitment to revolutionary transcendence. Impressionism, in its heyday, associated itself with a democratic politics, which, within the context of the times, was a gesture dramatic enough. Modernism and radical politics did go together, but the radical politics in question were not insurrectionary. For a number of the artists, more extreme commitments would come, but not until later, and even then, extreme politics took a variety of forms, rightist as well as leftist, setting the artists against each other and sealing the impressionist movement's collapse.

On first encounter with the new painting, its impressionist wing above all, contemporary Britons and Americans often find the pictures charming or gorgeous. They know a fuss was made about them in days gone by but puzzle over the reasons why. The aim of the book that follows is to evoke

what those reasons might have been, to highlight without exaggeration or illusion the insurgent coloration of a movement which made its militancy manifest on many fronts – aesthetic, institutional, and even political.

1 Under the Empire:
the origins of the new painting

Paris and its environs were the birthplace of the new painting. Young artists gathered here in the century's middle decades, constituting informal and overlapping networks of work and sociability. Many such currents fed into the making of the new painting, but two deserve particular mention.

The first was oriented toward landscape painting. It began to take shape in the late 1850s at a private arts establishment, the Académie Suisse, so named after its proprietor. The academy furnished no formal instruction but, for a fee, made available to art students live models to study from and paint. It was here in 1858 that Pissarro met Monet and then three years later Paul Cézanne (b. 1839). From the Académie Suisse, Monet relocated to the independent atelier of Charles Gleyre, and there met up with Frédéric Bazille (b. 1841), Renoir and Alfred Sisley (b. 1839). Such personal associations were bolstered by a shared interest in the landscape and a keen admiration for the innovations of the Barbizon school. No one in the group was Paris-born, although Renoir had grown up in the capital city.

A second current, much less provincial in cast, aspired to a realist-inflected painting of modern life. Its partisans first got to know each other at the Grand Gallery of the Louvre. It was a copyist's zeal that brought Fantin-Latour (b. 1836) to the gallery in the late 1850s. He crossed paths there with Manet in 1857 and with Morisot in 1859, both of Parisian origins. Degas, also a Parisian, did not record a first appearance until some years later.[1] The artists were in the main well-bred and not lacking in social refinement. Manet's father was a judge, Morisot's an official at the Cour des Comptes, and the Manet and Morisot households soon became gathering places for young artists well-versed in the protocols of *la grande peinture* but who were on the lookout for a more modern angle of approach. They found it in part in japonisme (see p. 18) of which Fantin-Latour and Félix Bracquemond (b. 1833) were such ardent devotees and in etching, an old medium renewed in the 1860s by the japonisant experiments of

Bracquemond, Fantin-Latour, and Manet. These artists had taken to heart the realist injunction to depict the faces and scenes of contemporary life. Japanese prints, in their sober handling of quotidian themes, gave added impetus to the injunction but, at the same time, revealed a range of techniques – bold coloring, planar composition, odd-angle perspective – that might be exploited to update the realist vision.

It would be a mistake to imagine either current – the Barbizon-influenced landscapists or japonisant painters of modern life – as altogether distinct and separate. There was much crossing back and forth, and by the late 1860s, the two streams had begun to converge, coursing into Paris' Batignolles quarter. Bazille and Manet had set up ateliers in the neighborhood, to which colleagues came in search of companionship and good talk. The regnant camaraderie is captured in Bazille's painting of his own workshop, *Studio in the Rue La Condamine* (1870, Plate 1.1), which shows a trio of artists – Manet, Monet, Bazille himself – examining a canvas, flanked on the left by a pair of figures engaged in separate conversation, Renoir and the critic Emile Zola. That same year, Fantin-Latour executed a painting similar in theme, although much more formal in its posing, *A Studio in the Batignolles*. The studio in question was Manet's, and the artist is shown seated center-canvas, surrounded by colleagues and friends, among them Bazille, Manet, Monet, Renoir, and Zola. After hours, these studio conclaves reconvened to continue the palaver at a local watering-hole, the Café Guerbois. The Guerbois crowd was more numerous and mixed. The usual suspects – Fantin-Latour, Manet, Renoir, and from time to time Monet – were to be found in attendance, joined by Degas and on rare occasions Pissarro and Cézanne. The critics also turned out in force: Burty, Edmond Duranty (b. 1833), and of course Zola. To contemporaries, a new school of painting appeared in the making up in the Batignolles, and that school was bestowed a name after the *quartier* it made its home, the Ecole des Batignolles.

THE NEW PAINTING AT THE SALON

The story of the new school's first stirrings is often recounted in heroic accents, a band of friendless, young innovators squaring off against a closed and unbending art establishment. No doubt, such a picture is overdrawn. The new painters had honored antecedents. Degas, as noted, looked to Ingres, Manet to the Spanish masters Velazquez and Goya. Nor were they isolated figures in the art world. The Barbizon landscapists and Gustave Courbet, the dean of the realist school, took an interest in the young artists who were eager to submit to such influences, painting forest scenes, portraits, and genre pictures very much modelled on the work of

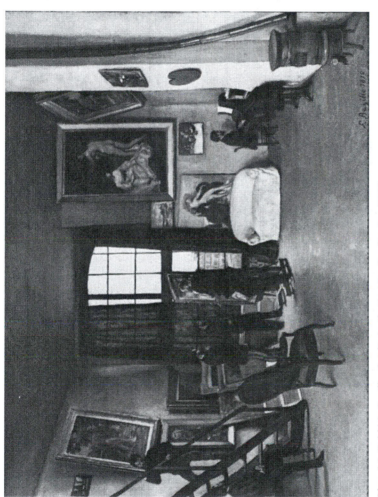

Plate 1.1 Frédéric Bazille, *Studio in the Rue La Condamine*, 1870.

Source: Musée d'Orsay, Paris

their elders. These elders, moreover, opened avenues of entry into the Salon system which, it turns out, was not so unyielding after all. The Barbizon painter Charles-François Daubigny was elected to the Salon jury in 1866 and again in 1868, on both occasions extending himself with success to win admittance for the canvases of younger colleagues – Bazille, Monet, Pissarro, Renoir, Sisley.[2] But for all such signs of artistic continuity and advancement, it is important not to forget the originality of the new painters and the militancy of the attitude they struck, which grew all the more confrontational as the decade of the 1860s wound to a close.

Landscape painting

Take the movement's landscapist wing as a point of departure. Gleyre's students – Bazille, Monet, Renoir, Sisley – were a restive crew. The master instructed them to learn from the antique. The exhortation exasperated Monet who counselled his friends to revolt: "Let's get out of here. The place is unhealthy: they lack sincerity."[3] The foursome did not in fact abandon Gleyre's atelier but took to supplementing a studio-based instruction with forays out-of-doors to the forests of Fontainebleau, home of the Barbizon painters. They made a first trip there, to the hamlet of Chailly, in 1863. Monet returned to the village two years later. Renoir and Sisley, joined by Pissarro, installed themselves not far distant at Marlotte. Such expeditions brought the new painters into closer contact with the older artists they most esteemed. Renoir, on his first trip out, bumped into the Barbizon landscapist Narcisse Diaz in a clearing, who proffered the young painter advice on coloring. Courbet paid a visit to Monet at Chailly in 1865 and may well have taken the occasion to pose for the monumental but never finished project on which Monet was working at the time, *Le Déjeuner sur l'herbe* (1865–6).[4]

The various pieces of the painting which survive give a rough indication of what the impressionist landscapists owed to their Barbizon mentors and of the original course they had begun to chart for themselves. Here was a sylvan scene executed *en plein air*, and in both respects Monet followed a path marked out by Daubigny, a particular favorite of his. But the new painters wanted to push past the Barbizon achievement: to paint not just landscapes – trees, clearings, sunsets – but figures in a landscape and contemporary figures at that handled on a grand scale. Monet's picnickers, attired in the latest fashions, are unmistakably city-folk out to have a good time. Barbizon painters projected feeling onto nature and then painted what they saw, a world shaded by the artist's moods, whether serene or brooding. Monet was less sentimentalist in approach. He took a step back from his material, let the scene work on him, and

then rendered the fleeting impressions it conjured. A variety of techniques were experimented with to capture such effects: strong, independent brushwork, a brightened palette, a flattening of form. In the latter two innovations, art historians have detected japonisant influences at work. The result was a landscape, less soulful than its Barbizon equivalents, but more observed and more powerful in its evocation of human presence. The Barbizon painters and young impressionists did not perceive nature in quite the same light, but they remained true to what they felt and saw and to this degree were in equal measure "sincere," a term of high praise in the lexicon of both.[5]

The notion of sincerity in art, of course, had a critical bite to it, for it etched an implicit, unflattering contrast with painting judged insincere, spurious, or meretricious. What made Barbizon and impressionist landscape so natural in appearance was, at least in part, the comparative artificiality of the classical or historic landscapes daubed by the great men of the Academy. The new painters wanted to have done with the academic manner. "All those great classical compositions, that's over and done with," as Bazille explained to Renoir.[6] Academy-members got the message, disparaging as it was, and the more unsympathetic among them did their best to impede the professional progress of the new painting. The Emperor's continual and inept tinkering with the Salon system, however, did not always make such obstructionism easy.

The year 1863 marked a moment of rupture in two respects. The Salon jury that season, composed in its entirety of Academy nominees, was harsh, turning back half of all submissions. The hue and cry that resulted persuaded the Emperor, always sensitive to changing public moods, to institute a losers' Salon, a Salon des refusés, at which rejected artists might exhibit. Pissarro and Manet were among that number. Manet scored a memorable succès de scandale on the occasion with Le Déjeuner sur l'herbe, an impertinent reinterpretation of the fête champêtre theme with the sitters posed in various states of modern dress and undress. The Salon des refusés was meant to be a one-time event; of more long-lasting consequence was the Emperor's decision to revamp the Salon jury selection process. The state would henceforth appoint a quarter of the jurors, the balance being chosen by an electorate made up of artists who had won medals at previous Salons.

The suffrage was not generous with predictable results. In the first elections under the new system in 1864, the four leading candidates were all current or former professors at the Academy, with Cabanel at 163 votes, topping the list. Two years later, however, Camille Corot and Daubigny managed to squeak in. Their presence made a difference but not that much. The Salon jury accepted submissions by Monet and Pissarro.

Bazille, on the other hand, got a more mixed reception. A still-life, *Poissons*, was taken but not *La Jeune Fille au piano*, prompting the artist to fire off an angry letter home:

> I've chosen the modern world because I understand it the best, because I find it more vital ... here's why I have been turned back. If I had painted the Greeks and Romans, I wouldn't have been bothered, because that's where we're stuck. ... [7]

Renoir experienced a similar fate. The jury admitted a sketch but not a more substantial landscape. Corot and Daubigny stood up for Renoir but to no avail, and Renoir in the end decided not to show at all. Cézanne was unluckier still. He was rejected altogether, a powerful disappointment to an artist who at this stage was still determined to break into what he called the "Salon of Monsieur Bouguereau." Cézanne let off steam in an epistolary outburst of his own. He drafted a pair of complaining letters to Louis-Napoleon's Superintendant of Fine Arts, the comte de Nieuwerkerke, calling for a new refusés.[8]

The regime demurred and in fact acted to strengthen the Academy's hand in the Salon jury selection process. The 1867 jury was chosen one third by the state, one third by medalled artists, and one third by the Academy itself. Bazille, Monet, Pissarro, and Renoir were all excluded from the Salon. Bazille was so infuriated he pledged never to submit himself again to the "administrative caprice" of an official jury. He reported to his parents that a petition, "signed by all the best artists," was circulating, which urged convocation, as had Cézanne the year preceding, of a second Salon des refusés. In the probable event the refusés gambit faltered (which it did), Bazille projected, with Monet's collaboration, formation of a young artists' "association" that would sponsor an exhibition of its own, outside of Salon auspices. Respected senior painters – Corot, Courbet, Diaz, Daubigny – were persuaded to sign on, although in the end the scheme collapsed for lack of funds.[9]

The battle was joined once more the next Salon season. The imperial administration had fiddled yet again with jury selection procedures, this time to the Academy's detriment. The state undertook to appoint one third of the jurors; the rest were voted in by a much expanded electorate that consisted of all artists who had exhibited at previous Salons. The results were stunning. Compared to 1864, the number of ballots cast quadrupled from 223 to 839, and Daubigny outpolled the entire field. Such were the circumstances that made possible "the triumph of realist landscape" at the Salon of 1868, but it was a triumph not everyone welcomed.[10] Nieuwerkerke for one is said to have derided Barbizon-style

landscape as "the painting of democrats, of men who never change their linen." Daubigny was the particular butt of the Superintendant's irritation, causing Alfred Castagnary, a pro-Barbizon critic, to chortle in the pages of *Le Siècle*: "M. de Nieuwerkerke has got it in for Daubigny, and why? Because he thinks him 'a climber, a liberal and a free-thinker.'"[11] Nieuwerkerke, providing he harbored such thoughts at all, was not far wide of the mark. Daubigny liked to sing while he worked, and the repertoire he favored – the subversive verse of Pierre-Jean Béranger, Pierre Dupont's rustic chansons, and "La Marseillaise" – is revelatory of the mix of views he subscribed to. He was a republican with a Christian socialist twist, much in the manner of Anthime Corbon, a long-time friend who was elected to the Senate in 1875 on the Gambettist ticket.[12]

Etchers and japonistes

There was just a hint of politics to the landscapists' institutional skirmishing. The new painting's japonistes and printmakers had their share of institutional wrangles as well, but here the thrust toward autonomy, not to mention the odor of politics, was stronger still. The mid-century vogue for things Japanese coincided with a renaissance in printmaking, and the two phenomena are not easy to distinguish.[13] Bracquemond, said to have been the first French artist to collect Japanese prints, made his earliest purchases from publisher Auguste Delâtre in the late 1850s.[14] It was Delâtre who, in collaboration with fellow publisher Alfred Cadart, organized the Société des aquafortistes in 1862, a money-making enterprise which undertook to market the wares of aspiring printmakers like Bracquemond, Fantin-Latour, and Manet who were charter members of the Société.

The Société des aquafortistes was from first to last a commercial operation. Printmakers had a material incentive to join the organization. Cadart and Delâtre published a catalogue every month which advertised members' work. But once a year the catalogue came prefaced with introductory remarks by the likes of Théophile Thoré and Castagnary, artworld personages of a critical cast of mind who made a point of imputing a similar independence of spirit to the Société's printmaking fellowship. The preface-writers made clear first that they had no use for "that venerable but fatal institution called *l'Ecole*" which parked would-be artists "in an atelier darkened by tradition." Burty, who reviewed the Société's 1863 catalogue in positive terms, got the point, vaunting the aquafortistes as "this independent band, very much outside of academic tradition."[15] It was possible to ratchet up the rhetoric of independence with the well-placed political aside. The Société's third annual catalogue, wrote Jules Janin in the preface, marked "the year III of the aquafortistes,"

a light-hearted allusion to the roman-numeralled calendar of the Great Revolution. Cadart travelled to the United States in 1866 to drum up customers. Castagnary dubbed him "a La Fayette of art," embarked on a mission to "to complete the work of emancipation and progress begun by the La Fayette of politics."[16] The significance of such flourishes can be exaggerated, but this much is certain. The aquafortistes understood themselves as independents who had broken with tradition and its institutional incarnation the Academy of Fine Arts.

Very much the same spirit animated France's earliest acolytes of japonisme. The term was in fact coined by Burty who articulated as well as any critic what it was about the Japanese aesthetic that appealed with such force. European ceramicists, he wrote in 1866, aspired to a rule-governed perfection akin to the complex, checkerboard regularity of the gardens at Versailles.[17] The Japanese, by contrast, did not pursue an ordered flawlessness but found beauty in an "elegant simplicity" full of irregularities but all the more vital for that. Like the English garden or Barbizon-school landscape, Japanese art by virtue of its imperfections and sober eloquence had captured a piece of "true nature." Here was a summons to create "sincerely original works," a challenge that might well upset "the classicizers" but which counselled the young to emancipation.[18]

As with the aquafortistes, so with acolytes of japonisme, such emancipatory impulses found institutional expression. Burty, joined by Bracquemond, Fantin-Latour, the painter Alphonse Hirsch, Marc-Louis Solon (an employee at the Sèvres ceramics works), and three like-minded amateurs, organized the Société du Jing-Lar in 1868, a drinking fraternity that met for a period of months in Solon's home out at Sèvres. The revellers carried on in high style, toasting with saki, dining with chopsticks, and paying general good-humored homage to the Japanese art they so admired.

Bracquemond paid homage in a more serious vein as well, conceiving a series of ceramics and prints in the Japanese style, two of which deserve comment in the present context. The first, the so-called "republican plate," was executed in 1868, and its design makes plain how it got its name. Beneath the words, "This sun causes me to be afraid," a black eagle (the imperial eagle?) is shown, screeching at a radiant, sun-like phrygian cap. The phrygian cap appears in a second work executed not long thereafter, a bookplate which Bracquemond designed for his friend Burty. The plate features the usual ex-libris inscription, but more. At the top, a stork with a banner marked "Free and Faithful" in its beak wheels over a rising sun on which is perched a phrygian cap once again swathed in rays.[19]

Few contemporaries would have had difficulty deciphering such imagery. In Roman times, manumitted slaves wore the *bonnet phrygien* as

a marker of their new-found freedom. French and American revolutionaries had revived the fashion of the cap, sporting it as revolutionary headgear, stamping it on coinage, and elevating it withal to a potent symbol of liberty. Japonisme held out to its celebrants a promise of aesthetic emancipation but for the men of the Jing-Lar at least, it appears that artistic liberty and liberty *tout court* were two sides of the same coin.

Manet

The new painters' institutional restiveness took a variety of forms: sniping against the Salon, refuge-taking in private clubs and associations. By the late 1860s, however, such low-cost gestures of discontent had crystallized into a more confrontational style, and no artist bore more responsibility for the transformation than Manet.

The *Déjeuner sur l'herbe* which he exhibited at the Salon des refusés established Manet's flair for controversy. The Emperor himself is said to have declared the painting an offense to good morals.[20] Manet struck once more at the official Salon the next year. He showed a *Dead Christ with Angels*, and what impressed critics both at the time and thereafter was the artist's unsentimental handling of the savior's lifeless body. Thoré remarked on how the corpse was seated "like a natural person." To Zola, Manet's dead Christ appeared not "*the Christ*" but a "cadaver freely and vigorously painted." Or, as the artist's first biographer Edmond Bazire formulated it, this Jesus looked more man than God.[21] Here was a religious painting drained of sacral content, and the provocation was all the greater given the intense public dispute, raging at that very moment, about Christ's divine nature. In February 1862, the philologist Ernest Renan delivered an inaugural lesson at the Collège de France, questioning Jesus' divinity. The event sparked a near riot and got Renan fired from the Collège. He was not deterred but went on to publish the *Vie de Jésus* in 1863, a biography of the historical Jesus which portrayed Christ as a paragon of humanity but as a man just the same. This was the context in which Manet's *Dead Christ* appeared. The art critic at *La Vie parisienne*, a boulevard journal with a weakness for badinage, had little trouble drawing a connection between Renan's demystifications and Manet's, retitling the artist's canvas "'The Poor Miner Pulled out of the Coal Mine' painted for Renan."[22]

Manet did not respect the idealizing conventions of Salon painting. Nor did he hesitate to make show of a studied disrespect toward the Salon system itself. It has been noted how unwelcoming the Salon jury of 1867 proved toward the new painting. Bazille and Monet grumbled about academic narrow-mindedness, but Manet took concrete action, mounting

a one-man exhibition of his own in a makeshift gallery on the Place de l'Alma. A catalogue was published in connection with the show, which spelled out the artist's position:

> The artist does not say today, "Come and see faultless work," but, "Come and see sincere work."
>
> This sincerity gives the work a character of protest, albeit the painter merely thought of rendering his impression.
>
> Manet has never wished to protest. It is rather against him who did not expect it that people have protested, because there is a traditional system of teaching form, technique, and appearances in painting, and because those who have been brought up according to such principles do not acknowledge any other. From this they derive their naive intolerance.[23]

It was not long thereafter that Manet's relish for contention got him into trouble, not with artworld authorities this time, but with the imperial state itself. In the summer of 1867, the Emperor Maximilian of Mexico was executed by firing squad. The incident was a humiliating blow to French foreign policy, for it was French troops, at Louis-Napoleon's behest, who had placed Maximilian on the throne in the first place. Now he was overthrown, slain by partisans of Benito Juarez, an anticlerical republican backed by the United States.

Maximilian's execution so clutched Manet's emotions, he painted three versions of it and composed a lithograph as well. It was expected he would submit one of the canvases to the 1869 Salon but he was warned against such an undertaking by imperial officialdom. The imperial censor went further still, prohibiting reproduction of the lithograph version altogether. A vexed Manet turned for help to Zola who published a protest in the newspaper *La Tribune*, edited by Théodore Duret. The venue chosen for the protest and the terms in which it was framed were calculated rather to goad the government than to mollify it. *La Tribune* and Duret had been indicted not two months before for organizing an unauthorized public subscription to honor the memory of Alphonse Baudin, a republican doctor killed in 1851 resisting Louis-Napoleon's coup d'état. Here is what Zola had to say in the pages of such an oppositional rag:

> On examining a proof of the condemned lithograph, I noticed that the soldiers shooting Maximilian were wearing a uniform almost identical to that of our own troops. Fanciful artists give the Mexicans costumes from comic opera. M. Manet who truly loves truth, has drawn their real costumes. ...

You can understand the horror and anger of the gentlemen censors. What now! An artist dared to put before their eyes such a cruel irony: France shooting Maximilian![24]

The confrontational posture which the new painting had begun to make its own in the late empire reached its culmination in the Salon elections of 1870. On the national political front, Louis-Napoleon was moving toward a liberalized constitutional regime, and similar policies were applied in the artworld. The Salon jury in its entirety was made subject to election with all former *exposants* conceded the right to vote. Jules La Rochenoire, an animal painter, assembled a slate of candidates, who agreed to stand for office.

La Rochenoire's maneuver is interesting on several counts. First, for the composition of the list which featured the two most notorious artworld dissidents of the day, Courbet and Manet, joined by a supporting cast of genre artists (like La Rochenoire himself) and landscapists (Corot, Daubigny, Millet).[25] No member of the Academy figured on the list. Of equal importance, La Rochenoire intended to run a serious campaign not all that different in *modus operandi* from a political campaign for elective office. This meant in part drafting a formal *profession de foi*. La Rochenoire wrote up the document which mandated an overhaul of the Salon system. Salon jury members were henceforth to be chosen by an electorate made up of all former *exposants*. No non-artist might serve. The jury in turn, free from all administrative interference, was to be invested with the necessary authority to run the Salon. The award of prizes and medals, which had worked in the past to bias public response, was suppressed. He had a slate of candidates and a program: all that La Rochenoire's campaign now lacked was publicity. Manet lent a hand in this domain, prevailing on Zola to have the dissidents' list inserted in the pages of *La Cloche* and *Le Rappel*.[26] The art critic at *Le Rappel* was none other than Burty who, of course, agreed to help out, published the list and added a few supportive words of his own: "Liberty. Liberty. Art must expect everything from itself, and nothing from the government."[27] As for La Rochenoire, he dashed off a letter to *Le Réveil*, touting "the ideas of independence" that motivated the dissident list, the spirit of "solidarity" that reigned among the candidates, and their embrace of the common program as "a binding mandate" [*mandat impératif*].[28] The readers of *Le Réveil*, edited by the old '48er Charles Delescluze, would have had no trouble picking up the charged resonances of such phrasing. It was the very language Gambetta had used the year preceding to get himself elected deputy from working-class Belleville.

In the event, the Salon of 1870 proved part triumph, part defeat for the new painting. Four of the La Rochenoire candidates were returned – Corot, Daubigny, Millet, and Ziem – but they might have won election anyhow. The jury majority rejected Monet's submissions, prompting Corot and Daubigny to resign. But Pissarro got work accepted, and so too Manet who had reason in the wake of the Salon to take a measure of satisfaction. Burty in *Le Rappel* and Duret in *L'Electeur libre* accorded him warm praise. Castagnary's review in *Le Siècle*, while critical in tone, was extensive and thoughtful. On the other hand, Burty, Castagnary, and Duret were hardly converts. They had not been won over at all but were friends and acquaintances of the new painters, engaged in promoting a movement of which they were themselves very much a part.

The course of the 1860s had not been an easy one. The new painters did not like the Salon as it was constituted nor what they understood to be academic aesthetics. They had tried to break into the system but were as often as not turned away. Without the backing of more senior men like Daubigny (himself a contested figure), their record would have been more dismal still. All sorts of institutional expedients had been resorted to in order to skirt the resistance they encountered: the Salon des refusés, the one-man show, independent association, Salon-jury electioneering. The new painting, by such means, made of itself an aesthetic opposition, an artworld equivalent to the anti-imperial insurgency of a renascent republican movement at that moment gathering momentum in the political domain. Indeed, "equivalent" is not quite the right word for the two oppositions were not just parallel but interlocking phenomena.

REPUBLICAN ART CRITICISM

Perhaps it is too much to claim that the new painting's institutional agitations had the look of a republican-style campaign. What is certain is that the movement found its first partisans among critics – Burty, Duranty, Duret, Thoré, Zola and to a lesser degree Castagnary – who worked for the opposition press, subscribed to its philosophic and political critique of the imperial status quo, and crafted a style of art commentary inflected by such wider concerns.

The Empire relaxed but did not abolish its censorship laws in 1868. The long-muffled voice of the opposition gave immediate vent. It was not that there had been no journalistic criticism of the Empire before. *Le Temps* had, since 1861, dissented from imperial policy in accents of dignified disapproval. *L'Avenir national* and *Le Siècle* were more outspoken and republican in their protests. For political exiles like the republican historian Edgar Quinet, the Brussels-based *Indépendance belge*

was the organ of choice. But such voices were neither numerous nor militant. The press reform of 1868 changed all that.

A spate of new papers came into being whose very titles broadcast a tone of heightened militancy. Charles-Louis Chassin, for many years Quinet's personal secretary, founded *La Démocratie* in June 1868. The paper did not survive long but metamorphosed into *La Tribune*, managed by Duret and edited by Eugène Pelletan (a Protestant, Freemason, and republican of long-standing). Louis Ulbach's *La Cloche* (The Bell), with its none too subtle allusion to Alexander Herzen's journal of the same name, dates from the late empire, as do Delescluze's *Le Réveil* (The Awakening) and Ernest Picard's *L'Electeur libre* (The Free Voter). Ulbach was a prominent mason, Delescluze (as we have seen) a veteran '48er, and Picard a republican deputy in the Corps Législatif. *Le Rappel* was founded by the Hugo family in May 1869. In this instance, it may not have been the title – a reference to the drum tattoo beaten to call troops to assembly – that gave surest guarantee of the paper's republican bona fides. That was provided by the name of *Le Rappel*'s spiritual patron, Victor Hugo, blazoned on the masthead. For incendiary titles, however, the prize must go to Rochefort who launched the weekly *La Lanterne* in 1868, printed on red paper, and then, from December 1869 to July 1870, published a daily *La Marseillaise*. Both names allude to revolutionary songs. "La Marseillaise" speaks for itself. It should just be added that the Empire had made singing the anthem in public a criminal offense. As for *La Lanterne*, the reference here is to the refrain of *Ça ira*, "Les aristocrates à la lanterne," which exhorted listeners to lynch aristocrats from the nearest lamppost.[29]

It has been observed how much the new painting counted on the press to make its way in an artworld governed by inhospitable institutions like the Academy and Salon. What needs emphasizing, though, is that the press in question came with a distinct political coloration. When the new painters wanted publicity or favorable notices, it was to the republican newspapers that they turned, and the reason is straightforward enough. *La Cloche, Le Rappel, La Tribune*: these were the papers that gave employment to the art critics most receptive to the *jeune école*. Zola in fact worked at one time or another on all three. It was not necessary for the critics to endorse every opinion expressed by the editors who paid them, but critics and papers did share a general political orientation.

Zola, to take one example, had innumerable differences with Ulbach and Pelletan, neither of whom could stomach the critic's naturalist fiction. Zola remained nonetheless a stout republican. At the outbreak of the Franco-Prussian war, he published a pro-peace article in *Le Rappel*, which landed him in legal trouble with imperial officialdom. The Empire had

collapsed before he could be brought to trial, surrendering authority to a republican Government of National Defence which resolved to carry on the war effort. Zola was now no longer the pacifist but solicited a post from Minister without Portfolio Alexandre Glais-Bizoin, an old '48er. He hoped for a slot in the prefectoral corps but had to settle for a position as the minister's personal secretary.

In Zola's case, art criticism, press work, and politicking were all of a piece, and he was not unique in this respect among the pro-new-painting critics. Burty's and Duret's political connections have already been alluded to. Burty worked at *Le Rappel* and pasted bookplates, republican in design, in the front of his books. In 1879, he wrote a letter to Auguste Scheurer-Kestner, invoking a life "devoted under the Empire to the Republic and under the Republic to liberty."[30] Duret, as we have seen, had been fined as manager of *La Tribune* for the part the paper played in the Baudin Affair; it was not one year later that he published his now famous apologia for the new painting in the pages of *L'Electeur libre.*

Thoré's political credentials are perhaps most impressive of all. A large chunk of the Salon criticism he published appeared in the *Indépendance belge*, and this for the simple reason that he was himself an exile. A devoted democratic socialist, Thoré had taken part in Alexandre Ledru-Rollin's June 1849 insurrection, an aborted effort to rescue the Second Republic from the creep of reaction. Thoré took refuge abroad, returning to France after the amnesty of 1859 under the pseudonym William Bürger.[31]

As for Castagnary, he was always more politician than art critic, destined to end his days under the Third Republic as a councillor of state. In the 1860s, he wrote Salon reviews for *Le Siècle*. But he also had legal training and kept company with the rising generation of republican lawyers (Gambetta among them) then making its mark at the Palais de Justice. In 1869, volume one of the so-called *Encyclopédie générale* appeared, an enterprise modelled on Diderot's Enlightenment master-piece, although this time the rallying cry was not *les lumières* but experimental science. Castagnary's name figured prominently on the list of contributors, itself a veritable Who's Who of Latin Quarter free-thinkers.[32]

Duranty's brush with the republican press may not have been as exten-sive as Castagnary's: he did a brief stint at *La Démocratie* in the late 1860s. But Duranty was every bit as much the habitué of free-thinking circles. He is remembered as the moving force behind *Réalisme*, a short-lived periodical that championed the painting of Courbet in the 1850s. Duranty, though, did not run the paper alone but with the aid of two collaborators: Dr. Henri Thulié and Jules Assézat, the former a militant materialist who, like Castagnary, later worked on the *Encyclopédie générale*,

the latter a materialist as well and a Diderot booster who spent a lifetime publishing a twenty-volume edition of the philosophe's oeuvre.[33]

The new painting found its first critic friends among republicans, democratic socialists, and free-thinkers. Nor did such men bracket their convictions when they sat down to write art criticism. Far from it. They composed in an idiom shot through with catchwords and slogans which identified them for what they were, partisans of an opposition that was as much political and philosophical as aesthetic.

As might be imagined, the critics, like the new painters, had little good to say about the Salon system and how it worked. Juries, Zola remarked, were not elected by "universal suffrage" but by a "restricted vote."[34] The painters chosen were partisans of an outworn academic aesthetic, Prix de Rome laureates who had made their reputations imitating the art of antiquity and the Italian renaissance. "This Roman-foreign Pleiad," as Thoré called them, favored its own, handing out the top prizes to like-minded epigones. The lesser awards went to the favorites of imperial officialdom, to "what in the political world liberals ... like to call *official candidates*" (the reference here is to the imperial regime's practice of lending administrative and financial backing to state-approved hacks at election time).[35] Castagnary rejected such proceedings as "an offense to the freedom of industry." It was "public opinion," not a clique sponsored by the administration, which ought to decide which paintings had value and which not. In the political domain, jabbed an angry Castagnary, the public had begun to clamor for a separation of Church and State. Why not then a separation of Art and State?[36]

But it was not so much the intolerance of the Academy that so nauseated the critics as its hypocrisy. The well-trained Salon artist pretended, in Duret's words, "that there exists an abstract type, and only one, of beauty in itself."[37] He looked to the masters of the past for lessons in the beautiful and then proceeded to paint studio pictures in a variety of high-minded genres: well-manicured nudes, society portraits, scenes from the Bible and classical antiquity. The whole business stank of phoniness from start to finish. In a world of flux and transformation, the notion of an unchanging *beau idéal* made no sense. Writing of the masters of the past, Zola boasted with a barbarian ruthlessness: "I care little for beauty or perfection. I thumb my nose at *les grands siècles*. ... There are no more masters, no more schools."[38] The studio painting lacked life; the colors rang false; the poses were stilted and the figures costumed like so many stage actors. But the unreality of such painting did have a purpose. The nudes, so many boudoir Venuses, played to the appetites of the rich and powerful. The portraits flattered them. As for religious painting and the classical landscape, Thoré put the matter with characteristic bluntness: "a

well-policed society would not know how to manage without pagan and Catholic mythologies." In the art of Cabanel, Gérôme, and Bouguereau were to be read the mores of the Empire itself: a despotism that dressed up its corruptions and worldliness in the language of religion and high ideals.[39]

There is no denying the reductive and polemical character of such criticism. Academic art was more varied and less craven than the caricature of it Thoré *et al.* sketched. The issue, though, is not to determine whether the critics got it right but to identify the terms and polarities in which they thought. The point is just as valid for what the critics had to say about the artistic currents they did like: Courbet-style realism, Barbizon landscape, and the new painting.

What Castagnary held against Bouguereau, as he explained in a Salon review of 1869, was the painter's unseeing indifference to "the society born of the Revolution."[40] The men and women of the nineteenth century, how they dressed and disported themselves, these were the proper subjects of a modern art. It is not that no models for such a painting existed. Critics cited the scenes of Third Estate domesticity painted by Chardin and above all the "civic realism" of the Dutch school as exemplars of the kind of art they approved.[41] And they had no shortage of suggestions how such a vision might be translated into nineteenth-century practice. Paint "the *social* aspect of man," urged Duranty, the frock-coat of the bourgeois and the smock of the working man.[42] Castagnary touted a naturalist art, outdoor scenes, unspoiled by learned allusion and accessible to all. And, he added, keep religion out. Not God but progress and science presided in the modern Eden of Castagnary's imagining, and such scientizing enthusiasm was shared in full measure by Thoré and Zola. Study the facts, they prescribed. Set aside the veils of mythological convention, and look the world square in the face.[43]

From such procedures, a new kind of painting might be fashioned. It would be simple and sincere in contrast to the elaborate deceits of the academic school, and it would be manly. At the Salon of 1861, appalled by canvases of prettified nudes, Thoré hankered for the work of Daumier, "a virile artist." Zola, in a similar frame of mind at the Salon of 1866, fell upon a Monet portrait with the exclamation: "now there is a temperament, there is a man among eunuchs."[44]

The critics had an idea what a modern art should look like, and they described it in similar terms. They wanted a painting that was democratic, sincere, secularizing, and scientific. In varying degrees, they believed they had found what they were looking for in the new painting. This was most true of Duret and Zola who were such enthusiastic partisans of Manet's oeuvre. It was less so of Castagnary who felt more comfortable with the

work of Courbet and, it may be suspected, took up the *jeune école* just so far as they reminded him of the older master.

A qualifying observation, however, needs to be made apropos the critics' positive agenda. They exaggerated the positivist procedures of the new painters who never painted just what they saw but composed their canvases with dogged effort to create effects of naturalness and spontaneity. Still, the critics were able to learn over time. Their lexicon of praise evolved with the new painting movement itself. The relentless scientizing and talk of manliness eased up in the 1870s as the female presence in the movement grew more substantial and its impressionist wing more self-assured. These nuances are important but ought not distract from the principal claim. The new painting's critic friends nurtured institutional and aesthetic agendas which they framed in a language full of political innuendo. In retrospect, it may well seem that the actual differences distinguishing the new painting from more conventional, academic-inspired art were not that great. But at the time, critics like Duret and Zola were working hard to create polarization. They set up the new painters against a hidebound Academy, in the process erasing all intervening shades of opinion. And they used politics to raise the stakes, recasting artistic differences into a confrontation between friends of liberty on the one hand and die-hard partisans of despotism and oligarchy on the other.

PAINTERS AND THE REPUBLIC

How did the new painters themselves feel about this? There is no evidence to indicate that they objected, and much to suggest the contrary. The argument is not that the *jeune école* were political fire-eaters. They all placed art first. Nor is it that they were unanimous in expressions of republican affiliation. Sisley to all appearances had no politics at all, and Degas in the 1860s was never more than a man of progressive, liberal views. But all the new painters frequented republican circles, fraternizing with party bigwigs at the salon or café, poring over the republican press for news and edification. Of the eleven or so artists who made up the core of the *jeune école*, a majority did in fact leave behind traces of republican commitment, an occurrence all the more remarkable for men and women who were painters, still young and little recognized.

Perhaps it is not so remarkable in the cases of Cézanne and Bazille who came from solid bourgeois families headed by republican fathers. Cézanne père was an Aixois banker, a mover in republican circles who landed himself a post on the local town council in 1870 following the Empire's collapse. The young Cézanne painted a portrait of his father reading *L'Evénement*, a boulevard paper in which Zola for a time published art

reviews (Plate 1.2). In the original version of the canvas, however, the sitter was shown with a copy of *Le Siècle* in hand, a natural choice of reading matter for the hardheaded anti-clerical that the old man was. The son also read *Le Siècle*, but what excited him more was "the noise of *La Lanterne*" which brought news of Rochefort's antics in Paris. Papa was a republican of the solid bourgeois type, but the younger Cézanne seems to have been more rough-edged both in his manners and his politics, "saying terrible things about the tyrant" Napoleon III and railing against Louis XIV as "the stupidest of our kings."[45]

Bazille was altogether a better behaved young man. He was born into a buttoned-up, wine-growing Protestant family from Montpellier. The father was a man of parts who got himself elected Senator in 1879, choosing to sit with Jules Ferry's *Gauche républicaine*. Bazille's parents nursed hopes that their son would make a career as a doctor and sent him off to medical school in Paris in 1862. There Bazille witnessed first-hand student protesting which in the end drove the Ecole de Médecine's Bonapartist dean to resign from office. The Latin Quarter was rocked again by disturbances in 1865. A band of student free-thinkers had gone to Liège to attend a conference which turned into a veritable anti-imperial jamboree. The students were punished on return home, igniting a second bout of Latin Quarter upheaval. Bazille at the time was living in the neighborhood with Monet and wrote home about the events with great excitement, winding up, however, on a note of reassurance: "Don't get upset on my account, I won't be making barricades." Bazille missed out on yet one more round of trouble in 1870. A relative of the emperor had gunned down Victor Noir, a staffer at Rochefort's *La Marseillaise*. Noir's funeral almost erupted into insurrection. Bazille had considered attending the event but bad weather and a promise to sit for Fantin-Latour's *A Studio in the Batignolles* had caused him to think better of it. Bazille did, however, get hold of the day's edition of *La Marseillaise* before the police had managed to seize all copies from the kiosks. Such evidence paints a Bazille very much in the thick of things but more as an interested spectator than participant.[46]

It may be that, as a young man of good breeding, he felt more at ease talking politics in the salon than acting them out on the streets. And the salon he attended with most regularity was that of Commandant Hippolyte Lejosne: a relative, an aficionado of the arts who came to the Café Guerbois, and also, it seems, a convinced republican. The guest list at the Lejosne salon bore witness to the host's diverse passions. Bazille, Fantin-Latour, and Manet represented the arts, Léon Gambetta politics. The conversation, it is reported, often turned to anti-imperial invective. Did Bazille join in? There is no doubt that he ended his short life a republican.

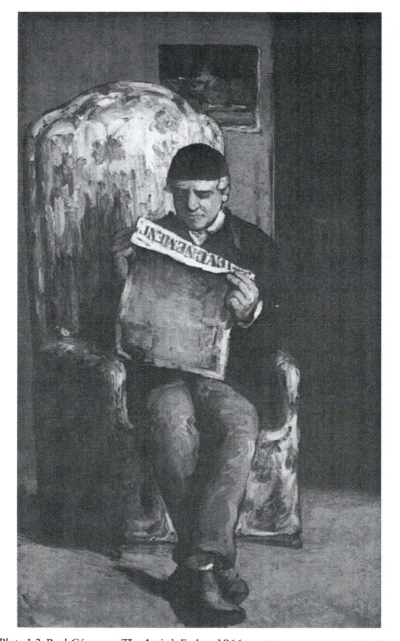

Plate 1.2 Paul Cézanne, *The Artist's Father*, 1866.

The outbreak of the Franco-Prussian war found him in the army performing military service. A string of stinging defeats set off a republican insurrection in September 1870, which marked the Empire's demise. Bazille, still in uniform, greeted the events with satisfaction: "I am stunned by the most recent news, but, my God, well pleased with the Republic, provided it lasts."[47] The Republic survived, but not Bazille who was killed in action before the year was out.

Bazille's friends from Gleyre days – Monet, Pissarro, and Renoir – were of more modest social origin, the sons of merchants and shopkeepers, and the political company they fell in with was in equal measure of the less well-bred sort. Monet arrived in Paris in the late 1850s and took to patronizing the Brasserie des Martyrs in Montmartre, meeting there the éminences of the realist school, among them Castagnary and Courbet. Not many years later Monet resettled in the Latin Quarter, a move that brought him into contact with local free-thinking circles. It was at this time that he first met Clemenceau, a philosophic materialist who spent much of the 1860s in and out of scrapes with imperial authorities. Mutual friends, Dr. Paul Dubois and Antonin Lafont, had brought the two men together. Now, Dubois and Lafont were themselves well-known trouble-makers. Both were militant atheists. Dubois took part in the French delegation to the student congress at Liège. On return to Paris, the Liège delegates organized a free-thinking burial society, Agis comme tu penses. Lafont, and Clemenceau as well, were among the first adherents. It should not be thought that Monet's associations with such men were superficial. He made gifts of paintings to Dubois and Lafont, both of whom acted as witnesses at Monet's first marriage in 1870 (so did Courbet). Clemenceau remained the artist's friend until Monet's death in 1926. And even in death Monet remained faithful to the attachments made in youth, leaving strict instructions that he be interred in a civil ceremony.[48]

For Renoir and Pissarro, the evidence of political involvement is much slimmer. Renoir's family moved to Paris in the 1850s, settling on the rue d'Argenteuil in the city's central First arrondissement. Aunt Lisa, an admirer of Auguste Blanqui, attended the meetings of a "*groupe révolution-naire*" in a nearby neighborhood; Renoir's brother married the daughter of a local Jewish goldsmith; the artist himself was first apprenticed to a porcelain maker named Lévy who ran a shop on the rue Vieille du Temple. Renoir's family connections to Jews and Blanquist rebels is not much evidence to go on, but it affords an approximate first sketch of the milieu the young artist moved in. The picture is confirmed by an incident, recounted by the artist's son Jean, that may be dated to the waning months of the Empire. Renoir was working at Fontainebleau. In the forest, he crossed paths with Raoul Rigault, a Blanquist provocateur then

in flight from the police. In 1869–70, Rigault had worked at Rochefort's *La Marseillaise* and was destined to become chief of police under the Paris Commune. How did Renoir deal with such incendiary company? He furnished Rigault a disguise and hid him for several weeks. Pissarro got in touch with the fugitive's friends back in Paris, who arranged to smuggle him out of the city.[49]

The story is revelatory not just of Renoir's indulgence toward an extremist firebrand but at the same time of the ease of Pissarro's access to far-left circles. Pissarro in fact counted numerous friends on the left: fellow painter Ludovic Piette who was a ferocious anti-Bonapartist and the free-thinking homeopathic physician Paul Gachet. As for Pissarro himself, he seems to have been a firm republican. During the Franco-Prussian war, not long after the Empire's collapse and in the face of continued German military advances, he was seized by an urge to enlist, although neither a French citizen nor, at forty, a young man. He did not, dissuaded by family members, the sickness of his soon-to-be wife, and the death of their out-of-wedlock daughter. A letter from Pissarro's mother gives an indication of the motive that had put such a rash notion in the painter's head in the first place: "I beg of you, don't go fight ... if something bad were to happen, what would I do? ... Put aside the Republic and think of your own [*à ton entourage*]."[50]

The impressionists-to-be rubbed shoulders with the more rabble-rousing wing of the republican movement. The company Manet and his friends kept was more reputable, but it was republican still, bleeding at the edges into an enlightened liberalism.

Manet himself was in many ways the most radical of the lot. As a young man, he had thought of a naval career and in 1848–49 embarked on a training cruise to Rio. In March 1849, four months after Louis-Napoleon's election to the presidency of the Second Republic, the teenaged Manet wrote home: "... try to preserve our good Republic until my return, for I well and truly fear that L. Napoléon is not himself much of a republican."[51] Such precocious republicanism is not so startling in a family full of republicans. Manet's cousin Jules de Jouy was an established lawyer who for a period gave employment to an up-and-coming member of the young bar, Gambetta. Manet's brother Gustave was a lawyer as well, a devotee of Gambetta from Latin Quarter days when the two had hung out together at the Café Procope. Manet's other brother Eugène was attached to a second luminary of the republican bar, Emile Ollivier. Eugène, Edouard, and Ollivier in fact met in Italy in 1853, paying a visit in Venice, on Jouy's recommendation, to the household of that old '48er Carlo Cattaneo.[52]

Edouard Manet, however immersed in his painting he became, never

distanced himself from this milieu. He disdained the Empire and its deco-
rations. Millet refused the Legion of Honor in 1868. Manet applauded
the gesture, dismissing the award as a "dirty gewgaw," suitable for children
and regime toadies.[53] He was no more generous to Louis-Napoleon's
foreign policy. *The Execution of the Emperor Maximilian*, as has been
noted, was understood as a slap at Bonaparte's Mexican adventure. Nor
was *The Execution* Manet's first foray into history painting with an aggres-
sive edge. At the time of the US Civil War, Louis-Napoleon tilted in favor
of the South. The American conflict came to France's doorstep in 1864.
A confederate raiding vessel, the Alabama, met a union corvette in
combat just off Cherbourg and was sunk. News of the engagement, a
defeat for the Confederacy as for imperial policy, so fired up Manet that

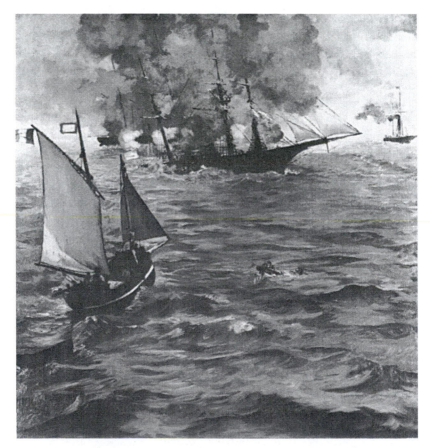

Plate 1.3 Edouard Manet, *Battle of the Kearsarge and the Alabama*, 1864.

Source: The John G. Johnson Collection, Philadelphia Museum of Art

he took off for the Normandy coast, sketched the Union ship the Kearsarge at anchor, and then executed a full-sized reconstruction of the event, *Battle of the Kearsarge and the Alabama* (Plate 1.3). The canvas, painted in deep seagreens, is brightened on the right border by the colors of the stars-and-stripes hoisted atop the triumphant Kearsarge.[54]

Does it seem probable that a picture of such critical content was not meant to carry a sting? And this at a time when the artist himself was drawing closer to the rising star of republicanism Léon Gambetta. It may have been brother Gustave who first brought the artist and the politician together. Or it may have been Edouard's friend from art-school days Antonin Proust who claims to have dined with Manet, Gambetta, and Gambetta's second-in-command Eugène Spuller in 1863. But such passing acquaintance did not become more intimate until 1868–70 when the two men began to meet on a more regular basis at the Café de Londres.[55] It was an association that would last until Gambetta's death in 1882 and from which the artist would profit, as we shall see.

Among the circle of new painters closest to Manet, Bracquemond seems to have been most similar in outlook. The evidence, while not abundant, is to the point. Bracquemond's so-called *assiette républicaine* and the bookplate designed for Burty were both decorated with the phrygian cap, a symbol laden with seditious meaning. Bracquemond frequented the Lejosne salon, known for its anti-imperial invective; and he belonged to the Jing-Lar which in recent art historical literature has been portrayed as a republican coven in japonisant disguise. This may well be so. Bracquemond and Burty were republicans. Alphonse Hirsch, a third Jing-Lar member, was a Jew, an early adherent of the liberal-minded Alliance israélite universelle, and related by marriage to Eugène Manuel, a future *chef de cabinet* of the moderate republican Jules Simon.[56] Hirsch's presence in the Jing-Lar attests, if not to the club's republicanism, then at least to its unusual openness of spirit.

Fantin-Latour also belonged to the Jing-Lar. In the 1850s, he had haunted a Left-bank hang-out the Café Molière, rubbing shoulders there with Irish nationalists, Fenian exiles "then seeking refuge in Paris." In the 1860s, he took up with the Lejosnes and enjoyed a standing invitation at the home of Paul Meurice, an editor at *Le Rappel*. There is no doubt of Fantin-Latour's republicanism in later years. He sketched a portrait of the dead Victor Hugo in 1885, voted against the troublesome General Boulanger in 1889, and plumped for the Dreyfusard cause at the end of the century. Whether such political resolve can be read back into the 1860s, though, is not altogether certain. At the Meurice salon, Bracquemond and Manet plunged into vigorous discussion about the relationship between art and democracy, but the debate left Fantin-Latour

cold. He wrote to a friend: "I share none of these ideas and I say that Art has nothing to do with such matters." It may well be that Fantin-Latour was already a republican in the 1860s, but the commitment was not so encompassing for him as it was for his friends.[57]

In the cases of Morisot and Degas, however, there is no evidence, circumstantial or otherwise, of a republican commitment at this early date. Morisot came from an open-minded family which allowed her to pursue an interest in painting with more than the usual seriousness for a youthful bourgeoise. Father, a government official, welcomed a rather mixed crew of visitors into the household: Manet, of course, but also Jules Ferry who for a time took a shine to Berthe. Still, the old man himself seems to have been a firm admirer of Adolphe Thiers, a liberal centrist but no republican.[58] At this stage, there is no reason to believe that Berthe Morisot dissented from the prevailing creed of the family household: a *bien-pensant* liberalism that was indulgent toward the more adventurous ways of the young. The disagreements would come later with the deepening of civil strife in the first months of 1871.

Degas came from a line of bankers which had just as much claim to standing and good form as the Morisots, perhaps more. They spelled the family name with a noble-sounding *particule*, de Gas, and made certain that Edgar attended the best schools. But Degas was a young man of prickly independence. He took to painting, scrapped the *particule*, and, under the sway of Lavater's physiognomic speculations, began to turn out a remarkable body of portraiture that communicated with disturbing exactitude a sitter's emotional depth and unease.[59]

Degas' social frequentations in these early years suggest a young man of tolerant and progressive views. In the mid-1850s, he drew close to the Breguets, a Protestant family possessed of a renowned watchmaking business. One of the Breguet daughters married Ludovic Halévy, a writer of Jewish ancestry, who was to become a long-time intimate of Degas. The Breguets hosted Monday dinners, inviting round a varied list of guests, a cultured set to be sure but one distinguished by a conspicuous tendency to heterodox opinion. Degas himself was an habitué, rubbing shoulders at table with the likes of Charles Robin and Edouard Laboulaye, the former a republican doctor and apostle of Comtean positivism, the latter an Americanophile of Unitarian sympathies who in later years helped negotiate the gift of the Statue of Liberty to the United States.[60]

Degas spent three years in Italy at the end of the decade, and here too fell in with a crowd at once cultivated and progressive in its convictions. In Florence, he stayed at the home of his uncle Gennaro Bellelli, who had been driven into Tuscan exile in the wake of the failed Neapolitan revolution of 1848. Degas toured the town in the company of two fellow

Frenchmen, Antoine Koenigswarter, scion of a wealthy Jewish family with close connections to the Alliance israélite, and Georges Lafenestre, a future inspector of fine arts of known republican views. With Lafenestre, he went to the Caffè Michelangiolo, sharing drinks with a band of artists, the Macchiaioli, who combined an experimental interest in realist painting with an enthusiasm for the cause of Italian unity. Degas' family and friends were Italian patriots and so, it turns out was he. On return to France, he set to painting *The Daughter of Jephthah* (1859–60) which has been interpreted as a veiled critique of Louis-Napoleon's vacillating support for Italian nationhood.[61]

The new painters in the late 1860s had begun to crystallize into a movement and one with an oppositional project. They painted in a style that artworld grandees found disturbing and wrangled over and again with Salon authorities. They counted a handful of admirers in the critical community, but such partisans as they had were a pack of troublemakers embroiled in endless difficulties with the imperial state. The new painting's critic friends, moreover, had no interest in calming tempers, but insisted rather on stirring the pot, adding a heavy dose of politics to their critical polemics. As for the painters themselves, they seemed willing enough to play along. They stood in need of friends, of course, but more than that: they in good measure shared the critics' political agenda.

It is easy to overlook what a curious mix the new painters were. Bazille was a Protestant, Pissarro a foreigner and a Jew, Morisot a woman. Degas and Manet came from affluent bourgeois stock; Monet and Renoir's antecedents were more humble, yet by no means impoverished. Theirs was a citified France of middle-class aspiration, uncommon in its dynamism and open-mindedness. At mid-century, this France had begun to edge toward embrace of a democratic republicanism, and the new painters moved in tandem. Not all moved, to be sure: Sisley remained to all appearances indifferent to politics. Nor did all move far: Degas and Morisot entered into conversation with republican celebrities at cultivated soirées but themselves seem to have ventured no further than profession of a broad-minded liberalism. Still, a half-dozen of the new painters did align themselves with the republican cause: Bazille, Bracquemond, Cézanne, Manet, Monet, Pissarro. Fantin-Latour and Renoir leaned in the same direction but did not make explicit gestures of commitment. The distance that separated the new painting and the *parti républicain* was not that great. In the aftermath of the disasters of 1870–71, the two movements would grow closer still.

2 The coming of the Republic

The 1870s was a decade of turmoil. France plunged into war with Prussia in the summer of 1870. A crushing defeat at Sedan discredited the imperial regime which was overthrown in September. A republican-dominated provisional government took its place but had little more success prosecuting the war. Paris came under siege; a French army of 175,000, commanded by the Maréchal Bazaine, surrendered at Metz in October; and at last in January 1871 a vanquished France sued for peace. Recuperation from a blow of such magnitude took time. A prosperous economy helped to heal France's material wounds, but the political legacy of defeat was more difficult to liquidate. It did not help that France's president from 1873 was the Maréchal MacMahon who, until wounded in action, had commanded French forces at Sedan. Yet, a coming-to-terms was in the end achieved. Bazaine was hauled before a court-martial in October 1873 and MacMahon forced to resign from office in 1879.

It was not, however, just the experience of defeat that required overcoming, but memories no less powerful of the civil war that followed. The Government of National Defence gave way in February 1871 to an elected assembly composed in large measure of royalists. The assembly selected as the nation's chief executive Adolphe Thiers, a wily and durable politician who had seen service as prime minister in July Monarchy days. After a brief sojourn in Bordeaux, the assembly opted to sit at Versailles, site of Louis XIV's imposing palace complex. Was a royalist restoration under way? Such provocative gestures incited a city-wide uprising in March 1871, from which emerged the revolutionary Paris Commune. A republican minority maneuvered to negotiate a peaceful resolution to the confrontation between Versailles and Paris but failed. Thiers brought the full resources of France's surviving armies to bear on the insurrectionists. The Commune was smashed and whole sections of central Paris razed in the process. Thiers subjected the conquered city to martial law, but a thaw eventually set in. Martial law was lifted in 1876, and three years later

parliament granted a partial amnesty to jailed and exiled communards, prelude to the full amnesty voted in 1880.

The gradual relaxation of public life in the late 1870s was in large measure the work of a republican movement coming into its own. The national vote of 1871 had dealt a blow to the republican cause, but in subsequent by-elections the movement gave signs of recovery. Thiers' apparent willingness to bargain with more moderate elements in the republican camp prompted the reactionary majority in parliament to unseat him in May 1873. MacMahon stepped in, inaugurating an era of redoubled official discipline or "Moral Order" as contemporaries called it. The *parti républicain*'s electoral advance, however, continued unabated, driving MacMahon to desperate measures. In May 1877, he prorogued the Chamber of Deputies, convened new elections, and applied heavy-handed administrative pressure to fix the results. Yet, the *seize mai* coup backfired. Voters returned a republican majority, and MacMahon, conceding defeat, soon retired from public life. The *parti républicain* acted with dispatch to consolidate its gains. The Chamber of Deputies elected the one-time firebrand Léon Gambetta its president. For years, republicans had clamored for recognition of July 14 as an official day of national cele-bration, but successive governments of Moral Order had resisted, finding the event too charged with revolutionary memory. On July 14, 1879, however, Gambetta hosted a spectacular, unofficial celebration of Bastille Day at the Palais-Bourbon (seat of the Chamber of Deputies). The *quatorze juillet* was made an official national holiday the following year.

Why rehearse events in such detail? The new painters were not detached observers of the history of their times. *L'Année terrible* shattered the new painting movement, reducing the painters as individuals to despondency. A beloved France, they felt, had suffered a crushing defeat. The nation had then descended into a disastrous and futile civil war. And no less dismaying to the painters, it was the reactionaries of Versailles who had, for the moment at least, gained the upper hand.

But the new painters recovered, knit their movement together again, and plunged back into the struggle. With an escalating zeal, they hammered away at the Salon system; they experimented with subject matter and painting technique in an unparalleled outburst of aesthetic invention and exuberance. In the fraught climate of the 1870s, such behavior took on an inescapable political coloration. The new painters were castigated as revolutionaries, communards, intransigents. Such labels, although exaggerated, did contain an element of truth. On the institutional front, the new painters campaigned against the Salon hierarchy, using the same techniques and rhetoric employed by the republican movement in its assault on the MacMahon presidency. There was a politics to the

emerging impressionist aesthetic as well. First, in that the aesthetic was framed (in part) in opposition to prevailing academic standards tarred for their unyielding conservatism; second, in that the new painters' critic friends interpreted the movement in a rhetorical idiom unmistakably republican in cast; and third, in that the art itself represented with a singular frequency events and personalities connected to the progress of the *parti républicain*.

The point is that the two movements, impressionist and republican, intersected in the 1870s. The new painters were in the main men and women of republican conviction, a *parti pris* that deepened as the decade wore on. They entered into republican society, painted its inhabitants, and looked to it for patronage. Such attentions were reciprocated, at least up to a point. It was in republican circles that the new painting found many of its first buyers. The Republic itself democratized the Salon system and extended a share of official recognition to members of the new painting movement.

The overlap between the two movements was never perfect. Degas took to frequenting republican society but does not seem to have made a home for himself there. The experimental vitality of the impressionists overwhelmed the Procrustean categories of critic friends like Burty and Castagnary. And, of course, much of France's new republican elite found impressionist art impossible to comprehend. Nevertheless, the larger claim still stands. For a moment in the 1870s, the worlds of experimental art and progressive politics drew together, a congruence that magnified the charge of the new painting and at the same time set the stage for its ultimate success.

1870–1: THE TERRIBLE YEAR

The new painters were patriots and conciliators. They reviled the Prussian invader; as for the Commune, they had no liking for either side, charting as best they could a middle course between revolution and reaction. Such a combination of views was characteristic of a certain strain of republicanism. No one prosecuted the war with more vigor than Léon Gambetta, minister of the interior in the Government of National Defense. No one worked harder to negotiate a settlement to the civil war than the mayor of Montmartre Georges Clemenceau.

The Franco-Prussian War

The Franco-Prussian war elicited a patriotic response from the new painters, tempered in certain cases by a self-preserving caution. No one

welcomed the conflict at first. Zola got himself into trouble with imperial authorities for a pro-peace article published on the war's eve. Manet regretted the event, blaming it on "the bad policies of the Empire."[1]

The proclamation of the Republic on September 4, however, changed the picture. Not perhaps for Monet who left en route to London, but certainly for Zola who performed a volte-face, soliciting a job with the Government of National Defense. Bazille, already under arms, waxed enthusiastic about the new regime. Pissarro was moved to consider enlistment, but the entreaties of his mother and death of his newborn daughter took the fight out of him. He joined Monet in London in December.[2] Degas and Manet, on the other hand, knew no such hesitations. They remained in Paris and with the onset of the siege joined the national guard. In the company of Manet's brother Eugène, the two painters went together to the Folies-Bergère to hear General Gustave Cluseret, a Union veteran of the American Civil War and partisan of *la guerre à outrance*, inveigh against the lackluster republicanism of the provisional government.[3]

Degas' and Manet's wartime patriotism never flagged in subsequent years – Degas in particular maintained a lifelong cult of the army – and the sentiment left its trace on their work. In 1871, Degas was commissioned to paint a double portrait of Rabbi Aristide Astruc and General Emile Mellinet (Plate 2.1). The two men were friends and Freemasons; Mellinet in fact had served a term in the late Empire as presiding officer of the Grand Orient, France's largest masonic order. And during the Franco-Prussian war, both had distinguished themselves as relief workers, a humanitarian bond which Degas' canvas was meant to commemorate.[4] Manet's artistic evocations of the war were more numerous and attest to the experience's enduring grip on the painter's imagination. While the siege of Paris was still under way, he executed a print of hungry citizens queueing up in front of a butcher shop. Eight years later, he returned to the theme. Paris was host to the Universal Exposition of 1878, advertized to the world as an affirmation of France's recovery from the debacle of 1870–1. In conjunction with the celebrations of the exposition, the MacMahon regime proclaimed June 30 a Festival of Peace (republicans, of course, had lobbied for the *quatorze juillet* instead). Manet took the occasion to paint a Paris street scene, emblazoned with tricolor flags, but anchored in the lower left quadrant by the somber figure of a man on crutches, in all likelihood a war veteran.[5] Manet joined in the revelry of the so-called Fête de la Paix of 1878, but he did not forget what defeat had cost the nation.

Nor did he forget the incompetence of the generals who had led France to disaster. In 1873, he travelled out to Versailles to observe

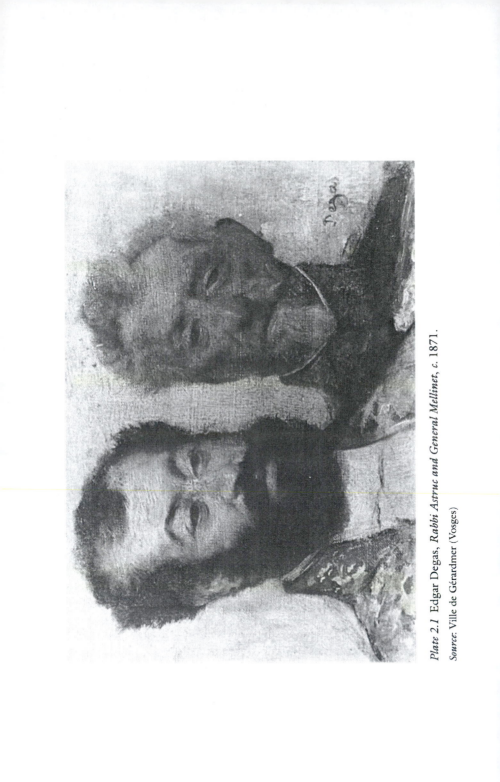

Plate 2.1 Edgar Degas, *Rabbi Astruc and General Mellinet, c.* 1871.

Source: Ville de Gérardmer (Vosges)

Bazaine's court-martial, sketching the Maréchal (a bald-headed man of "small understanding" in Duret's phrase) arraigned before his accusers.[6] The artist meted out yet harsher treatment to MacMahon. In the mid-1870s, Manet depicted in a variety of media the figure of Polichinelle (Punchinello), a subject innocent enough in appearance. Yet, when Manet ran off fifteen hundred lithographs of his polichinelle with the intention of distributing them to subscribers of *Le Temps* (a newspaper of moderate republican views), police stepped in to confiscate the prints. Why? Because they recognized in Manet's buffoon-with-a-stick a mocking likeness of then President Maréchal MacMahon.[7]

The Paris Commune

The defeat of 1871 left an angry memory. The experience of the civil war did not so much incite anger as despair. The brutal zeal of the Versaillais armies that subdued revolutionary Paris left the new painters prostrate. News of the violence plunged Monet into paralysis. "I haven't the heart for anything," he wrote to Pissarro. Pissarro received a second letter, this one from his friend Ludovic Piette, comparing the repression to the Saint-Bartholomew's day massacres.[8] In the summer of 1871, Berthe Morisot's mother related an encounter between her son Tiburce and two supposed "communards": "Manet and Degas! Even at this stage they are condemning the drastic measures used to repress them [the revolutionaries]. I think they are insane. ..."[9]

Manet, of course, had witnessed first hand the crushing violence of the Versaillais. After the siege of Paris was lifted, he had left for the provinces but returned to the capital in May just as the city's final conquest was under way, the so-called Bloody Week (*semaine sanglante*).[10] He composed two lithographs of the week's happenings, the first depicting a dead communard at the foot of a barricade, the second a Versaillais firing squad hard at work executing captured insurrectionists (Plate 2.2).

Manet was not alone among the new painting group to have had an unnerving brush with Versaillais repression. Dr. Paul Gachet, Pissarro's friend, was arrested on suspicion of communard sympathies (he had done service as a medic during the insurrection). So too was Paul Meurice who had remained in Paris throughout the insurrectionary months, turning out reportage for the Hugo family newspaper *Le Rappel*. Théodore Duret's experiences were more traumatic still. During Bloody Week, he had toured the scene of the fighting in the company of Henri Cernuschi, a moneyed ex-Garibaldino who had settled in France. The two were mistaken for communards by Versaillais troops, placed before a firing

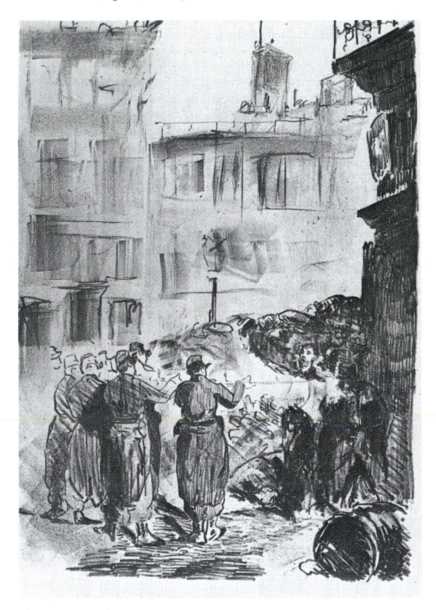

Plate 2.2 Edouard Manet, *The Barricade*, 1871, lithograph.

Source: S.P. Avery Collection; Miriam and Ira D. Wallach Division of Arts, Prints and Photographs; The New York Public Library; Astor, Lenox and Tilden Foundations

squad, and rescued from summary death at the last moment. They quit France not long thereafter on an art-collecting tour of the Orient.[11]

Yet however much the new painters disliked the Versaillais, that did not mean they themselves harbored pro-communard sympathies. To be sure, they had friends on the Commune, foremost among them Courbet who presided over the revolutionary government's arts commission. Renoir had a passing acquaintance with the chief of the communard police Raoul Rigault, a connection that he managed to turn to advantage. The painter was stuck in Paris at the time of the Commune and wanted to be able to move in an out of the city. He addressed himself to Rigault to obtain safe-conduct papers. Rigault obliged and went a step further, having a band on the spot strike up "La Marseillaise" in honor of "Citizen Renoir."[12] But such associations should not be mistaken for evidence of approval. Both Manet and Pissarro had occasion in 1871 to characterize the communards as "assassins."[13] It is true that such hard-line attitudes softened in later years. Pissarro collected mementoes from the insurrection and had harsh words for colleagues like Millet who continued to indulge in anti-communard invective. Renoir in conversation with his son Jean sentimentalized the revolutionaries as "brave fellows" but was quick to add, "you can't start Robespierre all over again."[14] Versailles represented reaction, the Commune a dead-end.[15] Where then did the new painters stand? The evidence, while sketchy and circumstantial, does point to a conclusion: they were partisans of a republican conciliationism. No sooner had hostilities erupted between Paris and Versailles than a handful of city-based republicans, never more than a few score, organized the Ligue d'Union républicaine to press for a peaceful denouement to the conflict. It is striking how many friends and relatives the new painters counted among the Ligue's membership: Georges Clemenceau, Anthime Corbon, Paul Dubois, Antonin Lafont, and Gustave Manet (the painter's brother). The conciliationist cause was seconded in the Paris press by *Le Rappel* and *Le Siècle*. Burty and Meurice worked on the former, Duret on the latter (which, it might be added, was owned by Cernuschi).[16]

The republican tilt of the new painters is confirmed in Manet's and Morisot's cases by pronouncements made at the time. In the summer of 1871, Manet shuttled out to Versailles to sketch Gambetta at the tribune. Efforts to persuade the politician to sit for a studio portrait came to nothing. Such recalcitrance irritated Manet who nonetheless remained a political admirer of Gambetta's, declaring him "the only capable man we have."[17] Morisot's republican *prise de position* was more tentative. Then again, as a woman with parents of enlightened but conventional political views, she had greater risks to run in striking out on an independent course. Her father was a staunch Thiersist. Sister Edma preferred the likes

of Gambetta, and Berthe, it seems from family correspondence, was inclined to agree. She even ventured to Papa a roundabout defense of Garibaldi, which moved the old man to exasperation.[18]

The new painters' conciliationist commitments did not waver in the decade after the Commune. It has been observed that the impressionists in the 1870s turned with an ever greater frequency to modern, Haussmannized Paris in search of motifs.[19] Monet painted magnificent high-angled views of the boulevard des Capucines and Tuileries gardens, the first in 1873, the second three years later. These were the very sites of the recent fighting, and yet Monet's urban landscapes depict, not a war-ravaged city, but a metropolis reborn, bustling with activity in the case of the Capucines or, as in the painting of the Tuileries (which had been gutted by fire), with the destructive evidence of civil war confined to a corner of the composition.[20] The Commune had left a scarring memory, but the new painters did not wish to dwell on the wound but to heal it over.

They dealt with the ex-communards themselves in a similar spirit of forgiveness. In 1875, the London office of art-dealer Paul Durand-Ruel was putting together a show on recent French art. Degas wrote to the gallery director, urging that the work of the sculptor and former communard Jules Dalou be included: "I would wish no *political* obstacle to stand in the way of his sending us s[ome]thing or of our being able to exhibit it."[21] The general amnesty of 1880 found Manet in the hospital. The occasion so moved him that he decorated a note to the model Isabelle Lemonnier with a pair of crossed tricolor flags and the inscription "Vive l'amnistie."

The terrible year had traumatized the new painters, scattering them to the winds. Bazille was dead and Manet almost too disconsolate to work. Monet and Pissarro took refuge in London while Degas abandoned France in 1872 to recharge himself among relatives in New Orleans. But however different the new painters' individual itineraries, they hewed to a similar line in face of the political upheavals of the day. They were republican patriots who in descending order detested Prussian barbarism, the ferocity of Versailles, and the excesses of the Commune. To be sure, Monet was more cautious than patriotic, Degas more nationalist than republican. That said, the shocks of war and civil war in no way diminished the political cohesiveness of the new painting movement. Nor had events diminished the immediacy of the common artistic project on which they were embarked. Dispersed and discouraged as the painters might have been, they did not tarry long before reentering the artistic fray, this time with a battle-hardened purposefulness.

THE POLITICS OF THE INDEPENDENT
EXHIBITION

The impressionist movement pieced itself together in the aftermath of the terrible year. The mulishness of Salon authorities, all the greater now in the reactionary climate of the 1870s, propelled the artists into an ever more confrontational stance. They opted in the end, with varying degrees of enthusiasm, to try out a range of secessionist strategies. This much has often been said. Less remarked on is just how politicized the artistic skirmishing had become. Friends and enemies alike, it seemed, were determined to impose a political gloss on every step the new painters took. The movement's repeated dust-ups with the Salon were not just about art; they were interpreted as the artistic manifestation of a more encompassing political struggle, pitting republicans against reactionaries. The new painters themselves, it will be ventured here, were not altogether unwitting bystanders to the game of politicization but invited much of the trouble they got.

Monet and Pissarro, while in London, had made the acquaintance of Paul Durand-Ruel, an enterprising gallery-owner who made a specialty of selling Barbizon painting to France's well-heeled. Durand-Ruel decided to add the new painters to his list, a gamble that was a godsend to the artists. Now at last they had found a reliable venue in which to exhibit. Durand-Ruel's patronage, it has been pointed out, played a considerable part in helping the movement pull itself together once again.[22] There is an apparent political irony in the Durand-Ruel connection, for the dealer was a dyed-in-the-wool Catholic Legitimist who favored a restoration of France's Bourbon line. But Durand-Ruel was not one to let politics interfere with the business of retailing paintings. He sold to France's leading Jewish families: the Bischoffsheims, the Cahens d'Anvers, the Camondos. In 1873, Durand-Ruel published a catalogue which detailed his holdings to potential buyers. The preface was penned by Armand Silvestre, an art critic who prided himself on his warm relations with Gambetta, and Silvestre opened his remarks with a standard gambit of republican art criticism: "It is to the public that this undertaking expressly directs itself. ..."[23]

The impressionist movement reconfigured

In the 1860s, Manet had been looked to as the new painting's undisputed champion, but the movement that re-formed itself in the decade following was more multipolar in constitution. The café had lost none of its importance as a focal point of artistic sociability. The new painters, for a period after the war, took to frequenting the Guerbois again but soon

shifted allegiance to the Café de la Nouvelle-Athènes on the Place Pigalle. The movement's realist wing occupied center-stage here: Burty, Castagnary, Duranty, and Zola among the critics, Degas and Manet among the painters. The cast of characters was enriched by a band of recent arrivals, Silvestre just then making a name for himself in criticism and a trio of painters introduced by Degas – Jean-Louis Forain, Jean-François Raffaëlli, and Federico Zandomeneghi.[24]

In aesthetic as in political orientation, the newcomers fitted in well.[25] All were practitioners of a modern-style realism that ranged in tone from the satirical and gritty in the cases of Forain and Raffaëlli to the more conventional renderings of Zandomeneghi. All were men of the left. Zandomeneghi had taken part in Garibaldi's Sicilian expedition of 1860. Silvestre was a friend of Gambetta and Raffaëlli of Clemenceau. In 1883–4 in fact, Raffaëlli painted a portrait of Clemenceau delivering an electoral address, flanked by the leading radical republicans of the day, among them the artist himself. As for Forain, he had come up from a hardscrabble bohemia. He was said to have occupied a low-echelon post on the Commune; the early 1870s were spent in the company of bohemian poet lovers, Paul Verlaine and Arthur Rimbaud, until Degas' patronage opened more promising vistas.

Not everyone in new painting circles, however, welcomed Degas' protégés, but Degas stood behind them, a force ever more to be reckoned with. In the United States, he had been swept away by the wonders of Yankee civilization, the wagons-lits and steamers,[26] and had returned to France brimming with energy and plans, prepared to match Manet quip for quip at the Nouvelle-Athènes. The Guerbois gatherings had centered on Manet, a preeminence now contested by the sharp-tongued and assertive Degas.

At the café, authority within the new painting movement had become increasingly a matter of give and take. In geographic terms as well, the movement had begun to decentralize, spreading out from the Batignolles to artistic enclaves in Paris' near suburbs. On return from London, Monet settled in Argenteuil where he enjoyed periodic visits from Renoir, Sisley, and others. A substantial colony was established by Pissarro in Pontoise and its environs. There he was joined by the painters Edouard Béliard, Cézanne, Armand Guillaumin and a pair of long-time friends, Gachet (who bought a home in neighboring Auvers) and Piette.

The Pontoise group is interesting for several reasons. First, for Cézanne and Pissarro's collaborative explorations in out-of-doors land-scape painting. They experimented with rhythmic brushwork and uneven, "built-up surfaces" to assemble canvases of a rustic "woven" appear-ance.[27] Such conjurings with a craftsman-like look in painting went hand

in hand with a free-thinking impulse in philosophic matters. Béliard in former years had been a confederate of the anarchist philosopher Pierre-Joseph Proudhon. Gachet's associations were of a more materialist and scientific bent. He belonged to the Société d'anthropologie which was presided at its founding in 1872 by Gachet's friend Gabriel de Mortillet, a veteran '48er turned scientific materialist.[28] Pissarro shared in Gachet's passion for homeopathic medicine, but it would be a stretch to read into such quirky preoccupations the first glimmerings of the scientific anarchism that would overtake him in the 1880s. Cézanne's free-thinking inclinations in this period, however, are not subject to doubt. In the mid-to-late 1870s, the painter returned home to the Midi but remained in touch by mail with Paris friends. He wrote to Zola in bantering tones of a visit to the "democratic bookseller" Lambert's in Aix and of the anticlerical carryings-on of Numa Coste, a common childhood friend who had won a seat on the Marseilles municipal council. Such light-hearted asides, however, did not betoken an indifference to matters transcendental. In a letter to Pissarro, dated 1876, Cézanne expressed an intention "to delve into" a periodical with the suggestive title *La Religion laïque*, ending with a defensive plea "Don't laugh!" Edgy and intense, Cézanne ever sought a creed that held out promise of spiritual repose. In the 1870s, it was not the Roman Catholic faith into which he had been born that tempted him but secular religion.[29]

The movement that regrouped in the 1870s had changed in certain respects from its antecedents. It had found an enterprising dealer in the person of Durand-Ruel. The painters' efforts revolved less around Manet's example. Theirs was now a cooperative enterprise made up of a loose network of studios and artists' colonies. The movement's membership had undergone certain alterations as well. Bazille was gone; Fantin-Latour had withdrawn. Degas' efforts to sign on Forain, Raffaëlli, and Zandomeneghi met with mixed results. But two other Degas-backed painters, both moneyed bourgeois like the master himself, were welcomed into the movement's ranks without murmur of protest: Gustave Caillebotte and Mary Cassatt. The former inclined to the realist mode, the latter to the impressionist. Whatever aesthetic nuances may have distinguished them, they brought to the new painting welcome energy and resources. Caillebotte's wealth helped to sustain the movement's collective fortunes; Cassatt's connections helped to open the American market.

Yet for all the comings and goings, certain features of the movement did not change. Café debate and collaborative work remained as always central to its identity. In matters of political opinion, differences had, if anything, narrowed. The troubles of the terrible year had edged the liberal-minded, like Degas and Morisot, that much closer to the republican

camp. In Morisot's case, marriage into the Manet clan (she wedded the painter's brother Eugène in 1874) added a personal dimension to the rapprochement. But what about the new arrivals, Caillebotte and Cassatt? Caillebotte's views are not easy to pin down. He was the sole new painter to hold public office, getting himself elected to the municipal council of suburban Gennevilliers in 1888. The district in the 1880s voted republican; Caillebotte served on the council alongside Manet's cousin Jules de Jouy, a man of firm democratic convictions. On the other hand, the small-town politics of the era often tended to the non-partisan, turning more on administrative than ideological concerns. It might be wisest not to conclude too much from Caillebotte's government service.[30] There is, however, no ambiguity in Cassatt's case. In 1871, at the very height of the communard insurrection, she wrote to a friend: "I enclose a Plea for the Commune which I wish you would read, I think it does them more justice than most of the newspaper correspondents." In art, Cassatt believed "liberty" to be the "first good." She felt just the same when it came to politics. "Don't talk to me about Monarchies!" she expostulated to Louisine Havemeyer in an undated letter, "Give me decent Republics. They may be corrupt! We know they are, but the others are worse."[31]

On the institutional front as well, the artists retained all the determination of former years to carve out an independent path. Had there been any slackening of will, the heavy-handedness of Salon authorities would have stiffened the painters' resolve. The terrible year had persuaded France's art mandarinate of the dangers of institutional experimentation. Chief Executive Thiers appointed Charles Blanc director of fine arts in 1871, and Blanc clamped down on Salon jury elections. In 1872, the state asserted its right to fill a portion of jury seats by appointment; the remaining jurors were chosen by election on the basis of a restricted franchise that excluded all but prize-winners at previous Salons. Universal suffrage was to be avoided at all costs. As Cabanel explained to a colleague: "It's just like in politics, it makes a fine mess of things."[32]

The results of such jury tinkering were not surprising. Voter turnout was small, between two hundred and two hundred and fifty in the first elections under the new dispensation. The juries so selected turned away the majority of the works submitted, a rough three in five. Landscape painting suffered most from the triage.[33]

The government's exclusionary policies stirred outrage in the artistic community. Blanc's decision to restrict the franchise for the 1872 jury elections prompted a burst of complaint. A petition signed by almost ninety artists – Daubigny, Corot, and Manet among them – was submitted to Thiers, reproaching the state for its neglect of that "very brilliant, very numerous and ever growing legion of genre painters and

landscapists."[34] Blanc, undeterred, pushed ahead with the elections, but when composition of the new jury became known, artists were moved to a second round of petitioning. This time, it seems, Manet took the lead, drafting a letter which criticized the government's electoral manipulations, its "partiality" and indifference to the fate of "so many young artists." What was needed to save the situation, the document expostulated, was a new Salon des refusés. The letter bore thirty-five signatures, including those of Béliard, Cézanne, Fantin-Latour, Renoir, Pissarro, and, of course, Manet. A Paris newspaper, *Le Corsaire*, counselled latecomers on how they might go about signing on.[35] The government did in the end agree to sanction a second Refusés which convened, not in 1872, but the following year.

There was no more than a hint of political confrontation in such institutional sparring. Corot, very much a man of order, would never have participated in the petition campaign had it been otherwise. Still, a hint of politics there was, and in this connection the lurking involvement of *Le Corsaire* is not without significance. It was among a handful of newspapers in the aftermath of the Commune to publish a labor column (written by Paul Alexis) and among the first to be suppressed by the regime of Moral Order which came to power in mid-1873.[36]

Indeed, the Paris press could not resist mixing into the artistic fracas, and as its engagement deepened, so the political stakes in the debate shot up. Republican newspapers – veteran journals like *Le Siècle* and *Le Rappel* as well as newcomers like *Le Peuple souverain* and Gambetta's *République française* – took up the cause of the disenfranchised artists. Why this should have been so admits of a simple explanation. The principal arts critics at the four papers – Castagnary, Camille Pelletan, Zacharie Astruc, and Burty – to a man cultivated close connections to the new painting movement. The cases of Castagnary and Burty have been discussed. A hirsute and brooding Pelletan figures in Fantin-Latour's *Corner of the Table* (1872), a group portrait of the day's most celebrated bohemians, among them Rimbaud and Verlaine. As for Astruc, he was a passionate amateur of japonnerie, a charter member of the Jing-Lar, and a long-time friend of Manet's (Manet painted Astruc's portrait in 1866).

Critics such as these wrote in accents that were shrill and polemical, transposing by force of rhetoric a quarrel over voting rights into an epic battle between the forces of reaction and progress. On the one side stood Thiers who "takes the part of the ruling classes in art as in politics." Thiers had chosen a fitting second-in-command in the person of Charles Blanc, a dessicated rulemonger who, "like Louis XIV," made a cult of the State.[37] Together, they had imposed an "altogether authoritarian" regime on the Salon, whittling down the franchise to "a privileged few." It was all

too predictable how juries chosen by such criteria would behave. They
showered medals and honors on the most mediocre of artists, practi-
tioners of "*la peinture honnête*," who dished up "pommaded Orientales"
and stage-set peasants decked out in Italian costume.[38] The rich and well-
connected might applaud such lying slickness, but not the republican
critic. Pelletan pronounced history painting dead beyond resuscitation.
Castagnary wished a similar fate on religious and mythological art. He
pleaded with the government to turn its back on such monstrosities:
"there's no better place to begin the separation of Church and State than
in painting."[39]

The sooner the corpse of "so-called classical art" was shuffled off the
better from the republican critic's point of view. For a new painting stood
at the ready to take its place, the fruit of a coming generation in tune with
the "aspirations of modern society." It was an art based on observation
that shucked off the disguises and phantasmagorias of yesteryear. It took
France as its subject, its roughhewn peasants and landscapes, eschewing
"the cosmopolitan geography of the romantic school." Banished were the
satyrs and Cleopatras of Salon art replaced by men and women engaged in
the day-to-day pursuits and pleasures of "modern life."[40] In a campaign
speech at Grenoble in 1872, Gambetta had celebrated the eruption into
public life of a new constituency, "a new social stratum" as he called it.
Into the artworld too, Castagnary proclaimed not a year later, "the new
social strata" had made eruption, a breakthrough which he trumpeted as
"a great sign of democratic progress."[41]

Republican critics did not always like the same artists. Castagnary's
preference went to Barbizon painters and tame realists like Jules Breton;
Astruc and Burty were clear partisans of the *jeune école*. But all wrote in
the same critical vocabulary, touting modernity of aspect, French content,
and democratic aspiration as the watchwords of a new art. They under-
stood as well who or what the enemy was, a Salon system "of despotic
origin" which counted political reaction as its surest ally.[42]

Yet, how was that system to be defeated? To the existing order, Duranty
counterposed an imagined "Republic of the arts."[43] The one thing needful
in such a Republic was liberty. Boot the state out of the business of Salon
organization and at the same time widen the Salon franchise. Universal
suffrage, augured Astruc, held out promise of a rich harvest: "social
emancipation" in the public domain and its more modest analogue in the
sphere of the arts "free exhibitions."[44] Fair and open competition was the
lifeblood of painting. As Duranty summed up: "if you want ardor in the
struggle … then laissez-faire, laissez-passer." Liberty once enthroned, it
would be left to public opinion to pass final judgment on the merits of
the work set before it.[45]

Politics, however, intervened to dim immediate prospects for the real-
ization of such democratizing dreams. Thiers was driven from office in
May 1873, and the yet more reactionary MacMahon succeeded him as
head of state. Castagnary, in the midst of praising *Le Bon Bock*, Manet's
contribution to that year's Salon, broke off to deplore the turn of events.
The Republic was the political will of the nation, just as landscape
painting was its "artistic expression." The present "government of
combat" refused to bend to such facts, but bend in the end it would have
to were art and the nation ever to achieve emancipation.[46]

Breaking away

In the first years after the war, the new painters had banged away at the
Salon system with petition and entreaty, but by mid-1873, that strategy
had reached an impasse. Manet, for one, never abandoned the head-on
confrontational mode, but not so Degas, Monet, and Pissarro, who began
to consider an alternative course of action, the mounting of an indepen-
dent exhibition outside Salon channels. A journalist friend of Cézanne
and Zola, Paul Alexis, pronounced words of encouragement in the pages
of *L'Avenir national*. Monet replied with a letter of thanks, which the
paper published, and the artists then got down to the serious business of
negotiating an organizational charter. The document was signed in Dec-
ember, and the exhibition itself opened the following spring at a well-
situated locale, the studio of photographer Félix Nadar on the boulevard
des Capucines.

So came into being the first independents' exhibition, the exhibition
that earned the new painters the label of "impressionists." Politics tinc-
tured the negotiations at every stage. It was in the aftermath of the dismal
1872 Salon that prospects of an independent showing were first mulled
over. Piette did not need much persuading. If the next Salon bears any
resemblance to the last, he wrote to Pissarro, "if Courbet is excluded and
the jury still composed of reactionaries and Bonapartists, I would join and
with pleasure."[47] Apropos the Alexis/Monet exchange of May 1873,
three points are to be made. First, the paper in which the exchange appeared,
L'Avenir national, was itself sufficiently republican in orientation that the
MacMahon administration shut it down not five months later. Second,
Alexis was not so much an arts reviewer as a labor reporter, and it was in
the context of a series entitled "Working Paris" that he raised the issue of
an independent artists' organization. Last of all, Alexis framed the issue in
trade-union terms. "Association," he wrote, was the order of the day.
Workingmen knew it, a knowledge that had powered a mighty rebirth
of "working-class organization [*le grand mouvement ouvrier des chambres*

syndicales]." Artists too were workers, and Alexis urged them to form a trade-union (*chambre syndicale*) of their own. This was the article that prompted Monet's letter, a letter which, even as it expressed thanks, solicited the newspaper's future backing for the artists' association then in the making.[48] In the event, the new painters did not form a trade-union but a cooperative. It was Pissarro, very much in "the old '48er spirit," who had insisted on the cooperative form. He wrote up the founding instrument, adopting the charter of the Pontoise bakers' union as a model.[49] Even the site selected for the artists' first independent exhibition, Nadar's studio, had a political edge. The photographer's name, in huge script letters, was advertized on the outside of the building, and it was a name to conjure with. Nadar was France's premier portrait photographer, but he was known too as a veteran '48er who during the siege of Paris had run a balloon service ferrying mail out of the city and on occasion the high-ranking political official. It was by such means that Minister of the Interior Gambetta, in the company of Eugène Spuller, had escaped to the provinces.[50]

The independents' exhibition opened in April 1874. On display were 165 works, most but not all by the core group of new painters (Manet excepted). After some dispute, a fringe of friends and associates had been invited to join in the enterprise, diluting in some measure the boldness of the new painters' statement. The artists' critic friends, however, did not mince words. Burty in *La République française* characterized the independents as a band of "militant and convinced comrades"; Castagnary in *Le Siècle* wrote of them as "veritable revolutionaries"; and the hostile press responded in kind, deriding the new painters as "rebels" and "insurgents."[51]

It is not hard to see why matters had come to such a pass, and the belligerent tone of the critical debate did not subside on the impressionists' next two outings in 1876 and 1877. The new painters understood the value of publicity and wanted to make certain that future showings did not fail for lack of it. In 1876, Duranty came out with a pamphlet, *La Nouvelle Peinture*, a quasi-manifesto which laid out for the uninformed what the new painting was all about. In conjunction with the artists' third exhibition in 1877, a newspaper was published, *L'Impressionniste*, edited by Renoir's young friend Georges Rivière. Renoir himself, as the exhibition got under way, paid a visit to Gambetta's *République française* to drum up a favorable review.

Such gestures, however anodyne in appearance, worked in practice to heighten perceptions that the new painting had a political *parti pris*. Duranty cast the painters as "artistic revolutionaries" locked in combat with a feudal arts establishment run by "legitimists." In the third issue of

L'Impressionniste, Rivière addressed an article "to the ladies," inviting them to cajole their republican husbands, progressive in all things but art, to come round to the cause of the new painting. The implicit assumption here about the political leanings of impressionism's putative public does not need spelling out. Is it any wonder then that Renoir, looking about for a press organ to puff the new painting's exploits, addressed himself to the offices of a Gambettist newspaper and this on the very eve of the *seize mai* crisis?[52]

The impressionists looked to the left for a sympathetic hearing, and they were not altogether disappointed. Morisot wrote to an aunt with satisfaction about the press reaction to the 1876 exposition. *Le Figaro*, "so popular with the respectable public," had heaped imprecation on the new painters but not the "radical papers" which were full of praise. "[W]e are being discussed," she concluded, "and we are so proud of it that we are all very happy." The press line-up had not much changed the following year, at least on Rivière's accounting: *Le Figaro* against, "*Le Rappel*, *L'Homme libre* and a few others" in favor. The reactionary press was no less aware than the painters themselves how art and politics had become entangled. *Le Rappel* published a favorable notice of the impressionists' 1876 exhibit, prompting the conservative *Moniteur universel* to crow: "the 'Impressionists' have found a complacent judge in *Le Rappel*. The Intransigents in art holding hands with the Intransigents in politics, nothing could be more natural."[53]

THE PAINTING OF REPUBLICAN LIFE

The impressionists' anti-Salon provocations and irritating choice of friends invited assaults of this kind. It is reasonable to inquire, though, whether there was anything in the painting itself that justified such political animus.

Let us start with certain aspects of the new painters' choice of subject matter. The impressionists painted events and personalities that defined a particular and circumscribed milieu. On their canvases can be made out the features of a democratic society under construction, a society inhabited by popular politicians and middle-class hostesses, by Protestants and Jews, by a whole cast of newcomers to the stage of public life. This was a new-made world, secular and republican in constitution. In choosing to paint it and to paint it in often mythic colors, the impressionists were not making a neutral choice. Quite the contrary.

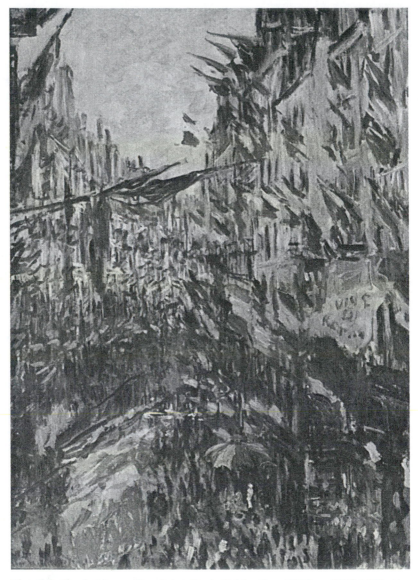

Plate 2.3 Claude Monet, *Rue Saint-Denis, Celebration of 30 June 1878*, 1878.
Source: Musée des Beaux-Arts, Rouen

Fêtes and grands hommes

The new painters welcomed the coming of the Republic and found
repeated occasion to express such feelings in paint. Mary Cassatt's father

wrote home with unconcealed satisfaction apropos the 1878 World's Fair: "The Exhibition is a continued success and its success has helped to establish the Republic – The Monarchists cannot conceal their spite at this."[54] The Fête de la Paix, as we have seen, was celebrated in conjunction with the exposition. Paris' citizenry festooned the streets with flags, not a loaded gesture in itself, but from time to time the flags carried markings of a more partisan character. Monet executed two versions of the festivities, *The Rue Montorgueil, Celebration of 30 June* and *The Rue Saint-Denis, Celebration of 30 June*, both street scenes ablaze with the blue, white, and red of the French tricolor. The day's flag-waving enthusiasm supplied visual delights, but Monet's purpose, it seems, was more than just decorative. In the right foreground of the *Rue Saint-Denis* canvas, he thought to include a large tricolor inscribed in bright gold lettering "Vive la République" (Plate 2.3).

The Fête de la Paix, whatever satisfactions it afforded, still remained a poor substitute for the genuine article, the *quatorze juillet*. Republican loyalists did not have to wait long to celebrate a real Bastille Day. Gambetta hosted a July 14 gala at the Palais-Bourbon in 1879. Manet was in attendance. The next year, the *quatorze juillet* was observed as a national holiday. Eugène Murer, an early collector of the impressionists who ran a restaurant on the boulevard Voltaire, invited his painter friends round – Gachet, Guillaumin, Renoir, and Sisley – to toast the Republic's health.[55] Manet, who was not in such good health himself, spent the day convalescing in a villa overlooking Paris, a perch that allowed him a fine view of the day's fireworks display. He commemorated the event with a watercolor sketch: a tricolor flag traversed with the exhortation "Vive la République."

In portraiture, no less than in flag-painting and street scenes, the new painters found ways to translate their political inclinations into graphic form. Raffaëlli's declamatory Clemenceau of 1883–4 has been mentioned. In 1885, Renoir painted the children of Senator Etienne Goujon, a physician-legislator of firm, but not adventurous, republican views. The Goujon commission might not seem a very dramatic gesture. The Republic in the mid-1880s stood on solid ground. In 1877, however, it was otherwise, and that year Renoir exhibited a portrait of Spuller, Gambetta's right-hand man, at the independents' third exhibition. He could take a political risk, it seems, but for risk-taking Renoir was far outmatched by Manet. In the midst of the *seize mai* crisis, Manet opened his atelier to a republican campaign meeting, presided by Spuller.[56] Then again, in 1879–80, he executed two portraits of Clemenceau, the most famed radical of the day (Plate 2.4). The amnesty of 1880 furnished the painter an opportunity to outdo himself. Henri Rochefort had done time

in New Caledonia for communard activity. He engineered an escape in 1874 and spent the balance of the 1870s in exile, returning to France with the amnesty. This was the figure Manet painted in an 1881 portrait: Rochefort, ever the intransigent with arms folded and hair swept back.[57]

Drawing-rooms of the Republic

It was not just rough-and-tumble militants like Spuller, Clemenceau, and Rochefort whom the new painters chose to fix on canvas. Republican society also had a more cultured face which showed itself above all at the salon. Here, politicians and artists rubbed shoulders, entering into a common conversation made possible by the animating graces of the salon hostess. And for how many hostesses did progressive politics and an appetite for the avant-garde in art go hand in hand? They did for Marguerite Charpentier. Charpentier's husband Georges ran a publishing house which specialized in the naturalist fiction of Alphonse Daudet and Zola. He fancied himself as well a man of advanced views, who counted Clemenceau and Gambetta among his acquaintance. Madame ran a salon which did ample justice to the family's multiple interests. Daudet, Zola, Clemenceau, Gambetta, Manet and Monet were all regulars, joined from time to time by Caillebotte, Degas, and Sisley.[58] Among the painters, though, Renoir was far and away the house favorite. He had occasion to return the compliment in paint, composing in 1878 a magnificent golden-toned portrait of Marguerite Charpentier and her two children posed in the family's fashionable Japanese sitting room (Plate 2.5).

Manet and Degas did *salonnière* portraits similar in type to Renoir's although perhaps not of the same high ambition. After the war, Manet took to frequenting the household of Nina de Callias. Cézanne too showed up there, although not quite so often.[59] Callias ran a salon much favored by bohemian litterateurs and artists. It is the bohemian hostess, stretched out on a divan, her face enlivened by a bemused seen-it-all expression, who looks out from the canvas Manet painted of her in 1873–4. Callias had indeed seen much. She had been the lover of Edmond Bazire, a colleague of Rochefort on *La Marseillaise* in late-Second Empire days. Bazire had taken off for Switzerland in the aftermath of the Commune, and Callias, it seems, went with him. Nor did she forswear such radical connections on return to Paris. A woman of independent means, Callias extended a helping hand to ex-communards in need of financial aid. As for her salon, she invited round not just poets and painters but political irregulars like Pelletan, Tony Révillon, and of course Bazire (who authored the first book-length treatment of Manet's oeuvre in 1884).[60]

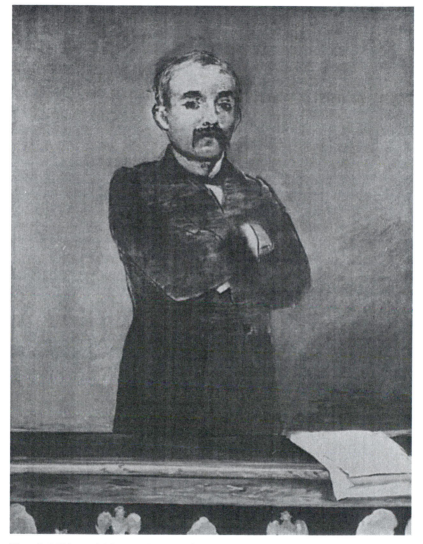

Plate 2.4 Edouard Manet, *Georges Clemenceau*, 1879–80.
Source: Kimbell Art Museum, Fort Worth, Texas

Degas' stab at a *salonnière* portrait is a more modest effort, a notebook sketch dating from the late 1870s but worth a mention in the present context. Degas' picture shows a drawing room presided by Madame Charles Hayem in the company of the poet Barbey d'Aurevilly and the distinguished cabbala scholar Adolphe Franck (who was Madame's

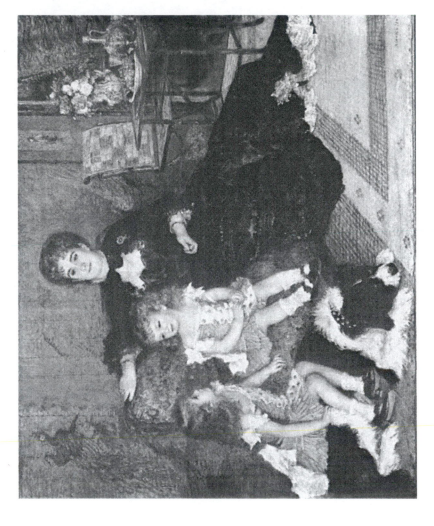

Plate 2.5 Auguste Renoir, *Madame Charpentier and Her Children,* 1878.

Source: The Metropolitan Museum of Art, Catherine Lorillard Wolfe Collection, Wolfe Fund, 1907 (07.122)

father). Charles Hayem, the son of a successful haberdasher, was an art collector with a particular liking for the painting of Gustave Moreau, Degas' former teacher. It was the Moreau link that in all likelihood brought painter and patron together. But Hayem, like his three brothers, was also a man of staunch, albeit moderate republican convictions, more comfortable with lawyer-politicians like Gambetta than with *clémenciste* hotheads. And the household Charles Hayem headed was a Jewish one. He, like his father Simon Hayem and father-in-law Adolphe Franck, was an early member of the Alliance israélite universelle, a Jewish self-help organization presided over by the eminent republican jurist Adolphe Crémieux.[61]

Protestants and Jews

Republican society was remarkable in its time for its welcoming attitude to distinguished members of France's religious minorities. So remarkable, indeed, that the regime's enemies were wont to tar it as a creature of Protestant, masonic, and Jewish influence. The new painters were accomplished chroniclers of the republican scene. It is little surprise then how often Jewish and Protestant subjects crop up in the impressionist portraiture and genre painting of the day.

This cannot be so in the case of Degas, it might be objected. The painter is remembered from Dreyfus Affair days as a ferocious antisemite, and he would not be alone among the new painters in expressions of such bigotry (see Chapter 3). Yet, in the 1870s and early 1880s, the signs of future prejudice were not much in evidence. Jewish subjects appear in his canvases with unexpected frequency. Degas' oil portrait of Rabbi Astruc and notebook sketch of Madame Hayem have been mentioned. Two Jewish artists, Alphonse Hirsch and Henri Michel-Lévy, hovered on the wings of the new painting movement. Degas drew a drypoint of Hirsch in 1875 and executed a full-length studio portrait of Michel-Lévy three years later. Ludovic Halévy, of Jewish descent, had gone to school with Degas; Ernest May, a well-to-do Jewish banker and would-be patron of the arts, was a more recent acquaintance. Both show up in Degas portraits from the late 1870s, the former engaged in a behind-the-scenes conversation at the Opéra, the latter deal-making on the stock-exchange. Protestant sitters occupied a much less prominent place in Degas' repertoire but were not altogether absent. In the late 1870s, the painter composed a series of portrait studies of Madame Dietz-Monnin, since identified as the wife of Charles Dietz-Monnin, a Paris businessman of note who was active in the affairs of the Protestant Reformed Church.[62]

It might be thought that Degas' preoccupation with such themes was symptomatic of a prejudice just waiting to boil. True enough, certain of

the portraits, in particular that of Ernest May, bordered on the caricatural (although there is no evidence that May himself found the painting objectionable). In the cases of Cassatt and Manet, however, both of whom also painted Jewish subjects, there can be no question of antisemitic bias at work, implicit or otherwise. Cassatt seldom executed portraits of men. Yet, she made an exception for Moïse Dreyfus (1879), a friend and collector who like so many of the Jews close to impressionist circles belonged to the Alliance israélite.[63] As for Manet, he counted a numerous Jewish acquaintance, among them Hirsch whose daughter appears in the painter's stunning *Gare Saint-Lazare* (1872–3). Charles Ephrussi, a lover of the arts and scion of a well-to-do Jewish family from Odessa, became a regular visitor to the painter's studio in the late 1870s, often coming in the company of his cousin Marcel Bernstein. Manet did a portrait of Bernstein's son Henry in 1881. The younger Bernstein is perhaps better remembered as the playwright/target of an antisemitic campaign orchestrated by the ultra-right Action française.[64]

As a portraitist, though, it was Renoir who scored the greatest successes. An inveterate networker, he managed to drum up a society clientele that furnished him a bundle of money-making commissions. It is important, however, to keep in mind just what "society" is being talked about. Like Manet, Renoir was acquainted with Ephrussi. The two had met at Cernuschi's Parc Monceau mansion in the late 1870s. Ephrussi in turn introduced Renoir to Louise Cahen d'Anvers, wife of the Jewish banker Louis Raphaël Cahen d'Anvers. The connection resulted in a trio of commissioned portraits: of the eldest Cahen d'Anvers daughter Irène, of Irène's two younger sisters Elisabeth and Alice, and of the girls' pianist uncle Albert Henri Cahen d'Anvers. Ephrussi himself even makes an appearance in a Renoir canvas, as the top-hatted figure seen from the rear in the background of *Luncheon of the Boating Party* (1881). Renoir in the end lost patience with the Cahen d'Anvers whom he dismissed as a stingy lot. He enjoyed far warmer relations with the Bérard family. It was at the Charpentier salon that Renoir first got to know Paul Bérard, a wealthy diplomat of Protestant stock with ties to the financial world. Bérard turned out to be the painter's most loyal patron, commissioning an entire gallery of family portraits: of Bérard himself, of his several children, of the entire clan at play on the family estate at Wargemont in Normandy.[65]

Middle-class utopianism

The "society" depicted in the work of the new painters is a diverse, open world. There is no doubt a difficult, even dark side to the new painting. Manet's *Bar at the Folies-Bergère* (1881–2), Degas' prostitutes, Cézanne's

Olympias (he painted several variations on the theme in the 1870s) confront the viewer with unsettling visions of modern life: of its blank indecipherability, its anomie, its phantasmagoric and eruptive carnality.[66] But the movement had its utopian moment as well, a moment that promised a series of yearned-for reconciliations.

Take Renoir's boating party as an example, in which the dandified Ephrussi shares with straw-hatted and bare-shouldered oarsmen the same space of pleasure. Or Monet's *Train in the Countryside* (1870–1), a green rural scene highlighted by the pink-and-white presence of parasoled strollers in the foreground and a band of engine smoke running along the upper border of the canvas. Effaced are the tensions between gentleman and plebeian, between nature and the machine.[67]

And what beauties did impressionist painting make the bourgeois home yield up. Rose-colored children divert themselves with hoops and toys; women, sometimes in fashionable dress, sometimes in more modest attire, immerse themselves in the secular rituals of daily life, tending to babies, serving tea, reading, or playing the piano. Degas in the 1860s painted charged family portraits, closed interiors revelatory of the psychological unease under which the sitters strained. In the 1870s, however, the impressionist interior opens up, warmed by a gentle light suffusing through curtained windows. Psychological discomfort does not altogether vanish, but what comes through with greatest insistence is the engrossing purpose and seriousness of domesticity.[68]

A society open to all comers, the brotherhood born of shared contentments, the reconciliation of nature and technology, the idyll of a secular domesticity: such themes bespoke a particular, harmonious vision of what modern life might be, a vision whose appeal has not tarnished much with the passage of time. And in the context of 1870s France, it may be ventured, such a vision carried a distinct political charge, whatever the caveats and qualifications that must follow. For who governed the nation in that decade of so-called Moral Order: "rurals," as Karl Marx called them, who anguished about the coming of industrial civilization, who decried the solvent consequences of democracy, and who embraced a penitential Catholicism in reaction. It was not this world that the impressionists painted, but, rather, a counter-society poised to supplant it. That counter-society had numerous and varied partisans: liberal-minded Frenchmen who accepted the modern but without much enthusiasm for the vulgarizing tendencies that went with it; radicals who embraced democracy but wanted more than a watered-down version congenial just to well-to-do bourgeois; and, above all, republicans who cast themselves as standard-bearers of the new order, believing with an often naive confidence that modernity and democracy made an uncomplicated match.

The society the new painters painted, the aspirations they captured on canvas, occupied an identifiable swath of political terrain, its heartland anchored in the *parti républicain* with liberal and radical outposts marking its frontiers. But little wonder, for this was the very terrain the new painters themselves made their home: from the enlightened Degas to the free-thinking Pissarro, with Cassatt, Manet, Monet, etc. occupying a capacious and varied republican in-between.

Republican critics

Well might viewers who occupied (and occupy) that same terrain resonate to impressionist art. In the event that they failed to, there were critics to spell the message out for them in a language they could understand and recognize as their own. A caricatured academic aesthetic, as usual, provided the necessary foil.

Beauty, the new painting's critic friends expostulated, existed in the here and now, in *la vie moderne*. No school had demonstrated that fact with greater conviction than the impressionists. Here was an "honest and solid" art which repudiated the lessons of an effete "anemo-academic training" to celebrate the "beauties of the people," "the graces which exist in the bourgeoisie."[69] Georges Rivière enthused over Renoir's *Ball at the Moulin de la Galette* (1876) as a "a precious monument of parisian life." This was true history painting, beside which the conventional article paled. "[W]hat do we care," he scoffed, "about operetta kings decked out in blue or yellow robes, with scepter in hand and crown on head!"[70] Marcel Proust wrote in almost identical terms of Renoir's *Madame Charpentier and Her Children* (1878):

> The poetry of an elegant home and of beautiful toilettes, will not posterity find it in the salon of the publisher Charpentier as painted by Renoir, rather than in the portraits of the princesse de Sagan or the comtesse de La Rochefoucauld by Cotte or Chaplin?[71]

Impressionism had effected a new deal in art, exiling kings and countesses from center-canvas, elevating in their stead the dancing *montmartrois* and middle-class *salonnière*, "the rising tides of democracy" in Castagnary's phrase.[72]

The new painters embraced the contemporary, and they did so without recourse to a story-telling moralism or idealizing convention. What the viewer got were real, identifiable subjects, engrossed in the daily business of life. Caillebotte, Degas, Manet were praised time and again for their attention to details of physiognomy and gesture which defined not

abstract types but flesh-and-blood individuals. To Edmond Lepelletier in *Le Radical*, it looked as though the open umbrella sheltering the well-dressed couple in the foreground of Caillebotte's *Paris Street: A Rainy Day* (1877) had just been plucked off the shelves of the Bon Marché department store. One critic marvelled at the spontaneous, scattered look of the figures in Degas' *Cotton Exchange at New Orleans* (1873), remarking how true-to-life they appeared, "just as you would see them in a wholesaler's shop on the rue du Sentier [the site of Paris' garment district]."[73] The new painters looked at the world with a disabused eye and, to communicate what they saw, did not hesitate to experiment: to crop paintings in unexpected ways; to try out new media – gouache and distemper; to jettison the standard-issue gilt frame in favor of simpler models. An alertness to the particulars of sensory experience and an uninhibited experimentalism, both hallmarks of modern science, such were the attributes that sympathetic critics claimed for impressionism.[74]

Science was invoked to justify the new painting and so too patriotism. This might seem a strange claim to make for a movement that encompassed a significant foreign-born contingent (Cassatt, Pissarro, Sisley). On the other hand, the impressionists lived and worked in France, certain brief excursions abroad excepted. The "real" world they captured on canvas was a French world: Paris, its suburbs, and the surrounding countryside. Republican critics had long complained about the "cosmopolitan" character of the academic landscape with its evocations of classical antiquity. "We are not Greeks, we are not Romans," expostulated Burty in 1883, "we don't drink wine which smells of resin, we eat Brie which runs." That was what the impressionists had understood, none better than Monet who rejected Italianate pastiche to paint France in its true colors. In so doing, Burty let it be known, the painter had created an art worthy of adorning the "republican edifice" just then achieving completion.[75]

Critics like Burty draped the new painting in the legitimating mantles of democracy, science, and republican patriotism. In lodging such claims, they were spinning out a discourse which had already seen some years of service. In certain respects, however, the new painting and its innovations had begun to outrun or elude familiar critical categories. In the 1860s when Manet set the pace, republican critics, attuned to realist technique, had had the requisite training to keep up. But the crystallization of the impressionist style in the next decade – the vibrant colors and rapid brushwork applied in pursuit of effects of light and shadow – proved more difficult to absorb. Yes, how welcome it was that the new painters had cleansed the palette of bitumen and chocolate, of "the tobacco juice, phlegm and burnt crust [*du jus de chique, du graillon et du gratin*]" so much favored by establishment artists.[76] But something had been lost in

the process. Critics worried about the "summary" finish of impressionist painting, about the "abandonment of detail."[77]

There was a gender dimension to the problem as well. Paul Mantz, reviewing the independents' exhibition of 1877, remarked: "There is only one impressionist in the whole revolutionary group – and that is Mlle Morisot." Joris-Karl Huysmans wrote of the charm, delicacy, and tenderness of Cassatt's domestic interiors. The new style, Burty observed in 1879, had shown itself an effective vehicle for female self-expression: "the women triumph in what is called 'impressionism.'"[78] Yet, hadn't critics in the 1860s touted the new painting as a virile antidote to the affectations of academic art?

The critics found a way out of such difficulties that did not require a serious reworking of a serviceable and effective vocabulary. Morisot, like her male counterparts, was said to have painted with a "sincere eye," recording what she had seen with a hand that "does not cheat." The impressionist artist, Duret pointed out, might well paint a shady wooded scene in violet tones, but it was not right to label him a "criminal" or "communard" for all that. He had worked in "perfect sincerity," reproducing sensory impressions as he had felt them, remaining "faithful to nature" throughout.[79] Honesty, fidelity, and sincerity, these were standard phrases in the republican dictionary of praise. For progressive-minded critics just a little puzzled by the course artistic progress was taking, they served a second purpose as well: to keep a hold on a movement spinning in directions not always easy to chart on existing critical maps.

PATRONAGE AND POLICY

In the painting of the impressionists can be discerned the contours of a new-made democratic society – its fêtes and celebrities, its aspirations and myths. The new painters' critic friends drove the point home, sometimes with a polemical crudeness. Yet, if the new painters were so much a part of the republican scene, why did republican society – as legend would have it – reciprocate with such a show of indifference? Or did it? There are two ways to cut into the problem: the first through a profile of impressionism's early collectors and the second through a review of the fledgling Republic's art policies. Both approaches, though, point to a similar conclusion. Such friends as the new painters had came, with few exceptions, out of the republican milieu. Here were recruited impressionism's earliest patrons. Here originated the reforming impulses that led to a change in the state's posture toward the new painting – away from the hostility of the 1870s toward a more approving stance, however modulated the approval.

Collectors

Who then were the new painters' first buyers? It is clear enough that the artists themselves imagined a clientele of apartment-dwellers. They painted apartment interiors and in smaller formats suitable for apartment walls. The independents' exhibitions were mounted in "apartment-like spaces" and lighted, in Burty's words, "in an apartment-like way."[80] This then was a painting intended for the middling-sort, newly affluent but not over-rich, who could afford a flat on one of the new streets of Haussmannized Paris.[81]

Many of the new painters' earliest collectors fit just this profile. A number were drawn from the professional classes like Gachet and fellow doctor Georges de Bellio. The arts too were represented: by Caillebotte first and foremost who doubled as both painter and patron; and by Jean-Baptiste Faure, a devotee of Manet's painting and star baritone at the Paris Opéra. It was men of business, however, who were most numerous. Murer was a restaurateur and Hayem the son of a haberdasher. Charpentier, who ran a publishing business, was both a host to the new painters and a collector of their work. The Hecht brothers, Henri and Albert, applied the proceeds from a colonial imports business to purchase the paintings of Manet. Ernest Hoschedé, who ran a wholesale firm in Paris' garment district, preferred the work of Monet.[82]

It was men such as these Gambetta had in mind when he employed the term "new social stratum," and like the "new social stratum" of Gambetta's imagining, the impressionists' early collectors tended to a politics of democratic hue. Charpentier's and Hayem's republican connections have been discussed. Henri Hecht's obituary described him as "one of Gambetta's closest friends." During the siege of Paris, Faure made a spectacle of himself on the Opera stage, booming out "La Marseillaise" while wrapped in the republican tricolor (the Empire's ban on the anthem had been lifted when the regime collapsed in 1870).[83] Now, this world was not without its quirkier side. De Bellio and Gachet shared a faith in the curative wonders of homeopathic medicine. Murer styled himself a socialist. The free-thinking Gachet had political ambitions as well, running alongside Daubigny for the Auvers municipal council in 1878. Both men campaigned as republicans; neither was elected.[84]

But it would be a mistake to conclude that the impressionists' first buyers were just middle-class types, recruited from a mixed milieu of the self-made and free-thinking. From the very first, as we have seen, a raft of affluent patrons presented themselves, men of substantial means like Bérard, Ephrussi, or May. To this list should be added, the name of Henri Cernuschi. Cernuschi hosted a salon, less well known than Charpentier's,

but similar in profile. He had made a huge contribution to the republican electoral effort in 1877, which assured him a social entrée into the party's inner circles. Gambetta, Clemenceau, indeed, the gratin of the *parti républicain* were regular guests at Cernuschi's soirees. Cernuschi also styled himself a patron of the arts inviting round (and purchasing the work) of painters like Renoir who in fact did a commissioned portrait of Cernuschi's dog Tama.[85]

Somtimes affluence spilled into outright wealth. Jean Dollfus had a passion for the new painting which he passed on to his nephew Raymond Koechlin, both men hailing from the moneyed textile patriciate of Alsace. Isaac de Camondo, who amassed one of the great impressionist collections of the fin de siècle, was the scion of a Turkish banking family of legendary fortune. It is significant that almost all these men were either of Protestant (Bérard, Dollfus, Koechlin) or Jewish background (Camondo, Ephrussi, May). The phenomenon did not go unnoticed at the time. "[I]n the mansion of an American or of a young Israelite banker," there, claimed Burty in 1885, was where the impressionist public was to be found. In an interwar memoir, Jacques-Emile Blanche recollected how the new painters, pushed by Bérard and Duret, had cultivated ties to the wealthy money men of the Parc Monceau neighborhood. He went on (not without a touch of antisemitic malice) to list the names of these so-called "princes of finance": "the baron Alphonse de Rothschild, the Sterns, the Cahens d'Anvers, the Goldschmidts, the Camondos. ..."[86]

The Republic built its political fortunes on *la nouvelle couche sociale* and extended its hospitality to the nation's religious minorities. Not every collector of the new painting came from these milieux, not the comte Armand Doria, for example, who was a titled gentleman and a practicing Roman Catholic. Yet a substantial majority did.

State policy

Republican society extended a measure of patronage to the new painting, and after some initial hesitation, so too did the republican state. The impressionist painters, it is true, did not have much success on this front at first. They lobbied for jobs and commissions in the 1870s, but to no avail. Never shy in such matters, Renoir met with arts official and soon-to-be Inspector of Fine Arts Georges Lafenestre in 1876 to solicit a mural commission. Not long thereafter, the painter was knocking at Gambetta's door in the hope of securing a museum curatorship. Neither effort bore fruit. Manet had no more luck with the Paris municipal council. In 1879, he proposed to the prefect of the Seine an ambitious mural series to decorate the council chamber but without result. At the same time, however,

the Paris municipal government did authorize Manet's good friend Henri Gervex to paint a panel entitled *Civil Marriage*, destined for the town hall of the Nineteenth arrondissement (Manet himself is said to have posed for the picture). Gervex, however, was no impressionist but a middle-of-the-road realist who did not threaten.[87]

No, in the 1870s, republican officialdom was not generous to the new painters, but the situation began to change in the decades that followed. The Gambetta government of 1881–2 marked a turning point. It awarded Bracquemond, Jean-Baptiste Faure, and Manet the Legion of Honor. Guillaumin got a decoration not long thereafter.[88] Burty was appointed to the fine arts inspectorate in 1881; Silvestre followed him in 1893; and Castagnary wound up a councillor of state.[89]

As for the impressionists' paintings, Prime Minister Ferry (an old acquaintance of Morisot) sanctioned use of the Ecole des Beaux-Arts for a Manet retrospective in 1884. Two years later, the state purchased a Raffaëlli, *Chez le fondeur*. At the state exhibit mounted in connection with the 1889 World's Fair, curators included nineteen works by the new painters. On the next occasion such a show was held, at the time of the 1900 expo, the figure had risen to fifty-four.

To be sure, there were disappointments, although it is important not to exaggerate their extent. Manet died in 1883. The new painters and friends banded together to purchase the artist's *Olympia* from his widow. The painting was donated to the state in 1890 which decided to hang it, not in the Louvre as the donors wanted, but in the Luxembourg museum. Yet, the donors' request was not a reasonable one, as standing rules prohibited the Louvre from exhibiting the works of artists who had been dead less than ten years. And in the end, the donors got what they wanted. The canvas was transferred to the Louvre in 1907, thanks to the intervention of then Prime Minister Clemenceau. There was trouble too in connection with the Caillebotte bequest. The painter passed away in 1894, leaving sixty-five artworks to the state. Bureaucratic regulations and the agitation of academic die-hards made it impossible for the Republic to accept the entire bequest on the terms stipulated. On the other hand, well over half the paintings *were* taken and a special addition built on to the Luxembourg to house them.[90] The new painters were not cold-shouldered by the Republic. They looked to it for rewards and recognition and in the long run got them.

On the institutional front, though, the satisfactions were more imme-diate and entire. In December 1880, Prime Minister Ferry issued a decree overhauling the Salon system. In the future, Salons were to be juried by a new body, the Société des artistes, composed of ninety elected members. All artists who had exhibited at least once at previous Salons were entitled

to vote in Société elections. The state had withdrawn from the business of Salon organization. The Academy still counted but just insofar as it could sway votes in a system now governed by quasi-universal suffrage. In the event, participation in Salon jury elections shot up to an estimated one thousand four hundred. Candidates had to conduct themselves "a little like candidates for parliament," circulating position papers and canvasing votes at artists' cafés. Burty, good republican that he was, was moved to salute the Salon of 1881, the first organized under the new dispensation, as "that democratized Salon."[91]

The new painters, with varying degrees of enthusiasm and conviction, had sidled up to republican society in the 1870s, making its causes their own, its salons their home. They had paid a price for the association. The public identified the new painters with political radicalism, an identification which was far from advantageous in a France then governed by a series of conservative not to say reactionary administrations. Yet, before the decade was out, Thiers had died, MacMahon resigned, and a fledgling *République républicaine* come into its own. As France's political horizons brightened, so too did the fortunes of the new painters, and the two phenomena were not altogether unrelated. It was the Ferry administration that democratized the Salon, patrons like Charpentier and Murer who doled out the earliest commissions, Gambetta who orchestrated the first round of public honors. The new painters' connection to republican society had its benefits as well as its costs. The connection, however, was never perfect. Nor, as we shall see in the chapter that follows, was it always lasting.

3 The crisis of impressionism

The new painting ceased to be a collective enterprise in the 1880s. The independent exhibitions, which had done so much in earlier years to concentrate the movement's energies, came to an end in 1886 as the artists began to strike out in ever more individual directions. They abandoned collaborative endeavors in favor of the one-man dealer-mounted show. Several decamped to locales far removed from Paris – Monet to Giverny, Pissarro to Eragny, Cézanne to Aix. And they worked toward signature styles, which made it increasingly difficult to discern a common aesthetic uniting them. Degas and Renoir both made a specialty of the nude, but there is no mistaking a Degas tubwoman, drawn with a gimlet-eyed trenchancy, for the chunky classical bathers which were Renoir's predilection. There is no mistaking a Monet wheatstack, radiant or crepuscular depending on season and time of day, for the architectonic southern landscapes composed by Cézanne. It had never been easy to find a satisfactory label to characterize the movement. The term "impressionism" had had to do, but now the new painters – a number of them at any rate – were painting "beyond impressionism."[1]

Why the movement fragmented admits of numerous explanations. The story may be told as one of success. The Salon system faltered consequent on the democratizing reforms of 1880. An old enemy had now been weakened, allowing long-submerged differences among the new painters, above all between the movement's realist and colorist wings, to erupt to the surface.[2] The artists parted company, but the separation in the long run did not impede their personal advancement. A buying public, sensitized by well-disposed critics and market-wise dealers, had at last awakened to the impressionist achievement, embracing the ex-new painters as individuals in a way it had not been prepared to do when they formed a group.

It is possible, while still retaining this basic plot line, to construct a narrative more negative in tone. Manet's death in 1883 (he was just fifty-one) was a sobering reminder of the shortness of life. The ranks of the

new painters began to thin at an accelerating pace in the nineties. Nor did it help that the aging painters had to face competition from a rising generation of artists – from the so-called neo-impressionists and from the symbolists of the Pont-Aven school – who claimed for themselves the mantle of artistic innovation. The new painters felt under pressure to reassess both life and work, a painful process which they did not negotiate with equal success. Renoir found a happy domesticity in the mid-eighties, one part bohemian, one part conventional, but his painting grew ever more prettified in proportion. Degas descended into a legendary caustic crankiness that found expression in an art that was startling in its analytic acuity and absence of sentimentality. Monet and Cézanne, it seems, achieved a hard-earned serenity (tempered by a growing self-absorption) that was both personal and artistic. Giverny and Aix became places of pilgrimage and the painters themselves cultural icons, Monet as painter to the nation, Cézanne as the first modern classic.[3]

I don't propose to disturb such accounts just to paint over them a further layer of interpretation. France (and indeed much of Western Europe) experienced last century's fin de siècle as a moment of disturbing transformation. The three decades from 1850 to 1880 had marked a period of almost unbroken expansion. Rural France enjoyed a summertime of prosperity that it would never know again. Haussmann's remodelled Paris stood second to none among continental capitals for its dynamism and splendor. Then in the 1880s and 1890s, the horizon darkened. A series of financial failures shook public confidence. The Union générale bank collapsed in 1882; the Panama Canal Company went into liquidation some years later amidst charges of swindle and political corruption. International competition chilled the farm economy, sparking a first massive wave of out-migration that soon came to be known as the "rural exodus." Between 1862 and 1892, a full quarter of France's country folk moved out, seeking a better life for themselves and their children in the city. As for the city itself, its look and rhythms had been changed by a spate of technical innovations – the electric streetlamp, the trolley car, and (at the century's end) the automobile. Machinism, it seemed, had taken command. The factories which proliferated in the Parisian *banlieue*, the department stores which clustered in the city center were its analogues in the spheres of production and exchange. The Eiffel tower, completed in 1889, was its symbol to the world.

The new painters experienced these transformations first hand and reacted with deep ambivalence. Well they might have, for the subjects they had made their own in the 1870s – Haussmannized Paris and the humanized landscapes of the capital's near suburbs – were the very locales most marked by the watershed changes of the fin de siècle. It was against

this backdrop that the artists beat their retreat: to the atelier in the cases of Degas and Renoir, to the distant countryside in the cases of Cézanne and Monet.

But the solvent effects of the fin de siècle crisis went deeper than that, not just scattering the new painters, but polarizing them. In the end, Cassatt, Monet, and Pissarro found ways to come to terms with the onrush of a dismaying modernity, but not so Cézanne, Degas, and Renoir who clung to visions of a bygone France, whether peasant, bourgeois, or *populaire*. These disagreements, inchoate at first, hardened into more overt political form in the nineties. Degas took to the company of anti-semites and Cézanne to that of Catholic revivalists. Monet and Pissarro, by contrast, travelled in leftist circles, still republican in Monet's case, out-and-out anarchist in Pissarro's. The lightning flash of the Dreyfus Affair in 1897–9 illumined just how far apart the new painters had strayed, splin-tering the group into hostile camps: Cassatt, Monet, and Pissarro for Dreyfus; Cézanne, Degas, and Renoir against. The disintegrative shock of success and the travails of middle age had much to do with the break-up of the new painting, but so too did politics, distilling emergent differences of world view into violent antagonisms that made enemies of one-time friends.

FROM THE SALON TO THE ONE-MAN SHOW

In the 1870s, the new painters had locked horns time and again with the Salon system. Manet favored the frontal assault, submitting his work to the judgment of the Salon jury in the hope of forcing his way in. Degas, Monet, and the others adopted a secessionist approach, mounting a series of independent shows which met at the same time as the annual Salon and rivalled with it for the viewing public's attention. By the mid-1880s, however, both strategies had been abandoned. The preferred exhibiting venue ceased to be the Salon, whether official or independent. What took its place was the private gallery. Art dealers, assisted by critic allies who turned out boosterish catalogues and newspaper reviews, took charge of brokering between the painters and their putative publics. The "end of the Salon" and its replacement by a "rival and looser … dealer-and-critic system" is a story often told.[4] How the new painters experienced the transformation will be sketched here in only summary detail.

The end of the Salon

The new painters' battle with the Salon, which had produced such magni-ficent fireworks in the mid-seventies, petered out in subsequent years,

ending more with a whimper than a bang. Manet could still cause the occasional stir. In 1876, the Salon jury turned down his entries, prompting the ever defiant painter to organize a much-publicized studio exhibition of the rejected works. He was at it again two years later, snubbing the official exhibition mounted in connection with that year's World's Fair to put on a one-man show of his own (much as he had done in 1867). Manet was not alone in such gestures of insubordination. Monet and Renoir both showed at the Salon of 1880 but were displeased with how their paintings were hung. They drafted an angry missive to the minister in charge of fine arts, and Cézanne importuned his old friend Zola to arrange its publication in *Le Voltaire*, a newspaper of decidedly free-thinking views.[5] Letters of protest, recourse to the radical press, such had been for years the impressionists' *modus operandi* when confronted with the obduracy of Salon authorities.

Yet, the 1880 set-to was not just one more round in an ongoing bout, it was the last of its kind. Official hard-headedness was more and more a thing of the past. The Republic overhauled the Salon regime in 1880. The next year, the Salon jury awarded a second-class medal to the once reviled Manet.[6] Renoir was never favored with a similar gesture of recognition, but he did encounter fewer difficulties getting his submissions accepted. He exhibited at the Salon of 1878 and indeed at every Salon thereafter, until he at last lost interest in the enterprise in the mid-eighties. At the very moment the Salon began to open its doors to the new painters, they turned away from it in favor of competing venues.

The final years of the independent Salon

Was the independent Salon the principal beneficiary of this change of direction? For a time, yes, but the impressionist movement was more and more beset by personality differences and artistic dissensions which in the end made collective action impossible to sustain.

The artists' previous experiences with the independent Salon – in 1874, 1876, and 1877 – had earned them more notoriety than clients. That in part was why Renoir returned to the official Salon in 1878. He was joined by Cézanne and Sisley the next year (whose submissions were both rejected) and then by Monet the year after who, as we have seen, had better luck.

That so many of the new painting's impressionist wing were absorbed in courtship with the official Salon altered the balance of power within the movement. The realists, with Degas at the head, gained in strength, so much so that Degas was able to insinuate into the group more and more of his friends, despite often bitter opposition. Cassatt, Forain, and Zandomeneghi

took part in the fourth independent Salon in 1879; Raffaëlli, a more contested figure, did not manage to gain entree until the fifth exhibition convened the following year. All four were Degas confederates. The presence of Cassatt and Forain provoked little complaint among more veteran members, but Zandomeneghi and Raffaëlli did, the most vociferous protests coming from Caillebotte. He had to swallow his objections though as Pissarro sided with Degas. Pissarro had a soft spot for Raffaëlli's naturalist depictions of urban down-and-outs in which he detected a critical edge not out of tune with his own social sensibilities.[7] In any event, Pissarro was in no position to grouse about cronyism as he himself took the occasions of the fourth and fifth independent Salons to introduce younger members of his own Pontoise circle: Paul Gauguin in 1879 and Victor Vignon in 1880.

So matters stood in 1880 with Caillebotte, Degas, and Pissarro caught in a tense equilibrium that inhibited but did not preclude common action. The balance came unstuck in the years following. Monet and Renoir, having had uneven success at the official Salon, wanted to rejoin the independents. They laid down terms, though, aimed against Degas' "realist" friends. Caillebotte might have been willing to meet the conditions but not the loyal Pissarro. In the end, Monet, Renoir *et al.* were not welcomed back into the fold, and an exasperated Caillebotte had to concede defeat. When the sixth independent Salon assembled in 1881, it was Degas, Pissarro, and various protégés who dominated the proceedings, Caillebotte and the bulk of the impressionist group having been frozen out.

The next year, however, Pissarro experienced a change of heart, in part on the urging of Gauguin who had nagged him to make up with the impressionists. Pissarro entered into correspondence with Caillebotte about organization of a seventh independent Salon, the two settling on a list of participants which included the impressionist hard-core to the exclusion of the Degas camp in its entirety. The group which ended up showing at the 1882 exhibition was the smallest ever, a mere nine artists, but they were a choice few, featuring all the stars of the new painting's impressionist wing: Monet, Morisot, Pissarro, Renoir, and Sisley.[8]

The new painting had broken down into feuding camps: the impressionists with Caillebotte as their champion, Degas' coterie of realist friends, and, occupying the middle ground, Pissarro's circle of landscapists. It was no longer feasible for all three groups to exhibit together, although more modest alliances – between Pissarro and Degas, between Pissarro and Caillebotte – still remained possible. Even these options were soon closed out.

In the mid-eighties after several years' quiescence, discussions heated

up about prospects for an eighth independent Salon. Most of the impressionists – Monet and Renoir in the forefront – dropped out early on, lured away by the financial temptations of working with the private dealer Georges Petit. The path then lay open to a renewal of the Pissarro/Degas entente but with a difference this time. The configuration of the Pissarro camp had begun to change. Via Guillaumin, Pissarro had met a promising young artist Paul Signac in 1883, who two years later introduced him to Georges Seurat. Signac and Seurat were then experimenting with pointillist technique, and Pissarro was much taken with the new style. He wanted the two painters included in any future exhibition and prevailed on Degas to go along. The inclusion of the pointillist group, however, kindled a fresh set of dissensions which were all too evident when the eighth independent Salon opened to the public in 1886. Morisot's husband Eugène Manet, who had helped to finance the show, objected to the pointillist presence. To placate him, it was agreed that the work of Signac and Seurat (along with that of Pissarro and his son Lucien) would be displayed in a separate room. Manet was not alone in his distaste for the art of Pissarro's new friends. Monet from the impressionist camp and Zandomeneghi from Degas' derided pointillist technique. More serious still, one of Pissarro's own close allies, Gauguin, hated its hyper-scientist pretensions.[9]

No one had done more than Pissarro to keep the new painting afloat as a collective undertaking. As strains in the movement ripened, he had taken up the role of mediator and in part been successful at it thanks to the backing of a phalanx of Pontoise loyalists. That phalanx was now dissolving, and he himself had become a source of division. There would not be a ninth independent Salon.

Even the artists' café-going habits, once such a vital source of social cohesion, had taken a fractious turn. The Nouvelle-Athènes gatherings began to flag in the late seventies and early eighties. Monet, Renoir and above all Caillebotte cast about for a substitute, inviting colleagues round once-a-month to banquets at the Café Riche. But the so-called *dîners des impressionnistes* led a fretful life. Degas never came, preferring to socialize with friends at the Café de La Rochefoucauld.[10] The controversy stirred by Pissarro's pointillist associations caused him to drop out for a while in the mid-eighties.[11] Caillebotte's death in 1894 finished the venture off altogether.

The rise of the one-man show

The new painting's dissolution as a collective enterprise, however, did not hamper the careers of its individual members. Indeed, it was in part the

artists' own escalating and ever more successful pursuit of individual advantage that hastened the movement's demise in the first place. In this course of action, they were encouraged by entrepreneurs and dealers on the look-out for money-making opportunities, Georges Charpentier first among them.

Charpentier launched *La Vie moderne* in 1879, an illustrated weekly devoted to the latest happenings in culture and public life. The paper's offices came equipped with galleries large enough to accommodate art exhibitions on a modest scale. *La Vie moderne* hosted a Renoir exhibit in 1879. Manet and Monet held one-man shows the following year. It was Sisley's turn in 1881. Durand-Ruel, not to be outdone, seized on the Charpentier example, running a whole battery of one-man shows in the early months of 1883. Monet, Pissarro, Renoir, Sisley, all were beneficiaries. The collapse of the Union générale bank, however, dealt Durand-Ruel a financial blow, taking him out of the running for the moment.

Georges Petit stepped in at this juncture, the owner of a spacious and well-appointed gallery on the rue de Sèze described by Zola as "the department store of art." Guillaumin and Pissarro were revolted by Petit's commercialism, but not Monet and Renoir who were attracted by the possibility of actual sales. Monet first showed with Petit in 1885 and Renoir in 1886.

The brouhaha sparked by the Caillebotte bequest of 1894 created an opening for yet another independent dealer, Ambroise Vollard. The state in the end excepted the bulk of the legacy although not all of it, slighting in particular (whether by design or not) the work of Cézanne. Vollard, just then starting out, profited from the state's misstep. He presented himself as Cézanne's paladin, mounting the artist's first major one-man show in 1895.

It was through showings with private dealers that the new painters got their first taste of real success. Monet was disappointed with the results of his 1883 show at Durand-Ruel's. Three years later, however, the situation had begun to reverse itself. Durand-Ruel, now recovered from financial difficulties, attempted to tap into the lucrative American market, organizing an exhibit in New York which included some forty works by Monet. The show was a triumph. A yet more massive exhibition of Monet's art was mounted by Petit in 1889, which confirmed the painter's command of the market.[12] It was Renoir and Pissarro's turn the next year. A Pissarro exhibit at the Boussod-Valadon gallery (Théo van Gogh was the director) was a solid success; Renoir had a show at Durand-Ruel's which, according to Rivière, turned the painter's fortunes round, marking "the end of difficult times."[13] Even Cézanne, for so long the most

marginalized among the new painters, began to bask in a measure of public recognition thanks to Vollard's 1895 retrospective.

In the 1880s and 1890s, the new painters aligned themselves with a network of gallery-owners who engineered (and profited from) the artists' financial breakthrough. It was clear what it took to make a go of it in this brave new world: dealer backing first and foremost. A dose of well-timed publicity did not hurt. Monet attributed the failure of his 1883 Durand-Ruel exhibit to poor preparatory advertising.[14] No less important was an artfully conceived catalogue which pitched the painter's work in appropriate terms to potential buyers, whether French or American. The catalogue for Monet's 1889 Georges Petit show was done by Octave Mirbeau, for Pissarro's 1890 Boussod-Valadon show by Gustave Geffroy, both coming young critics full of verve and ambition. The rest was up to the newspaper reviewers. This system, with its accent on the one-man show and a personalized style as a selling point, subverted collective endeavor, and as the new painters got caught up in its machinery, their sense of group identity eroded.[15]

From this angle, it seems clear enough how the impressionist movement came unstuck. A democratized Salon system, so long sought after by the new painters themselves, no longer exercised the same authority or attraction as in years gone by. The independent Salon, which had played such a central part in crystallizing the group's identity, fell victim to multiplying disputes of both a personal and artistic nature. The final blow was delivered by a dealer-critic system in the making, which, dangling promises of financial reward, lured painters away from group-centered action onto more invidualized career paths.

THE TRIALS OF MIDDLE AGE

This account of the new painting's break-up is fine so far as it goes, but it leaves much out. What is obscured is the biographical dimension, just how agonizing the process was for the painters, marked as it was by feelings of loss, restlessness and withdrawal, and a wavering self-confidence.

Death, retreat, and family crisis

Age began to take its toll on the movement in the fin de siècle. Pissarro developed an eye condition in the late eighties, and Degas' weakening vision made it increasingly difficult for him to read. Duranty died in 1880, followed by Manet in 1883 and Castagnary five years after that. The losses continued to pile up in the decade that followed. Burty died in 1890, Caillebotte in 1894, Morisot in 1895, Sisley in 1899.

Such intimations of mortality fed a jitteriness which found expression in a restless moving about. Pissarro's Pontoise circle dissolved under the impact. Gauguin left for Pont-Aven in Brittany, before heading off to the South Seas. Cézanne stopped coming to Pontoise in 1882. He still made regular trips to Paris but it was evident that he felt most at home working in quiet isolation in his native Midi. As for Pissarro himself, he uprooted to the more distant Normandy, spending a couple of months in Rouen in 1883, then the next year taking up permanent residence in a village farm-house at Eragny. Monet's movements were more agitated still. He left Argenteuil in the late seventies, moving down the Seine to Vétheuil. From here, he undertook a series of forays into outlying regions, embarking on a veritable tour de France which took him from Normandy to the Mediterranean. His pace of travel did not slacken until he relocated to Giverny in 1883, about halfway between Paris and the Norman coast. Even then, it did not slacken much as he made subsequent trips to Antibes, Bordighera, the Creuse, and other locales.

The new painters settled into isolated havens which made the kind of collaborative endeavor they had known at Fontainebleau or in the studios of the Batignolles impossible. Even artists, like Renoir and Degas, who stayed in Paris charted itineraries patterned by a similar mix of flight and retreat. Renoir, although not a great traveller, jumped about from site to site in the early eighties, visiting Algeria, Italy, and then Algeria again. He did in the end come home to Paris albeit not to the same neighborhood. He had maintained an atelier on the rue Saint-Georges, for many years the gathering place of a close circle of friends, but he shut it down in 1883–4 to move to the bohemian enclave of Montmartre. Degas, the most Parisian of the lot, changed addresses several times but never roamed far. He moved to the rue Pigalle in 1882, to the rue Ballu in 1890, and then to the rue Victor-Massé sometime in the mid-nineties, all three residences clustered in the same corner of the Ninth arrondisse-ment. Settling into the Victor-Massé address took a period of years. When the move was completed, Degas occupied the entire building, creating a world apart for himself complete with flat, studio, and a private museum for the installation of his substantial and remarkable art collection.[16]

The restlessness of the eighties wound down as the new painters settled into scattered personal retreats, whether rural or Parisian. Part of what had fueled the travel and shuffling about were dramatic changes in the artists' personal lives. It had become clear to the bachelor Degas that he was not about to marry. He felt himself closing off to emotional contact, losing "the thread of things," and expressed his dismay in a wrenching letter (dated 1884) to his friend and fellow painter Henry Lerolle:

If you were single, 50 years of age (from the last month), you would know similar moments when a door shuts inside oneself and not only on one's friends. One suppresses everything around one and once all alone one finally kills oneself, out of disgust. I have made too many plans, here I am blocked, impotent.[17]

Degas cast about for ways to fortify himself against a loneliness that would not go away. For many of the new painters, though, the personal transitions of the 1880s found resolution, not in a walling-off against emotion, but in the satisfactions of a sanctioned domesticity. It was in part to house an expanding family that Pissarro relocated to Eragny in 1884 where spacious accommodations were to be had for a reasonable price. For Berthe Morisot, the decade brought joy in the person of a daughter, Julie Manet (b. 1878), whose growing-up became a key theme of the artist's maturing work. Renoir and Monet followed messier paths, although both in the end wound up as more or less conventional married men. Renoir had gotten involved with a dressmaker, Aline Charigot, in the early 1880s. The artist's decision to close down his rue Saint-Georges atelier marked a symbolic end to his bachelor days, Aline and he subsequently setting up house together in Montmartre. The couple had an illegitimate son in 1885 and then married in 1890 (Renoir was almost fifty at the time), a union that produced two additional children, Jean (the film-maker) and Claude. Renoir found peace as an older father. To unknot the complexities of Monet's personal life, it took not one marriage but two. Monet, as we have seen, married for a first time in 1870 with Camille Doncieux. The couple had two children. The Monet household tripled in size in 1878 when the Hoschedé family moved in: Ernest, one of the artist's first patrons now gone bankrupt, his wife Alice with whom Monet may have had an earlier liaison, and the six Hoschedé children. Then in 1879 Camille died; Ernest Hoschedé, for some time on difficult terms with his wife, decided to move out; and Monet took up with the still-married Alice first with discretion and then from 1881 in a more public way. Here is where matters stood until Ernest Hoschedé's death a decade later, which left Monet and Alice Hoschedé finally free to marry.

Cézanne too in the eighties labored his way through a trying personal transition. Marriage was involved in the process, but it did not provide him the same emotional détente it had for Renoir and Monet. Cézanne had an out-of-wedlock son, Paul, with model Hortense Fiquet in 1872. For years, he tried to keep the details of his personal relations secret from his father, but the story came out, leading to a break. A reconciliation was worked out in the mid-eighties thanks to Cézanne's sister Marie, a devout Roman Catholic. Cézanne married Hortense in 1886; Paul Jr. was made

legitimate; and the artist's father died in peace later that same year. But Cézanne's strongest loyalty turned out to be, not to Hortense, but to his sister Marie. Hortense left her painter husband in 1890; Cézanne moved in with his sister the next year; and in all likelihood under Marie's guidance, he experienced a rekindling of religious faith which at last afforded him the spiritual repose he had been unable to find in matrimony.

Younger rivals

The collapse of the new painting coincided with a barrage of deaths and upheavals in the painters' personal lives. Such personal difficulties were compounded by a series of artistic contestations. The arrival on the scene of a rising generation of artists – Signac (b. 1863), Seurat (b. 1859), Gauguin (b. 1848) – made the new painters, already worried about their staying-power, feel that much more played out.

The younger men came equipped with new and challenging agendas. Signac and Seurat did not set out to capture fleeting sensation but to distill experience, and to aid in the enterprise they had recourse to science (or pseudo-science), borrowing from the latest findings in color theory and optics.[18] The neo-impressionists, as they came to be known, broke down the visual into myriad points, accumulating and juxtaposing dabs of paint to reconstitute what was seen, paring away the transient in pursuit of the permanent forms and elemental harmonies that underlay the surface of things.

Gauguin, it has been remarked, detested such scientizing, dismissing Seurat and Signac as so many "little chemists."[19] He broke with Pissarro who was much impressed by the "neos" and began to move in an altogether different direction. What counted, Gauguin wrote to a friend in 1888, was not a slavish faithfulness to things seen:

> ... don't paint too much from nature. Art is an abstraction which, dreaming before nature, you take out of it. Think more of the creation that will result, the only way to climb toward God is to do as your Divine Master does, create.[20]

Gauguin's celebration of the dream-like state and invocations of the divine marked a dramatic rupture with the naturist and secularizing aspirations of the new painting. For Gauguin, it was not the visual but the visionary which the painter sought to evoke. The hallmark traits of impressionist technique – the brightened palette, the rapid brushwork – no longer mattered quite so much when it was emotion or immanent presence, rather than sensory experience, that the artist sought to fix on canvas.

The new painters in the eighties thus found themselves outflanked on two fronts: first by the neo-impressionists who disputed their claim to the legitimating mantle of science; and then later in the decade by Gauguin and the band of artists gathered about him at Pont-Aven who broke with impressionism altogether in quest of a more spiritualized art.

Under the double pressure of personal crisis and artistic challenge, the new painters embarked on an exhausting reassessment of their common project. What resulted was a reworking of styles which drew the artists away from collective action, down more invidualized paths. Pissarro took the neo-impressionist challenge most to heart. He fell in with the younger artists and for a period attempted to imitate their divisionist technique. In the end, he found it too formulaic, returning to the impressionist style he had done so much to originate.[21]

Monet rejected neo-impressionism on similar grounds. Work came hard to him in the eighties (although he remained as prolific as ever). He concentrated as never before on rural subjects, criss-crossing the country-side in search of motifs. In the process, he positioned himself to claim the title of artist to the nation, the master practitioner of an impressionism "attuned" to the kaleidoscopic beauties of France's varied landscapes.[22]

Renoir's art took a different turn. His Italian trip in 1881 won him over to the rich splendors of the High Renaissance. He remained as ever a devotee of pleasure, although it was less popular amusements that attracted the aging patriarch now – dance halls, dining parties, and the like – than the lushness of the female form. The precipitate of this tug of influences – part-Raphael, part-Watteau – was a series of bather paintings, representing ensembles of fleshy *baigneuses* executed with a classicizing chunkiness.[23]

Nudes held a similar fascination for the mature Degas. He painted his subjects with an unsparing objectivity, capturing them not in luxuriant poses but in intimate grooming activities that emphasized an unstudied physicality (Plate 3.1).[24] And it was a physicality not always at rest, the bodies of his models sometimes twisted and cropped in ways that undercut their carnal appeal. Degas' paintings and pastels do not bespeak a dislike of women but an obsession with them (nude women bathers represented roughly a third of the artist's output in the 1890s)[25], an obsession that remained walled within the bounds of a watchful detachment but which on occasion turned back in on itself in knots and contortions.

Similar narratives – more or less skillful blends of the biographical and aesthetic – might be told about each of the one-time new painters: how religious feeling in the case of Cézanne or motherhood in the case of Morisot contoured the artist's mature sensibility. The major point, however,

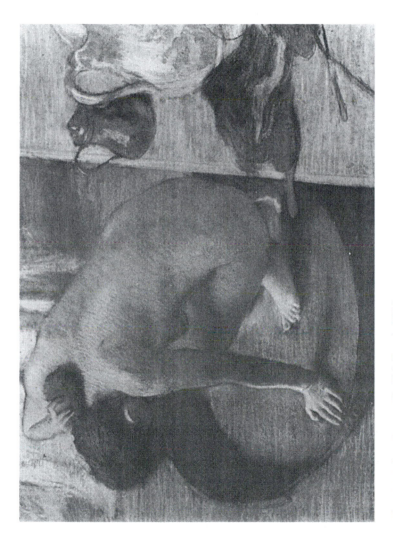

Plate 3.1 Edgar Degas, *The Tub*, Pastel, 1886.

Source: Musée du Louvre, Département des Arts Graphiques, Fonds du Musée d'Orsay, Paris

would remain the same. Middle age hit the new painters hard. They worked out answers, embracing or spurning the satisfactions of domesticity, finding refuge in the consolations of faith, learning from or rejecting the example of younger competitors. But whatever the solution, it was individual in nature, an individuality that expressed itself not just in the more and more separate lives they led but in their agitated and on the whole successful pursuit of personalized styles.

CULTURAL CRISIS

It is never an easy matter to demarcate the personal and the political, although the task is more difficult at certain historical conjunctures than at others. In last century's fin de siècle, what did it mean to clasp at nature when the countryside was beginning to empty out; to espouse Catholic belief when republican anticlericals ran the nation; to revel in female flesh when a feminist revival was just under way? It meant to be out of joint. Here then was one more challenge the new painters had to meet: how to come to terms with a wider world that seemed to have veered off course. Not everyone felt the problem with same urgency, not Monet for example, who was less given to vituperative outbursts than the others. Still, all had to orient themselves in relation to a new world in the making, a world of big cities and machines populated by novel types. How they did so implicated them in wider movements of opinion, sucking them into the agonistic realm of partisan politics.

Town and country in the fin de siècle

None of the new painters welcomed the new urban civilization of the fin de siècle. Renoir took a particular dislike to "all the new-fangled machinery" which, he complained to Vollard, had drained the fun out of life. The worker, "more unhappy than a slave," no longer sang at his task. People, swept up in pointless hurry, were forgetting the pleasures of laughter and conviviality.[26] The modern cult of speed was in part to blame. "Speed, speed, is there anything more stupid?" So exclaimed Degas to a turn-of-the-century interviewer, singling out automobiles – "those dirty horseless carriages" – for special abuse. Renoir chimed in, ridiculing the motor car as "an idiotic thing." And both men recalled in accents at once nostalgic and resentful how much slower and more agreeable the rhythm of life had been in younger days.[27]

Yes, France had become too mechanical-minded, too fast-paced; and it was losing its patrimony of beauty in the process. The "picturesque shores of L'Estaque," Cézanne fumed in a letter to his niece, had been spoiled

by electric lighting and "odious" docks. The crooked charms of old Aix had been steamrollered flat by town engineers obsessed with "straight lines." Yet, there were no straight lines in nature; and what was so wrong with the oil lamps of old which had glowed with such a mysterious and subtle radiance?[28]

Cézanne bemoaned the fate of old Aix; Degas mourned the passing of *vieux Paris*. He was an aficionado of *articles de Paris* and fine antiques. In later years, he grew closer to the Léouzon-Leduc family, Parisians of old stock who boasted a marvelous collection of ancien régime furnishings which Degas much admired. But good taste seemed more and more a thing of the past. Degas, who relished a stroll on the boulevards, was offended by the proliferation of vulgar baubles in local shop windows. He loved the genuine article, and the spectacle of so much "gilded junk" [*camelote dorée*] revolted him. It came as a hard blow when Degas' rue Victor Massé retreat was torn down in 1912 to make way for a more modern building. Degas was obliged to find accommodation elsewhere, a prospect all the more unsettling as he had so little liking for the up-to-date accoutrements with which newer housing stock came equipped. "[J]ust the very mention of *confort moderne*," Vollard recollected, "put him in a rage."[29]

Pissarro found a symbol to sum up the machine-mad brutishness of the modern world. In 1889, he assembled a series of pen-and-ink drawings under the title *Turpitudes sociales*. The volume was intended for the edification of his nieces Alice and Esther Isaacson, and the frontispiece summed up the lesson he meant for them to learn. An old philosopher is sketched, perched on a hillside looking out over a sleeping Paris. On the far horizon, the sun of anarchy is rising, its radiance as yet (although not forever) obscured by that emblem of *Paris nouveau*, the just completed Eiffel Tower. "[France] is ill from transformation," Pissarro had written to his son Lucien three years before. "We are in decadence," was how Renoir put it to Julie Manet in 1897.[30]

Haussmann's Paris had been a subject of choice for the new painters in the 1870s, but now, in the fin de siècle, many of the artists found little of charm in the fevered commotion of the capital city. Degas and Renoir hunkered down in studio sanctuaries to paint nudes. The landscapists adopted a different strategy. They stuck with nature but jettisoned the *urbs in horto* theme once so dear to them. No more suburban scenes traversed by train tressels for Monet. He took to wilder settings, the valleys of the Creuse or the rock formations of Belle-Isle. Cézanne's gaze fixed on the purple-topped crag of the Mont Sainte-Victoire, Pissarro's on the fields of Eragny. The countryside Monet, Pissarro, Cézanne chose to paint was no longer half rural, half urban. This was a rustic France, populated (if at all) by peasants and provincials.

But it was not quite the same rural France in each case. Monet's country-side was rich in its variety: at once wild and domesticated, dramatic landscapes of sea and rock alternating with compositions of undulating poplars and noble wheatstacks. France was a breathtaking spectacle drenched in a glowing and benevolent light, a land made fertile by the hand of man. Human figures were a rarity in Monet's fin de siècle canvases, but a human presence was often insinuated in the shape of a fishing boat or peasant farmhouse (Plate 3.2).[31] There was grandeur here, grandeur which was the handiwork of common folk who had planted the soil and reaped its bounties.

Sowing and tilling might be evoked in Monet's painting, but they were never shown. For Pissarro, however, collective labor was a major theme. Whatever the subject – apple-picking, haymaking, or going to market – the action was performed in groups, by peasants, often peasant women. As a painter of peasant labor, Pissarro has often been measured against Millet, but how different were the two men's understandings of the meaning of work. Millet was guided by biblical injunction: it was man's destiny to earn his bread by the sweat of his brow, and Millet's peasants, bent and tired, bore the stigmata of hard physical toil. But for Pissarro what counted was harmony, the harmony of men and women working side by side, not to scratch out a meager (although sanctified) existence, but to gather in the harvest of a fecund nature. Cooperation, not humility or struggle, was the watchword here. The "pastoral idyll" which Pissarro painted was a utopia of peace and healing, a needed restorative in a machine-ridden world diseased with competitive and acquisitive impulse.[32]

Monet painted a rural France of farmhouses and wheatstacks; Pissarro painted an earthly arcadia of harmonious labor. Cézanne's vision, by contrast, was at once more regionalist in theme and more religious in inspiration. The artist's deep attachment to the Midi is well known. Settled in the region, he proceeded to go native, dressing up "like a peasant in his Sunday best" and speaking in the strong nasal accents char-acteristic of the region.[33] He wrote of the "vibrations" awakened in him by the warming sun of Provence, of the "deep impressions" its "horizon, landscapes and unforgettable outlines" had made on his consciousness. "In the great classical lands – our Provence, Greece and Italy," he told a young aixois admirer Joachim Gasquet, the spectacle of nature had "a spiritual quality ... like a hovering smile of acute intelligence."[34] It was that spiritual essence, suffused in the landscape, imprinted on the artist's own soul, which Cézanne wished to extract and reproduce on canvas. Cézanne's expressions of regional piety captivated Gasquet, himself a Felibrigian poet and ardent classicizer who dreamed of an ancient Provence

Plate 3.2 Claude Monet, *Grainstack (Sunset)*, 1891.

Source: Museum of Fine Arts, Boston, Juliana Cheney Edwards Collection

still echoing to the strains of the pan-pipe. Through younger friends like Gasquet, Cézanne crossed paths with the Provençal revival of the fin de siècle, and he answered to the call, agreeing to take part in exhibitions of regional art in 1902 and again in 1906.[35]

In a variety of contexts, Cézanne declared his intention to "redo Poussin ... *sur nature*."[36] He aspired to place a Provençal stamp on the tradition of classical landscape, but there was more to the artist's mature vision than that. Nature, Cézanne explained to fellow painter Emile Bernard, was God's creation, a "spectacle laid out before our eyes by the *Pater Omnipotens Aeterne Deus*." The divine resided in the grand sweep of a landscape, in its expanse and surface. The artist used lines parallel to the horizon for panoramic effect; he used geometric patterning and planar composition to construct surface. But the artist painted not just in pious submission to God's creation; he painted for humankind. "Now for us men," he went on to Bernard, "nature consists more of depth than of surface, whence the need to introduce into our vibrations of light, represented by reds and yellows, a sufficient amount of shades of blue to make the air felt."[37] But the merging of the human and divine was more than a matter of technique; the artist had first to experience that fusion as an inward revelation. He "had to look on the world as a catechism," to submit to it "without discussion," and through such contact, direct and naive, he might feel stirring within himself a "personal truth."[38] It was that moment, "half-human and half-divine," when nature seen and nature felt co-mingled, that the painter set out to translate into a work of art (Plate 3.3).[39]

The spectacle of fin-de-siècle modernity was daunting to the one-time new painters, painters of pleasure and nature, who recoiled on instinct from the grinding harshness of the new machine civilization. For Monet and Pissarro, however, the initial withdrawal gave way to renewed engagement. Monet maintained contact with Parisian goings-on via city-based friends – Clemenceau, Geffroy, Mirbeau – who commuted out to Giverny on regular visits. An avatar of machine civilization even found its way into the quiet precincts of the artist's Giverny paradise. Degas and Renoir hated the automobile. Monet, on the other hand, purchased a brand-new Panhard in 1900 and took to motoring about the Norman countryside with the gusto of an enthusiast. As for Pissarro, lament as he did the ill-effects of the late-century climacteric, he did not doubt that France would "get through it."[40] Renoir complained that "science" had killed the worker,[41] but Pissarro never lost faith in experimentalism, taking part in the divisionist explorations of Seurat and Signac, maintaining ties to the latter even after he himself had returned to the impressionist fold.

However ruralist in preoccupation Pissarro and Monet had become,

Plate 3.3 Paul Cézanne, *Mont Sainte Victoire Seen from the Bibémus Quarry, c.*1897.

Source: The Baltimore Museum of Art: The Cone Collection, formed by Dr Claribel Cone and Miss Etta Cone of Baltimore, Maryland (BMA 1950.196)

they continued to feel the pull of urban ways. In the nineties in fact, both returned to the city in search of subject matter. Pissarro visited Rouen in 1896, turning out a series of bridge and dock scenes that transformed a gray, smoke-filled cityscape into a "poem" to industrious energy.[42] From Rouen, he moved on to Paris to paint the *grands boulevards* in all their fin-de-siècle glory (Plate 3.4). Degas might bemoan the vulgar commercialization of boulevard life but not Pissarro, whose street scenes throbbed with bustle and vitality. Monet too took a break from the countryside, pulling up stakes in 1899 for a series of on-and-off stays in London. And the London he proceeded to paint was not the genteel city of gardens and squares, but the working seaport with its ship traffic, bridges, and belching smokestacks.

Cézanne, Degas, and Renoir spurned the artifacts of modernity; Pissarro and Monet but half turned away. This might not seem more than a sliver of difference at first glance. Yet, it was not just things – cars, electric street lamps, the Eiffel Tower – that made up the new world of the late nineteenth century but people as well. The modern world opened the doors of opportunity to a host of newcomers: feminists, Jews and the like. On this point – on the matter of how to perceive and judge such novel types – the fissure of difference among the new painters widened into an abyss.

Professors, feminists, Jews, and socialists

Renoir and Cézanne had no patience at all for the apostles of a rationalizing modernity. "Nature abhors a straight line. And to hell with engineers!" was how Cézanne, with characteristic bluntness, put it to Gasquet.[43] Renoir expressed similar sentiments although with more intellectual nuance. In 1882, Charles Blanc, now retired from the arts administration, published *Le Grammaire des arts décoratifs*, a long-winded disquisition on the rules of good taste in home design. Blanc's zeal for symmetry aggravated Renoir who debated organizing a Société des irrégularistes. What made nature a source of joy, he believed, was the uniqueness of every living object: flower, leaf or figure. The organic world did not repeat itself, and an art worthy of the name recognized the fact and charm of variety. Yet, a "mania for false perfection" had seized the contemporary world, threatening to wring the fantasy out of life and art. Behind this mania lay aesthetic grammarians like Blanc, "professors" who had "invented the modern compass regularity."[44] The mere mention of the word "professor" in Cézanne's presence invited an outburst of temper. Vollard, on a visit to the artist in 1896, ventured a word of praise for Degas' old teacher Gustave Moreau. Cézanne slammed down his glass

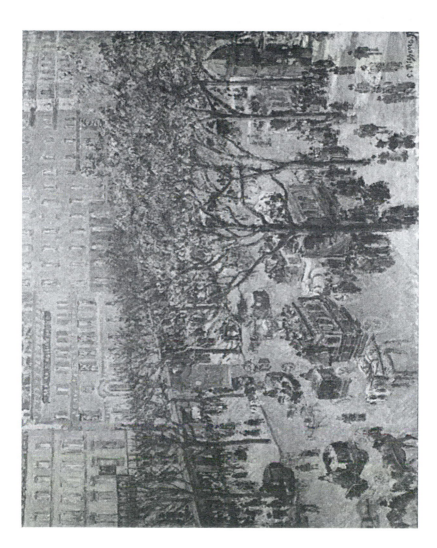

Plate 3.4 Camille Pissarro,
*Boulevard des Italiens,
Morning, Sunlight*, 1897.

so hard it broke: "*Les professeurs*," he exploded in, "they are all bastards, castrati, sons-of-bitches; they've got no guts at all!"[45]

Professors were a joyless crew, and to Renoir's mind, so were socialists, although it is important to distinguish the particular variety of socialism he found so loathsome. It was not the kind represented by Clovis Hugues. Hugues, an independent socialist, was Montmartre's deputy in parliament, and it was as a neighbor that Renoir first got to know him. Renoir found Hugues a remarkable figure with all the requisite qualities to make a superb president of the Republic.[46] He was a man of the people, a carpenter's son from the South, who never forgot his origins; he was a bearded poet with an appetite for life and a generous spirit; and he had an eloquence of voice and pen that he placed at the people's service, singing of the joys and sorrows of the common man. Hugues' politics, as one commentator put it, owed more to Saint Francis than to Karl Marx, and that may well have been what Renoir found so attractive.[47]

It was the materialist, intellectualist variety of socialism that revolted Renoir. Mirbeau, a would-be dramatist as well as art critic, authored a play *Les Mauvais Bergers* which debuted in Paris in December 1897. It was the story of an industrial strike, so "revolutionary" in theme that it provoked the audience to noisy interruptions. Renoir hated the *Mauvais Bergers*, at Julie Manet's, when the play was alluded to in conversation, he was moved to a general diatribe against "*les oeuvres socialistes.*"[48] In later discussions with Manet and Vollard, Renoir had occasion to explain what it was he had against "your damned socialists." They were a bunch of prattling bores who cared about petty material advantage but not a jot about the working man's spiritual well-being.[49]

On the subject of upstart women, Renoir could wax just as bilious, and in this Degas joined him, although the two men did not come at the "woman question" from quite the same angle. Renoir, as paterfamilias and painter, had a clear sense of woman's place. She was destined for motherhood, for child-bearing and the care of the young. Renoir owned to a liking for women singers and dancers. Grace, after all, was the special province of womanhood. The aging Renoir looked on women with a mix of sentimentality and desire, and that is how he painted them, with a charm bordering on the saccharine, with a ripe sensuality that at times threatened to turn over-ripe. In 1886, he executed a canvas entitled *La Maternité*, showing a winsome Aline suckling their new-born son Pierre; the next year, he completed a monumental *Baigneuses*, which depicted a bevy of women bathers, arching and stretching in an astonishing display of breasts and thighs (Plate 3.5). It was when women broke out of the mold assigned them that Renoir grew irritable. Asked his views about feminism in 1888, he replied with a charge against bluestocking females:

"I consider as monstrous women litterateurs, lawyers and politicasters, Georges Sand, Mme Adam and suchlike bores who are little better than long-tailed sheep." To Vollard, he expressed contempt for the "intellectual female."[50] As he told his son Jean: "I like women best when they don't know how to read."[51]

Renoir delighted in playing the part of the grumbling patriarch. There is little of delight, however, in Degas' views on the subject of women.[52] It was, as we have seen, toward working women – models, often prostitutes – that he more and more turned as a source of inspiration. The subject elicited from him a deep ambivalence. He wanted to capture his models as he felt them to be: "simple, honest people," physical and unself-conscious. Geffroy for one found Degas' late-century nudes stunning. These were "living bodies" painted without idealization, a welcome respite from the sugared shapes of academic art. But the critic was at the same time unsettled by Degas' almost "zoological" handling of the subject, which stripped bare the female form, reducing it to a "rude animality."[53] Degas acknowledged as much himself. George Moore, a critic and novelist who had known the new painters since Nouvelle-Athènes days, paid a visit to the artist's studio sometime before the turn of the century. Degas showed him paintings of tubwomen. Here is "the human animal," he explained to Moore, "a cat who licks herself":

> Up to the present moment ... the nude has always been shown in poses that assumed a public. But my women are ... occupied with nothing but their physical grooming. Here is another one, she's cleaning her feet, it's as though you were looking through a keyhole.[54]

Degas' obsession with the nude did not come untainted by condescension and voyeurism. He could be just as biting when it came to women of his own class. Degas helped nurture the careers of Cassatt, Morisot and, later, Suzanne Valadon. Talent he respected, but not an exaggerated femininity decked out in the "deliciously ridiculous inventions" of high fashion. Nor did Degas have much patience for intellectual aspirations in women. In the old days, he told a young friend in 1888, the daughters of concierges had been content to become dancers, but now they aspired to schooling and diplomas. Yet, what was more useless than an over-educated female? According to Julie Manet, he judged the painter and diarist Marie Bashkirtseff "deserving of a public whipping." As for feminism, Degas' peevishness on the subject afforded Cassatt, herself a feminist, an occasion for a small chuckle. She wrote in ironizing tones to her friend Louisine Havemeyer in 1914, proposing a Degas exhibit "in

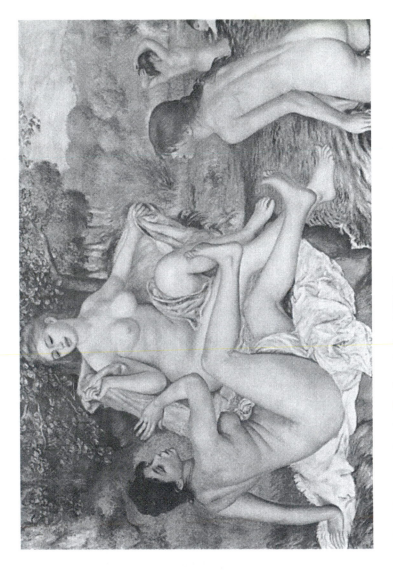

Plate 3.5 Auguste Renoir, *The Great Bathers*, 1884–87.

Source: Philadelphia Museum of Art: The Mr and Mrs Carroll S. Tyson Jr Collection

favor of the suffrage": "It [would be] 'piquant' considering Degas' opinions."[55]

Degas was attached to his female relatives. He could acknowledge the grace of a considerate hostess or the gifts of a *femme artiste*. Yet he was by no means at ease with the women of his class, expressing exasperation by turns with their silly modishness, bluestocking pretensions, and feminism. Women, whether prostitutes or bourgeoises, had become a subject of difficulty for Degas, and it was not just because of the disappointments attendant upon a celibate middle age but because of a growing unhappiness with a modern world that more and more seemed to have lost its bearings.

Jews too had become a subject of difficulty for Degas and not for him alone. Renoir broke off relations with the Cahen d'Anvers in 1882, complaining of the family's stinginess. "I'm washing my hands of the Jews," as he explained in a letter to a friend. A week later, Renoir drafted a second letter, this one to Durand-Ruel, justifying his decision not to take part in that year's independent Salon:

> To exhibit with Pissarro, Gauguin and Guillaumin, it's as though I were exhibiting with the first socialist who came along [*avec une sociale quelconque*]. It won't be long and Pissarro will invite the Russian Lavrof or some other revolutionary. The public does not like what smells of politics, and as for me, at my age, I don't want to be a revolutionary. To stick by the Israelite Pissarro, that's Revolution.[56]

Renoir's irritability on the subject of Jews, however, was no more than episodic. With Degas, on the other hand, antisemitism was becoming a more serious business. In the 1890s, he struck up a friendship with Maurice Talmeyr, a man of letters who, like himself, was a connoisseur of the old boulevards. The two men had a second set of interests in common, "antisemitic reading and conversation" as Degas put it.[57] What antisemitic literature might Talmeyr and Degas have talked about? Degas' niece Jeanne Fevre published a memoir of her uncle in 1949. For the frontispiece, she selected a photograph which Degas himself had composed and taken in the nineties. It showed the artist at a lamp-lit table, listening to an old servant reading aloud from that day's edition of *La Libre Parole*, the most scurrilous antisemitic newspaper of the day, edited by the most scurrilous antisemite Edouard Drumont.[58]

Still, a caveat is in order. Degas' ripening antisemitism did not stop him from frequenting the household of his old friend Ludovic Halévy. Halévy, although not Jewish himself, was of Jewish descent, and welcomed into his home a varied company which included numerous representatives

of France's religious minorities, both Protestant and Jewish. Degas' break with the Halévys would come but not until later.

It should not be thought that all the new painters indulged in such expressions of prejudice. Take "the woman question" as an example. Cassatt, as we have seen, ended a suffragist with sufficient serenity to find amusement in Degas' anti-feminist attitudes. Berthe Morisot and Eugène Manet, like Degas, talked about Marie Bashkirtseff but with admiration rather than choler.[59] It was a more fiery-eyed example of militant woman-hood who excited Pissarro's admiration: "the red virgin" Louise Michel, a veteran of the Commune who remained active in anarchist and feminist causes into the twentieth century.[60] As for Monet, he read with interest Tolstoy's *Anna Karenina*, recommending it to Alice Hoschedé for its vivid observations on the Russian scene. During a visit to Scandinavia in 1895, he took in and enjoyed a series of Ibsen plays.[61] Monet had an appetite for foreign novels and theater, for a modern literature such as Tolstoy's and Ibsen's which took a critical and sympathetic look at the condition of contemporary womanhood. The evidence on this point, however, is slight, and it may be wisest not to press too hard the case for Monet's proto-feminist sympathies.

It is certain, though, that Monet was no antisemite. He busied himself in the eighties cultivating Jewish patrons like Hayem and May, and this at a time when Renoir had grown crabby about Jewish cupidity and revolutionism.[62] In 1899, with the Dreyfus Affair in full swing, Monet headed off to London. Thanks to Geffroy and Clemenceau's connections, he gained entry into the more progressive fringes of English society, dining with the Asquiths (Liberal Party stalwarts) and with the wealthy Jewish art-dealer Asher Wertheimer. Monet warmed to the chaotic gaiety of the Wertheimer household, writing home to his wife with appreciative bemusement: "It's a real loony bin, the mother and father good-hearted souls."[63]

On the matter of Jews, it was Pissarro's attitudes that turn out to be the most complicated. He included in the *Turpitudes sociales* numerous caricatures of hook-nosed and bloated Jewish capitalists. Yet, in the face of a Drumont-style antisemitism, Pissarro recoiled. Bernard Lazare, a friend of the painter and like him an anarchist and a Jew, published *L'Antisémitisme* in 1894, a sharp-toned dissection of antisemitic prejudice. The kind of bigotry spewed by a Drumont, Lazare argued, represented the reactionary reflex of a frightened bourgeoisie which invested all its fears of revolution in the figure of the alien Jew. Lazare forwarded a copy of the book to Pissarro in 1896, who was so taken with it that he proposed arranging an English translation. " ... [H]ow happy I am," an effusive Pissarro wrote Lazare, "to see a Semite defend my ideas

with such eloquence; so there is at least one Jew, anarchist and well-informed, who is capable of raising his voice with authority."[64]

It is not that Cassatt, Monet, or Pissarro were without biases of their own, just that their prejudices, compared to Degas' or Renoir's, bespoke a less backward-looking, more free-thinking vision of the direction the modern world was taking.

Pissarro, as a committed anarchist, was certainly a man of powerful antipathies. He detested artworld poseurs like Paul Gauguin and Maurice Denis, "catholico-primitive '*symbolos*'" who conjured imaginary worlds of mystical transcendence.[65] Behind the errors of the symbolists, in Pissarro's view, lay "the bourgeoisie," those "Zulus in straw-yellow gloves, Opera hats and magpie tails," as he called them. The stuffed shirts of the world had grown anxious in the fin de siècle, unnerved by the ever more clamorous demands of "the disinherited masses." The befuddling distractions of religion promised the rich and powerful a way out, hence the stirrings of a new art based on "superstitious beliefs," the art of a Gauguin or Denis.[66]

Cassatt and Monet shared Pissarro's rationalist skepticism. Geffroy tells the story of a visit Cézanne made to Giverny in 1894. The painter found himself in the company of Monet and a circle of friends that included Cassatt, Clemenceau, Mirbeau and Geffroy himself. Such company made Cézanne ill-at-ease, and Geffroy had no doubt as to the reasons why. This was an unbelieving band, "liberal atheists" all, whose aggressive secularizing ways terrified the religion-minded Cézanne.[67]

Pissarro had a diagnosis for the sorry state of contemporary France, and he pointed the finger at decadent art, top-hatted bourgeois, and the intrigues of the Catholic clergy. Monet and Cassatt were inclined to agree with him on the latter point. Cézanne, Renoir, and Degas, were just as unhappy about the current crisis but identified a different line-up of culprits – professors, feminists, Jews, and the like.

The emblems and archetypes of modernity – the big city and the machine, the feminist and the Jew – haunted the late nineteenth-century imagination, and the new painters were no exception. Almost all of them harbored second thoughts about the industrial civilization they saw settling across France. Hence the tendency, so strong among the landscapists, to paint rural life in ever more mythic hues, excising all trace of metropolitan ways.

In the cases of Cézanne, Degas and Renoir, at issue was not just an iconographic turning away, but an actual and growing dislike of the modern world itself. All three harkened to the siren-calls of nostalgia, and it affected how they came to think about their painting. It may be too much to read into Renoir's beefy nudes a yearning for the departed

pleasures of younger days spent dancing on Montmartre. Or to read into Degas' tubwomen the expression of a tormenting obsession that was part and parcel of a widening distemper. Or to read into Cézanne's architectonic landscapes an impassioned search for God in nature.

What is certain is that all three painters wanted to reconnect with tradition, to construct themselves as worthy successors to the great masters of the past, whether Raphael, Ingres, or Poussin. Degas and Cézanne were explicit on the point. Moore, in conversation with Degas in 1890, made a passing reference to the artist and his painter friends as revolutionaries. Degas answered with an outburst: "Revolutionaries! We are *tradition*; it cannot be said often enough."[68] Cézanne had occasion to express a similar sentiment. He believed he had invented anew the landscape form. The nature he painted was a divine spectacle redone according to Poussin. In returning to classical principle, in reconnecting to the past, Cézanne felt he had moved beyond impressionism.[69] "There you are," he exclaimed to Gasquet, "tradition! I am more traditional than people think."[70]

The encroachments of modernity stirred Pissarro and Monet as well to expressions of anger or anxiety. Both embraced nature as a solution, deepening a lifetime's commitment to the impressionist mode in the process. But neither Pissarro's pursuit of a ruralist utopia, nor Monet's mythicization of agrarian France, betokened an all-out rupture with modernity. Pissarro for a period joined in the scientizing experiments of the neo-impressionist school. Monet read the latest fiction and took pleasure in the new car culture. The two painters retained an ongoing interest in the avant-garde currents that splashed outward from Europe's capitals. Indeed, at century's end, both felt called to return to the city in search of motifs – Pissarro to Rouen and Paris, Monet to London. They, like Cassatt, remained the stalwart partisans of a secularizing creed that shunned antisemitism and anti-feminism as the prejudices of a world outworn. France had its problems, but it was the privileged or bigoted few who were to blame, and in the long run they would lose. The present might be riven with inequities, but a healthful and harmonious tomorrow could yet be anticipated.

Culture into politics

A widening cultural divide split open the impressionist movement in the fin de siècle, and it did not take long for the divide to assume adversarial political form. Already in the eighties, Pissarro's republican enthusiasms had begun to cool. He dismissed the electoral process as a "joke" and in a letter of 1883 warned his son Lucien against the false promises of bour-

geois politicians like Clemenceau.[71] Pissarro broke out of the republican orbit, bolting leftward toward a humanistic anarchism. He was inspired by the writings of Peter Kropotkin and Elisée Reclus who conjured visions of a redeemed humankind living in peaceful communion with nature. Such visions might be utopian, he conceded to Mirbeau, but what "a beautiful dream" they made.[72] Pissarro himself labored to give artistic form to that dream in the arcadian canvases of his mature years. And it was not just his art that was reshaped by his new political commitments. Pissarro became an avid reader of the anarchist press and in 1889 joined the anarchist Club de l'art social. Such connections brought him a set of new friends – Jean Grave, Bernard Lazare, Octave Mirbeau, anarchists all; and they landed him in near trouble with the law. The assassination of the President of the Republic Sadi Carnot in 1894 prompted a police round-up of anarchist suspects, among them a number of Pissarro's comrades. Under the circumstances, he thought it prudent to spend several months abroad in self-imposed exile until the climate at home cooled.[73]

In contrast to Pissarro's turn leftwards, Cézanne and Degas broke to the right. Cézanne's return to the Catholic fold plunged him into a milieu steeped in rigorist impulse. He relied for spiritual guidance, he told Vollard, on his sister who took her lead from a Jesuit confessor who in turn took his from Rome. Under such influences, Cézanne's reading habits began to change. He took to buying *La Croix*, soon to distinguish itself at the time of the Dreyfus Affair for the virulence of its antisemitism.[74] Cézanne's circle of acquaintances began to change as well. He found the hard-headed atheist Clemenceau too difficult to take. As he explained to Geffroy: "It's just that I'm too weak! ... And Clemenceau couldn't protect me! ... I can only find protection in the Church!" The painter grew estranged from Geffroy as well not long thereafter. It was at this juncture that Gasquet entered the scene, a devout Catholic who rejoiced in Cézanne's new-found religiosity. He was into the bargain a close friend of Charles Maurras (future founder of the far-right Action française) and the editor of a series of short-lived literary magazines.[75] In the pages of these little reviews, recollected fellow litterateur Edmond Jaloux in 1942, Gasquet had begun to piece together "a national philosophy," a way of thinking which bore a striking kinship to "certain of the ideas that today *l'Etat français* [a reference to the Vichy regime of Maréchal Pétain] is striving to realize. ... "[76]

The company Degas kept at the century's end was no less reactionary. True, he maintained ties to the Halévys, a liberal-minded crew, but they were now more the exception than the rule. Degas grew closer in the eighties to Albert Bartholomé, a fellow painter, frequenting the family salon and treating the assembled guests to diatribes of an "intransigent"

nationalism.[77] An intransigent nationalism was among the predilections (along with old furniture) Degas shared with Léouzon-Leduc. Léouzon-Leduc had gotten himself elected deputy of Paris' Seventeenth arrondissement in 1889, running as a backer of General Georges Boulanger.[78] Boulanger was a military man, a critic of parliamentary institutions who gathered to himself a mixed bag of followers from rabble-rousing populists to nationalist authoritarians. Léouzon-Leduc was to be numbered among the latter as he had occasion to demonstrate at the time of the Dreyfus Affair. The Seventeenth elected him its representative once more in 1902, this time as an anti-Dreyfusard "nationalist."

Degas' social milieu was riven with antisemitic and nationalist prejudice, and with a hard-core Catholicism as well. Degas, although seldom demonstrative in expressions of belief, grew more attentive to matters of religion with the passing years. In 1890, he wrote to Bartholomé of the emotional confusion that had gripped him during a chance stopover at Lourdes: "There was a pilgrimage. All kinds of moving things ... Miracles of the body or of the soul, or physical or mystic reactions, what things were painted on their faces."[79] And then there was Degas' painter friend Henry Lerolle who came from a family described as "very Catholic."[80] Lerolle's brother Paul served on the Paris municipal council in the fin de siècle, representing the conservative and bien-pensant Seventh arrondissement. At the time of the Affair, anti-Dreyfusard Catholics joined forces to form the Action libérale, the first full-fledged Catholic party in France's history. Paul Lerolle was an early adherent, winning election to parliament in 1902 on the Action libérale ticket.

Degas' biases were not just the ineffectual ravings of an isolated old man. The painter in the fin de siècle embedded himself in a social network of right-wing activists, accomplished figures all who, much like the painter, looked on the republican regime *en place* as the antithesis of the values they held most dear. These men were prepared to do something about it, casting about for ways to translate their shared outrage into an effective right-wing politics – nationalist, Catholic, and antisemitic in orientation.

In certain respects, it is Renoir's fin-de-siècle trajectory that is hardest to pin down. He had always been a straddler, a man who painted portraits of republican patrons even as he evinced sympathy for defeated communards. In the 1880s, Renoir began to turn away from the commissioned portrait, setting out on a self-reliant course more consonant with his nonconformist impulses. But there was an ambivalence even to Renoir's nonconformism. In the personal domain, he combined montmartrois bohemianism with a patriarchal marriage, and a similar ambivalence marked the painter's politics. He inveighed against finance capital and the

fate of the working man in a machine-mad age but at the same time groused about a proliferating cast of modern-day spoilsports – intellectuals, feminists, etc. Hugues, the non-intellectual socialist, was in many ways the perfect choice for Renoir. When it came to taking concrete political action, though, Hugues was all over the map. He spoke up for striking miners in 1894 but was also a Boulangist sympathizer willing to dabble in the rhetoric of antisemitism. At the time of the Dreyfus Affair, after some initial hesitation, he plumped for the anti-Dreyfusard cause. Would Renoir, like Hugues in so many ways, do the same?

Pissarro, Cézanne, Degas, and Renoir: all four opted out of the republican mainstream, albeit heading off in quite different directions. Cassatt and Monet did not wander so far. Not Monet for sure. In 1880, Clemenceau founded a newspaper of radical views, *La Justice*, recruiting a staff of young collaborators that included Mirbeau, Geffroy, and Camille Pelletan. The first two, as we have seen, were regular visitors at Giverny. In 1889–90, Monet organized a subscription campaign to purchase the *Olympia* from Manet's widow with the intention of donating the canvas to the state. It was Pelletan who helped out in Monet's negotiations with republican officialdom. As for Clemenceau, the painter and politician had known each other for decades, a friendship that grew warmer with time. In 1891, Clemenceau delivered a notorious speech in parliament, declaring the French Revolution a "bloc" to be taken whole, the Terror along with the glorious days of 1789. Monet had painted a Creuse rockscape not so long before nicknamed *Le Bloc*, and Clemenceau for obvious reasons coveted the canvas. Monet was eager to sell the painting to his friend and, "in the present circumstance" as he confided to Geffroy, for a bargain price.[81] For reasons unknown, the deal fell through at the time. Yet, the principal point still stands: Monet in the nineties, as in the decades preceding, remained a confirmed republican, a *clémenciste* in fact at a time when Clemenceau's unbending radicalism still made him a figure of controversy.

Mary Cassatt too remained a republican. At the Bartholomé salon, she was the sole guest willing to dissent from Degas' nationalist jeremiads. For more like-minded company, at least on the matter of politics, she was obliged to seek out the free-thinking band who gathered at Monet's Giverny. Yet, Cassatt's republicanism was not cast in a fixed mold but had begun to change in the 1890s. This did not mean that she was becoming less of a democrat, just more of a feminist. Cassatt was invited to paint a mural on "Modern Woman" for the Woman's Pavilion at the Chicago Columbian Exposition of 1893. In the end, she contributed a triptych, the central panel entitled "Young Women Plucking the Fruits of Knowledge or Science" (Plate 3.6). On a trip to America in 1898, Cassatt befriended

the ardent feminist and socialist Theodate Pope, and it was via figures such as Pope and long-time confidant Louisine Havemeyer that Cassatt was persuaded to take a more active role in the suffragist movement in the years prior to World War I.[82]

THE DREYFUS AFFAIR

How far the new painters had come. A unanimity of opinion, even in younger days, had never reigned among them. Manet and Pissarro inclined to a free-thinking republicanism, Degas and the young Morisot to a well-bred liberal-mindedness. But such differences in the political context of mid-century had not amounted to much. In the fin de siècle, however, the old *esprit de corps* shattered. Cultural crisis ate away at the political optimism of earlier decades, scattering the artists to the four winds – to anarchism and nationalism, to suffragism and Catholic reaction. Yet however far apart the new painters had grown at century's end, it was as nothing compared to the bitter gulf which the Dreyfus Affair was to open among them.

Captain Alfred Dreyfus, a Jew, was court-martialed in 1894 for betraying military secrets to the Germans. The case against Dreyfus had never been more than circumstantial, but a zealous prosecution, abetted by the Minister of War General Auguste Mercier, railroaded through a conviction. Dreyfus was stripped of his rank in the courtyard of the Ecole Militaire and packed off to Devil's Island in the French Caribbean. Evidence later surfaced pointing to Major Ferdinand Esterhazy as the actual culprit, not Dreyfus. A campaign to exonerate the unfortunate captain gathered momentum, and Bernard Lazare was among the first to sign on, publishing the now-celebrated brochure *Une Erreur judiciaire: la vérité sur l'affaire Dreyfus* in 1896. Late the next year, Emile Zola began publication of a series of articles in *Le Figaro*, casting doubt on the army's case, but the paper found the series too inflammatory and broke it off. Zola then turned to *L'Aurore*, edited by his old friend Clemenceau. In January 1898, *L'Aurore* printed Zola's bombshell, "J'accuse," which indicted the military with a wilful miscarriage of justice. Dreyfus' partisans, however, did not have an easy go of it. Zola was brought up on charges of libel in February and found guilty. As for Dreyfus himself, mounting anxieties in military circles that he might get a second trial, prompted a senior officer long associated with the case, Colonel Hubert-Joseph Henry, to plant forged documents of an incriminating nature in Dreyfus' dossier. No one looking at the doctored file could doubt Dreyfus' guilt, and the ploy at first worked to perfection. In July, reading aloud from the file in parliament, the new Minister of War Godefroy Cavaignac declared Dreyfus' guilt

Plate 3.6 Mary Cassatt, *Modern Woman*, 1893.

Source: Decoration of South Tympanum, Woman's Building; World's Columbian Exposition, Chicago (Illinois), 1893; Photographer Unknown. Courtesy of Chicago Historical Society

incontrovertible and the Affair a non-event. But Henry's crude forgeries were soon discovered; Henry committed suicide; and in the face of an unraveling case, a beleaguered military had to grant Dreyfus a new trial which opened at Rennes in August 1899.[83]

The Affair, touching as it did on fundamental issues of truth and justice, individual right and military honor, forced French men and women to take sides. The new painters were no exception, all the more so given how many of the principals in the Affair were one-time acquaintances or associates: Lazare, Zola, Clemenceau, even General Mercier who was an old comrade of Degas' good friend the painter and businessman Henri Rouart.

Dreyfusards

Pissarro was among the first to react. He had gotten hold of Lazare's *Une Erreur judiciaire* which caused him to have second thoughts about Dreyfus' guilt. Then came Zola's newspaper series, convincing him that the Jewish captain had in fact been framed. Pissarro dashed off a letter of encouragement to his old, novelist friend. "Accept the expression of my admiration," he wrote Zola, "for your great courage and the nobility of your character."[84]

Pissarro's correspondence from these months gives an indication of what he felt was at stake in the Affair. The Dreyfusards were "free men." Arrayed against them was an unholy alliance of "generals and sprinklers of holy water" who were plotting a new *seize mai* coup. It was the bourgeoisie who held the balance, terrified of social revolution but at the same time suspicious of clerical and military machinations. Pissarro, however, remained hopeful that "the healthy portion of the population," grasping the danger the Republic was in, would in the end come around to the Dreyfusard side, allowing justice to prevail.[85]

Pissarro was in Paris at the time the Affair broke, hard at work on his cycle of boulevard paintings. He observed first-hand the passions the scandal unleashed, the recriminations among friends, the riots against Jews. Monet, however, remained at a distance, not leaving Giverny. Yet removed though he was from the main scene of action, he followed the unfolding of events with every bit as much intensity as Pissarro, perhaps more. Monet penned not just one note of congratulation to Zola but three.[86] He wanted to attend Zola's libel proceedings, "that ignoble trial" as he branded it in a letter to Geffroy, but illness in the family prevented him from doing so. Monet, though, kept abreast of what was happening through Mirbeau who made no secret of how he himself felt, likening Zola to "a Christ" and the army to a pack of "bandits."[87] As for Monet,

he found ways, if not by physical presence then through other means, to signal his solidarity with the Dreyfusard cause. He signed the pro-Dreyfus "Manifesto of the Intellectuals" which circulated among *universitaires* and publicists in the first weeks after the appearance of "J'accuse." In a more private gesture, he made a special gift of thanks to Clemenceau, Geffroy acting as the go-between. Clemenceau had long had an eye on Monet's *Le Bloc*. The artist gave the canvas to him gratis in December 1899, an act of friendship and of recognition, as Monet wrote, for the "fine campaign [you have waged] on behalf of right and truth."[88]

There were a variety of ways of expressing pro-Dreyfusard sympathies.[89] Mary Cassatt was in the United States for much of 1898 and so did not have the opportunity to make her views known at the outset. But in subsequent months, she had occasion to stand up for Dreyfus in salon debate, and to Havemeyer she spoke in moving terms of a passing encounter at the railroad station with Madame Dreyfus, "that brave and noble wife."[90] There were more formal means, of course, of advertising support, petition-signing among the most favored of them. Monet signed the "Manifesto of the intellectuals," as did Raymond Koechlin, Lucien Pissarro, and Paul Signac. Monet and Pissarro penned Zola admiring notes; Mallarmé did the same or almost, for it was a telegram he sent, not a letter. Zola and Mirbeau printed pro-Dreyfus pieces in the press; Duret furnished favorable coverage of Zola's February 1898 trial to the correspondent of the English-language *Daily News*. Indeed, as a gesture of solidarity, the mere act of showing up in court was as effective as any. Monet did not make it to Zola's first libel trial, but Mirbeau did. Zola was found guilty and over the summer filed an appeal scheduled to be heard at Versailles. Zola's lawyer Fernand Labori motored from Paris to Versailles in the company of Clemenceau and the art-dealers Josse and Gaston Bernheim (who made a specialty of impressionist painting). They met for lunch along the way with Georges Charpentier and Zola himself. It was not just individuals who rallied to the Dreyfusard cause but whole networks of sympathizers. And what a heteroclite crew they were: anarchist litterateurs, republican politicians, and not least of all, veterans of the new painting – artists, critics, and dealers all in it together.

Anti-Dreyfusards

But the same point may be made apropos the anti-Dreyfusard camp. They had their own networks of support, their own repertoire of techniques for signalling solidarity. The rant was one technique, and Julie Manet was witness to several such displays of emotion. In January 1898, a Dreyfusard acquaintance invited Renoir to sign the "Manifesto of the Intellectuals,"

but he refused point blank. Julie Manet, an anti-Dreyfusard herself, cari-
catured the petition as the handiwork of "Jews, anarchists and
litterateurs," and Renoir made no secret that he despised the lot. When it
came to literature, he told Julie, he liked writing that was amusing and
comprehensible, the novels of Dumas for example. But Zola was Dumas'
opposite in every respect: a heavy-handed chronicler of popular life who
painted the lower orders in the very bituminous colors which he, Renoir,
so detested as a painter. Cézanne did not care for the teachings of the
professorial Gustave Moreau. Even more hostile was Renoir who
dismissed Moreau's entire oeuvre, with Julie's nodding approval, as "Jew
art."[91] As for Pissarro, who was both an anarchist and a Jew, he came in
for yet rougher handling. Julie Manet overheard Renoir slamming the
whole Pissarro family, father and sons. They belonged to "that Jewish
race," a "tenacious" tribe of cosmopolitans and draft-dodgers. But wasn't
that just like the Jews, Renoir went on:

> They come to France to make money, but the moment a fight is on,
> they hide behind the first tree. There are so many in the army
> because the Jew likes to parade around in fancy uniforms. Every
> country chases them out, there is a reason for that, and we must not
> allow them to occupy such a position in France.[92]

Degas' anti-Dreyfusard sorties were less explosive, intended more to
strike a posture or provoke than to vent spleen. Durand-Ruel tells of a
jaunty Degas coming into the gallery, announcing his intention to pay a
visit to the Paris law courts. "To attend the trial," asks the art-dealer?
"No," replies Degas, "to kill a Jew!"[93] The *mot* was meant as a joke,
however elusive the humor. Degas could just as easily be cutting. He
continued to frequent the Halévy household into the early weeks of the
Affair, but the pro-Dreyfusard, anti-militarist talk he heard there from the
household's younger set infuriated him. He had his revenge on the
whipper-snappers, not all of them good Catholics like himself. At dessert,
one evening, he is said to have told a story on himself, recounting how he
had fired on the spot a model who ventured reservations about Dreyfus'
guilt: "You're Jewish yourself?" he is supposed to have asked her. "No.
monsieur, I'm a Protestant." "Ah, you're Protestant. Well, then, get the
hell out of here."[94] But there were times when Degas' anti-Dreyfusard
fury got the better of him, reducing him to tears of impotent rage. In
January 1898, Julie Manet stopped by the painter's studio to invite him
to dinner, but finding Degas in such "state against the Jews," she had to
withdraw "without asking him a thing."[95]

Such ferocity was bound to lead to quarrels which in fact abounded.

Julie Manet's diary recounts several, the anti-Dreyfusard Renoir squaring off against Edma Morisot, the poet Paul Valéry speaking up for the *patrie* against Mme Normant who took Dreyfus' part. Degas and Cassatt too had a falling out over the Affair. It is not clear when the argument occurred, but a rift there was, and for a period of time the two artists, once such good friends, broke off relations.[96]

Such ruptures were not infrequent, so intense was the anger kindled by the Affair. Renoir and Degas, it seems, no longer spoke to Pissarro and refused to greet him in the street. Degas ceased to attend the fashionable soirées of the Dreyfusard hostess Geneviève Straus and in December 1897 broke at last with the Halévys.[97] As for Cézanne and Zola, the Affair may not have played the key part in souring their friendship since childhood days, but it did complicate matters. The initial parting of ways dated back to 1886, with the publication of Zola's novel *L'Oeuvre*, a fictionalized account of the new painting's early history. In the novel and in a later newspaper article, Zola had disowned the impressionist movement, Cézanne included, as a botched experiment. Cézanne, for good reason, was very much wounded by what Zola had written, and then came the Affair. Cézanne, who was persuaded of Dreyfus' guilt, reproved Zola's behavior: "They took him in," he was heard to say apropos his old friend. In 1899, Cézanne was invited by a mutual acquaintance to pay Zola an impromptu visit, but he balked at the prospect, for how many reasons were there not to renew relations: all the unsettled emotions, old wounds, and now the toxin of political difference.[98]

Rants, quarrels, ruptures: such were the tactics of the anti-Dreyfusard camp among the one-time new painters. Yet, the anti-Dreyfusards did not just lash out in anger and pain but also found more focussed and effective ways to give backing to the cause they believed in. In December 1898, *La Libre Parole* mounted a subscription campaign to help out Colonel Henry's cash-strapped widow. Degas, Denis, Talmeyr, and Valéry all contributed to the enterprise.[99] Like many of the good nationalists of the era, Degas' friend Léouzon-Leduc took out membership in a right-wing league, in his case the *Ligue de la Patrie française*. In fact, Degas counted several friends in LPF ranks, among them Talmeyr, his soulmate in antisemitism, and Forain who over the course of the Affair established himself as the premier antisemitic caricaturist of the day.[100] But the Rouart clan was the most zealous in its anti-Dreyfusism, not so much the father Henri, as his four sons whom one common acquaintance described as "fanatics." They liked to attend pro-Dreyfus meetings, spoiling for a fight it seems, for at one such event Ernest Rouart had occasion to "knock down a Dreyfusard." It

was Degas who told the story, a dutiful Julie Manet (Ernest's future bride) jotting down the account in her diary.[101]

The Dreyfus Affair poisoned relations among the one-time new painters. There was some patching up later. A friend invited Cassatt to a luncheon at which Degas was also a guest (Havemeyer, the source of this story, does not specify the date). An anxious Cassatt was relieved to find her old friend in an agreeable mood although very much aged.[102] And Degas did consent to see Ludovic Halévy once more in 1908, although it was a funerary visit – to pay last respects to Halévy's corpse – that occasioned this final encounter. Such gestures, however, seem more elegiac tributes to friendship long gone than expressions of a present warmth.

The new painters had become like strangers to each other. Pissarro died in 1903; Degas did not attend the funeral. Zola and Cézanne passed on without ever seeing each other again, Zola in 1902 and Cézanne in 1906. And the survivors went their very separate ways. Renoir continued to chew Vollard's ear about the sorry state of the modern world. The ever irascible Degas can be found in 1907 attending an Action française rally to celebrate the anniversary of Dreyfus' degradation. Monet in the meantime kept up with the "progressive" causes of the day, signing a petition in 1905 at the time of the first Russian revolution to protest the arrest of novelist Maxim Gorki at the hands of Tsarist police. Cassatt did much the same, deepening her involvement in the cause of women's suffrage in the years before the Great War.[103]

The break-up of Impressionism was enacted on multiple fronts. The generational and aesthetic crises the new painters traversed in the 1880s unfolded against the backdrop of a more encompassing cultural crisis. The radiant colors of an older Paris, an older France, had been dimmed by a grinding modernity. Cézanne, Degas, Renoir rejected the new world, oscillating between poles of faith and *ressentiment*. But not all the new painters turned away, not Monet and Pissarro for example, who plunged into a restorative nature without indulging in traditionalist nostalgia. Such divergent paths fed into a politics no less divergent, as the Dreyfus Affair made plain. The Affair consummated a parting of the ways begun in the 1880s; and in this sense, it was on the stage of politics that "the crisis of impressionism" played out its final act.

Indeed, from beginning to end, the new painting had been entangled in the shifting political contests of its era. In the decades of mid-century the struggle to democratize the institutions and public culture of national life had occupied center-stage. The new painting's wrangle with the Salon and an entrenched academic aesthetic were very much implicated in this wider engagement. Politics helped to frame impressionism's identity, and they helped to undo the movement as well. France, and not France alone,

experienced a crisis of civilization in the fin de siècle, the passing of an old order and the coming of a new. Artists who had been able to agree on so much in the 1860s and 1870s could not agree on how to respond to a shift of such epochal proportions. They shot out in divergent directions, and the paths they took were premonitory of the politics of our own age. Monet's brush with the Russian revolution, Cassatt's with women's suffrage, Degas' with the integral nationalism of the Action française, were not just individual choices, for these forces – revolution, feminism, nationalism – were the very ones destined, for better and for worse, to shape the history of the twentieth century.

In the history of impressionism is to be read the best that the nineteenth century had to offer, the flowering of a democratic impulse which, it is to be hoped, has not altogether played itself out. In it also are to be read the first glimmerings of the politics of our own century, a politics that put democratic institutions to the test, by turns urging them to greater inclusiveness and threatening their very existence. Impressionism, as so much else, was unable to withstand that challenge.

Notes

INTRODUCTION

1　John Rewald, *Histoire de l'impressionnisme*, 2 vols. (Paris, Albin Michel, 1976; original *The History of Impressionism*, New York, Museum of Modern Art, 1946).

2　Gary Tinterow and Henri Loyrette, *Origins of Impressionism*, exhibition catalogue, Metropolitan Museum of Art (New York, 1994).

3　Pierre Vaisse, *La Troisième République et les peintres* (Paris, Flammarion, 1995).

4　Vaisse's French tradition is a house of many mansions, encompassing impressionism, academic art, and many of the shades of painting in between.

5　Robert Herbert, *Impressionism: Art, Leisure, and Parisian Society* (New Haven, CT, Yale University Press, 1988).

6　Robert Jensen, *Marketing Modernism in Fin-de-Siècle Europe* (Princeton, NJ, Princeton University Press, 1994).

7　Timothy J. Clark, *The Painting of Modern Life, Paris in the Art of Manet and His Followers* (New York, Alfred A. Knopf, 1985).

8　Clark, *Image of the People, Gustave Courbet and the Second French Republic 1848–1851* (Greenwich, CT, New York Graphic Society, 1973); and *Farewell to an Idea: Episodes from a History of Modernism* (New Haven, CT, Yale University Press, 1999), intro. and chapter 2.

9　Roy McMullen, *Degas: His Life, Times, and Work* (London, Secker & Warburg, 1985), p. 245.

10　The year 1867 was an exception. State officials authorized the Academy to select a third of Salon jurors, but the experiment was not repeated again.

11　Vaisse, *La Troisième République*, pp. 71–2.

12　Ambroise Vollard, *Renoir, An Intimate Record*, trans. Harold L. Van Doren and Randolph T. Weaver (New York, Dover, 1990), p. 43.

13　Patricia Mainardi, *The End of the Salon, Art and the State in the Early Third Republic* (New York, Cambridge University Press, 1993).

1 UNDER THE EMPIRE: THE ORIGINS OF THE NEW PAINTING

1　Roy McMullen, *Degas: His Life, Times, and Work* (London, Secker &

Warburg, 1985), p. 151; Henri Loyrette, *Degas* (Paris, Fayard, 1991), pp. 183–4. Bazille and Renoir also frequented the Louvre.

2 Madeleine Fidell-Beaufort, *Daubigny* (Paris, Geoffroy-Dechaume, 1975), p. 57; Steven Adams, *The Barbizon School and the Origins of Impressionism* (London, Phaidon, 1994), p. 177.

3 Gustave Geffroy, *Sisley* (Paris, Cres & Cie, 1923), p. 10.

4 André Parinaud, *Les Peintres et leur école Barbizon: les origines de l'impressionnisme* (Paris, A. Biro, 1994), pp. 123–4; Jean Bouret, *L'Ecole de Barbizon et le paysage français au XIXe siècle* (Neuchâtel, Ides et Calendes, 1972), p. 234; Marie-Thérèse de Forges, *Barbizon et l'Ecole de Barbizon* (Paris, Editions du Temps, 1971), p. 126.

5 See Gary Tinterow and Henri Loyrette, *Origins of Impressionism*, exhibition catalogue, Metropolitan Museum of Art (New York, 1994), pp. 73, 233; John House, "Framing the landscape," in House, ed. *Impressions of France: Monet, Renoir, Pissarro, and Their Rivals*, exhibition catalogue, Museum of Fine Arts (Boston, 1995), pp. 20–2; Adams, *Barbizon School*, p. 186ff.

6 Quoted in Jean Renoir, *Renoir* (Ottawa, Cercle du Livre de France, 1963), p. 97.

7 Cited in Gaston Poulain, *Bazille et ses amis* (Paris, Renaissance du Livre, 1932), p. 63.

8 Etienne Moreau-Nélaton, *Corot raconté par lui-même* (Paris, H. Laurens, 1924), vol. 2, p. 15; Adams, *Barbizon School*, p. 177; J. Renoir, *Renoir*, p. 107; Georges Rivière, *Cézanne* (Paris, Librairie Floury, 1936), pp. 64, 71.

9 Letter from Bazille to his mother, April 1867, and from Bazille to his parents, May 1867, in Didier Vatuone, *Frédéric Bazille, Correspondance* (Montpellier, Presses du Languedoc, 1992), pp. 137, 140.

10 Tinterow and Loyrette, *Origins*, p. 92; Jane Mayo Roos, "Herbivores versus Herbiphobes: Landscape Painting and the State," in House, ed. *Impressions*, pp. 47 and 47 n.40.

11 Nieuwerkerke, cited in Roos, "Herbivores versus Herbiphobes," p. 44; Castagnary, cited in Fidell-Beaufort, *Daubigny*, p. 60.

12 Moreau-Nélaton, *Daubigny raconté par lui-même* (Paris, H. Laurens, 1925), p. 25; Robert Herbert, *Barbizon Revisited* (New York, Clarke & Way, 1962), p. 38. See as well Fidell-Beaufort, *Daubigny*, p. 72, and letters from Daubigny to Trimolet, 14 October 1839 and to Geoffroy-Dechaume, 16 June 1871, in idem., pp. 241, 262.

13 Gabriel Weisberg, ed. *Japonisme: Japanese Influence on French Art, 1854–1910*, exhibition catalogue, Cleveland Museum of Art (Cleveland, 1975), p. 14; Philip Dennis Cate, "Japonisme and the Revival of Printmaking at the End of the Century," in Yamada Chisaburo, ed. *Japonisme in Art: An International Symposium* (Tokyo, Committee for the Year 2001, 1980), p. 279.

14 Weisberg, *The Independent Critic: Philippe Burty and the Visual Arts of Mid-Nineteenth Century France* (New York, P. Lang, 1993), pp. 101, 117–18 n.18.

15 See Eugène Montrosier's preface, 5e année, in Bailly-Herzberg, *L'Eau-forte de peintre au XIXe Siècle: La Société des aquafortistes 1862–1867* (Paris, L. Laget, 1972), vol 1, p. 275. Burty's review, first published in *La Gazette des beaux-arts*, is cited in ibid., vol. 1, p. 84.

16 Janin, preface to 3e année, in Bailly-Herzberg, *L'Eau-forte*, vol. 1, p. 90; Castagnary, preface to 4e année, in ibid., vol. 1, p. 212.

17 Philippe Burty, *Chefs d'oeuvre des arts industriels* (Paris, P. Ducrocq, 1866), pp. 170–1.

18 Burty, "Le mobilier moderne," *La Gazette des beaux-arts*, 1, 24 (January 1868): 27; idem., *Chefs d'oeuvre*, pp. 8, 170–1, 210, 255; Weisberg, *Burty*, p. 110; Rivière, *Renoir et ses amis* (Paris, H. Floury, 1921), p. 58.

19 See above all Jean-Paul Bouillon, "'A Gauche': note sur la Société du Jing-Lar et sa signification," *La Gazette des beaux-arts*, 6, 91 (March 1978): 107–18; and Geneviève Lacambre, "Les milieux japonisants à Paris, 1860–1880," in Chisaburo, ed. *Japonisme*, p. 49.

20 Nils Sandblad, *Manet, Three Studies in Artistic Conception* (Lund, C.W.K. Gleerup, 1954), 149.

21 Thoré, "Salon de 1864," in *Salons de W. Bürger* (Paris, Renouard, 1870), II: 99; Zola cited in George Heard Hamilton, *Manet and His Critics* (New Haven, CT, Yale University Press, 1986), p. 98; Edmond Bazire, *Manet* (Paris, A. Quantin, 1884), p. 44.

22 Cited in Anne Coffin Hanson, *Manet and the Modern Tradition* (New Haven,CT, Yale University Press 1979), p. 106.

23 Cited in Hamilton, *Manet*, p. 106.

24 Zola, "Coups d'épingle," *La Tribune*, 4 February 1869, reproduced in *Manet, 1832–1883*, exhibition catalogue, Metropolitan Museum of Art (New York, 1983), p. 532; see also Juliet Wilson-Bareau, John House, and Douglas Johnson, *Manet: The Execution of Maximilian. Painting, Politics and Censorship* (Princeton, NJ, Princeton University Press, 1992).

25 This is not to suggest a happy unity in the La Rochenoire camp. It required cajoling to persuade Courbet to join the enterprise, and Corot was more than a little displeased that Manet's name figured on the list at all. Paul Crapo, "Courbet, La Rochenoire et les réformes du Salon en 1870," *Les Amis de Gustave Courbet, Bulletin* (1990), *passim*; Moreau-Nélaton, *Corot raconté par lui-même*, vol. 2, p. 38; Roos, "Herbivores versus Herbiphobes," p. 47.

26 *Manet, 1832–1883*, pp. 522–3.

27 Burty, "La prochaine exposition," *Le Rappel*, 15 March 1870, cited in Weisberg, *Burty*, p. 131.

28 *Le Réveil*, 21 March 1870, cited in Crapo, "Courbet, La Rochenoire, et les réformes du Salon en 1870."

29 Irene Collins, *The Government and the Newspaper Press in France, 1814–1881* (Oxford, Oxford University Press, 1959), pp. 148–55; Pierre Albert, *Histoire de la presse politique nationale au début de la Troisième République, 1871–1879* (Paris, Champion, 1980), vol. 1, pp. 112–14.

30 Archives Nationales, 276 AP1, Scheurer-Kestner papers, letter from Burty to Scheurer-Kestner, 9 February 1879.

31 Bouret, *L'Ecole de Barbizon*, p. 142; Philippe Rebeyrol, "Art Historians and Art Critics – I: Théophile Thoré," *Burlington Magazine*, 94 (July 1952): 196.

32 Nord, *The Republican Moment, Struggles for Democracy in Nineteenth-Century France* (Cambridge, MA, Harvard University Press 1995), pp. 36, 123, 162–3; Archives de la Préfecture de Police, Paris, B/a 1001, Alfred Castagnary, report of 14 July 1873.

33 *Réalisme* was published for a brief period from 1856–7. The entire run of the periodical, with supporting documentation, has been reprinted. See *Réalisme* (Paris, L'Arche du Livre, 1970). The volume includes biographical notices on Assézat and Thulié, reprinted from the press of the day: Louis Asseline, "Jules Assézat," *La Vie littéraire*, 6 July 1876, and Coudrelles, "Le Docteur Thulié," *La Vie littéraire*, 14 March 1878.

34 Zola, "Mon Salon (1866)," in Gaëtan Picon and Jean-Paul Bouillon, eds. *Emile Zola, Le bon combat, de Courbet aux impressionnistes* (Paris, Hermann, 1974), p. 59.

35 Thoré, "Salon de 1863" and "Salon de 1865," *Salons*, I: 375 and II: 165–6.

36 Castagnary, "Salon de 1869" and "Salon de 1870," *Salons* (Paris, Charpentier, 1892), I: 328, 411; idem. *et al., Le Bilan de l'année 1868 politique, littéraire, dramatique, artistique et scientifique* (Paris, Armand Le Chevalier, 1869), p. 297; Thoré, "Salon de 1863," *Salons*, I: 375.

37 Duret, "Le Salon III," *L'Electeur libre*, 2 June 1870.

38 Zola as cited in Nina Athanassoglou-Kallmyer, "An Artistic and Political Manifesto for Cézanne," *Art Bulletin*, 72 (September 1990): 484 fn 10.

39 Thoré, "Salon de 1865" and "Exposition de 1867," *Salons*, II: 173, 350. See also Castagnary, "Philosophie du Salon de 1857," *Salons*, I: 7.

40 Castagnary, "Salon de 1869," *Salons*, I: 339.

41 Castagnary, "Salon de 1869," *Salons*, I: 339; Rebeyrol, "Art Historians," p. 197. The anarchist philosopher Proudhon, a friend of Courbet, extolled Dutch art as "republican and rationalist, not having to bother with gods or grandees, with pontiffs or monks, and compelled to fall back on secular life." Cited in Tinterow and Loyrette, *Origins*, p. 271.

42 Duranty, "Pour ceux qui ne comprennent jamais," *Réalisme*, 15 December 1856; and "Notes sur l'art," in the unpublished 10 July 1856 edition.

43 Castagnary, "Philosophie du Salon de 1857" and "Salon de 1863," *Salons*, I: 6–7, 105; Thoré, "Salon de 1864," *Salons*, II: 70, 73; Zola, "Mon Salon (1866)," p. 63 and as cited in Hamilton, *Manet*, pp. 95–6.

44 Thoré, "Salon de 1861," *Salons*, I: 16; Zola as cited in Paul Hayes Tucker, *Claude Monet, Life and Art* (New Haven, CT, Yale University Press, 1995), p. 24.

45 I. Tchernoff, *Le Parti républicain au coup d'état et sous le Second Empire* (Paris, A. Pedone, 1906), p. 412; letter from Cézanne to Numa Coste, beginning of July 1868, in John Rewald, ed. *Paul Cézanne, Letters* (New York, Hacker Art Books, 1984), pp. 126–7 and 123 n.31.; and above all Athanassoglou-Kallmyer, "An Artistic and Political Manifesto for Cézanne," pp. 483, 486.

46 See Bazille's letters home: 15 November 1862 and January 1870, in Vatuone, ed. *Bazille*, pp. 30, 184–5; and letter (*c*. 1865–6) cited in Poulain, *Bazille*, p. 48.

47 Letter from Bazille to his parents, 6 September 1870, in Vatuone, ed. *Bazille*, p. 196; for the Lejosne Salon, see McMullen, *Degas*, p. 163.

48 Clemenceau, *Claude Monet: The Water Lilies* (New York, Doubleday, 1930), pp. 15, 82; Daniel Wildenstein, *Claude Monet, Biographie et catalogue raisonné* (Lausanne, Bibliothèque des Arts, 1974), vol. 1, pp. 160, 172; Tchernoff, *Le Parti républicain*, pp. 301, 316, 358.

49 J. Renoir, *Renoir*, pp. 48–9, 55, 87, 121–2. For Rigault's comings and goings at the end of the Empire, see Luc Willette, *Raoul Rigault 25 ans, communard, chef de police* (Paris, Syros, 1984), p. 52.

50 Letter from Rachel Pissarro to Camille Pissarro, 6 November 1870, in Bailly-Herzberg, ed. *Correspondance de Camille Pissarro* (Paris, Presses Universitaires de France, 1980), vol. 1, pp. 17, 30–1. On Piette and Gachet, see Ralph E. Shikes and Paula Harper, *Pissarro, His Life and Work* (London, Quartet Books, 1980), pp. 86, 118.

51 Letter from Manet to his father, 22 March 1849, in Manet, *Lettres de jeunesse 1848–1849, Voyage à Rio* (Paris, Louis Rouart, 1928), p. 67.
52 Charles Limet, *Un Vétéran du barreau parisien: quatre-vingts ans de souvenirs, 1827–1907* (Paris, A. Lemerre, 1908), pp. 201, 205, 250; Denis Rouart, ed. *Berthe Morisot, The Correspondence*, trans. Betty Hubbard (London, Moyer Bell, 1987), p. 149.
53 Letter from Manet to Fantin-Latour, 26 August 1868, in Pierre Courthion and Pierre Cailler, eds. *Manet raconté par lui-même et par ses amis* (Geneva, P. Cailler, 1945), vol. 1, p. 45.
54 Marianne Ruggiero, "Manet and the Image of War and Revolution: 1851–1871," in *Edouard Manet and the "Execution of Maximilian"*, exhibition catalogue, Brown University (Providence, 1981), p. 26. The American flag figures in the top foreground of Monet's *Hôtel des Roches Noires, Trouville*, painted in 1870.
55 Antonin Proust, *Edouard Manet, Souvenirs* (Paris, H. Laurens, 1913), pp. 56–7.
56 On the Jing-Lar, see Bouillon, "A Gauche." For details on Hirsch, see the notice in the *Dictionnaire de biographie française* (Paris, Librairie Letouzey et Ane); and two articles in the *Archives israélites*: "Salon israélite de 1878," 39 (15 June 1878): 372, and "Nouvelles diverses," 39 (1 July 1878): 412.
57 Adolphe Jullien, *Fantin-Latour, sa vie et ses amitiés* (Paris, L. Laveur, 1909), p. 18; Douglas Druick and Michel Hoog, *Fantin-Latour*, exhibition catalogue, National Gallery of Canada (Ottawa, 1983), p. 99.
58 Rouart, ed. *Morisot, Correspondence*, pp. 22–3, 54.
59 Carol Armstrong, *Odd Man Out: Readings of the Work and Reputation of Edgar Degas* (Chicago, IL, University of Chicago Press, 1991), p. 6; Ian Dunlop, *Degas* (London, Thames & Hudson, 1979), pp. 12, 63; Tinterow and Loyrette, *Origins*, p. 204.
60 Loyrette, *Degas*, pp. 67–70.
61 McMullen, *Degas*, p. 12; Loyrette, *Degas*, pp. 137, 167; Theodore Reff, "More Unpublished Letters of Degas," *Art Bulletin*, 51 (1969): 283 and 283 n.27.

2 THE COMING OF THE REPUBLIC

1 This is Antonin Proust's characterization of Manet's position. See Antonin Proust, *Edouard Manet, Souvenirs* (Paris, H. Laurens, 1913), p. 58.
2 Ralph E. Shikes and Paula Harper, *Pissarro, His Life and Work* (London, Quartet Books, 1980), pp. 86–9.
3 Letter from Manet to his wife, 15 September 1870, in Pierre Courthion and Pierre Cailler, eds, *Manet raconté par lui-même et par ses amis* (Geneva, P. Cailler, 1945), vol. 1, p. 45.
4 Henri Loyrette, *Degas* (Paris, Fayard, 1991), pp. 257–8.
5 Theodore Reff, *Manet and Modern Paris* (Chicago, IL, University of Chicago Press, 1982), pp. 236–40.
6 Françoise Cachin, Charles Moffett, *et al.*, *Manet, 1832–1883*, exhibition catalog, Metropolitan Museum of Art (New York, 1983), p. 329.
7 Reff, *Manet and Modern Paris*, p. 124.

8 Letter from Monet to Pissarro, 27 May 1871, in Daniel Wildenstein, ed. *Claude Monet, Biographie et catalogue raisonné* (Lausanne, Bibliothèque des Arts, 1974), vol. 1, p. 427; letter from Piette to Pissarro, 30 January 1872, in Janine Bailly-Herzberg, *Mon Cher Pissarro: lettres de Ludovic Piette à Camille Pissarro* (Paris, Editions de Valhermeil, 1985), p. 71.

9 Letter from Madame Morisot to Berthe, 5 June 1871, in Denis Rouart, ed. *Berthe Morisot, The Correspondence*, trans. Betty Hubbard (London, Moyer Bell, 1987), p. 73.

10 Théodore Duret, *Histoire de Edouard Manet et de son oeuvre* (Paris, Bernheim-Jeune, 1926), 4th edn, p. 166.

11 Louis Fiaux, *Histoire de la guerre civile de 1871* (Paris, Charpentier, 1879), pp. 525, 581; Paul Gachet, *Deux Amis des impressionnistes: le docteur Gachet et Murer* (Paris, Editions des Musée Nationaux, 1956), p. 46.

12 This incident is recounted in Ambroise Vollard, *Renoir: An Intimate Record*, trans. Harold Van Doren and Randolph T. Weaver (New York, Dover, 1990), p. 24. The original 1925 edition was published in New York by Alfred A. Knopf.

13 Letter from Manet to Bracquemond, 21 March 1871, in Jean-Paul Bouillon, "Lettres de Manet à Bracquemond," *La Gazette des beaux-arts*, 6, 101 (April 1983): 151; letter from Pissarro to Piette, nd (1871), in Bailly-Herzberg, ed. *Correspondance de Camille Pissarro* (Paris, Presses Universitaires de France, 1980), vol. 1, p. 67.

14 Shikes and Harper, *Pissarro*, 96; Jean Renoir, *Renoir* (Ottawa, Cercle du Livre de France, 1963), p. 127.

15 Berthe Morisot's sister Edma referred to the National Assembly perched out at Versailles as that "reactionary chamber." Letter from Edma to Berthe Morisot, 23 February 1871, in Rouart, ed. *Morisot*, p. 61.

16 Nord, "The Party of Conciliation and the Paris Commune," *French Historical Studies*, 15 (Spring 1987): 1–35.

17 Proust, *Edouard Manet*, p. 65; Etienne Moreau-Nélaton, *Manet raconté par lui-même* (Paris, H. Laurens, 1926), vol. 1, p. 131; Manet as cited in letter from Madame Morisot to Edma, 29 June 1871, in Rouart, ed. *Morisot*, p. 79.

18 Edma to Berthe Morisot, 23 February 1871, and Berthe to Edma Morisot, 27 February 1871, in Rouart, ed. *Morisot*, pp. 60, 61.

19 Loyrette, "Modern Life," in Gary Tinterow and Henri Loyrette, *Origins of Impressionism*, exhibition catalogue, Metropolitan Museum of Art (New York, 1994), p. 288.

20 Albert Boime, *Art and the French Commune, Imagining Paris after War and Revolution* (Princeton, NJ, Princeton University Press, 1995), pp. 37–8, 68–73.

21 Letter from Degas to Charles W. Deschamps, 22 [August 1875], in Reff, "Some Unpublished Letters of Degas," *The Art Bulletin*, 50 (March 1968): 89.

22 Robert Jensen, *Marketing Modernism in Fin-de-Siècle Europe* (Princeton, NJ, Princeton University Press, 1994), p. 82.

23 Lionello Venturi, *Les Archives de L'impressionnisme* (Paris, Durand-Ruel, 1939), vol. 1, p. 19. See also idem., vol. 2, p. 188; and Armand Silvestre, *Au pays des souvenirs* (Paris, Prinzine, 1887), 3rd edn, pp. 297–304.

24 Roy McMullen, *Degas: His Life, Times, and Work* (London, Secker & Warburg, 1985), p. 287.

25 For much of what follows, see Kathleen Adler, *Unknown Impressionists* (Oxford, Phaidon, 1988), p. 96ff.

26 See letters from Degas to Désiré Dihau, 11 November 1872, and to Edmond Tissot, 19 November 1872, in Marcel Guérin, ed. *Degas Letters*, trans. Marguerite Kay (Oxford, B. Cassirer, 1948), pp. 13, 17.

27 Martha Ward, *Pissarro, Neo-Impressionism, and the Spaces of the Avant-Garde* (Chicago, IL, University of Chicago Press, 1996), p. 29.

28 Gachet, *Deux Amis*, p. 90.

29 Letters from Cézanne to Zola, 1 June 1878 and July 1878, and to Pissarro, 2 July 1876, in John Rewald, ed. *Paul Cézanne: Letters* (New York, Hacker Art Books, 1984), p. 167.

30 Georges Quiqueré, "Gennevilliers à la fin du XIXe siècle," in Patrice Bachelard, ed. *De Manet à Caillebotte. Les Impressionnistes à Gennevilliers* (Paris, Editions Plume, 1993), pp. 62–4.

31 Letter from Cassatt to Emily Sartain, 22 May [1871], in Nancy Mowll Mathews, ed. *Cassatt and Her Circle: Selected Letters* (New York, Abbeville Press, 1984), p. 72; Cassatt as cited in Griselda Pollock, *Mary Cassatt* (New York, Harper & Row, 1980), p. 22; letter from Cassatt to Havemeyer, undated, in Louisine Havemeyer, *Sixteen to Sixty, Memoirs of a Collector* (New York, Ursus Press, 1993), p. 290. This is a reprint of a 1961 edition that was privately published under the same title.

32 Cited in letter from Daubigny to Henriet, 25 July 1875, cited in Moreau-Nélaton, *Daubigny raconté par lui-même* (Paris, H. Laurens, 1925), p. 115.

33 Jane Mayo Roos, *Early Impressionism and the French State (1866–1874)* (Cambridge, Cambridge University Press, 1996), pp. 169, 171, 180, 184; and idem., "Herbivores versus Herbiphobes: Landscape Painting and the State," in John House, ed. *Impressions of France: Monet, Renoir, Pissarro, and Their Rivals*, exhibition catalogue, Museum of Fine Arts (Boston, 1995), p. 49.

34 Archives Nationales (AN), F21 534, Salon de 1872, I: dossier "Règlement."

35 AN, F21 535, Salons 1866–82, dossier "1872. Salon."

36 Michelle Perrot, *Les Ouvriers en grève, France 1871–1890* (Paris, Mouton, 1974), vol. 1, p. 41; Pierre Albert, *Histoire de la presse politique nationale au début de la Troisième République, 1871–1879* (Paris, Champion, 1980), vol. 1, p. 339.

37 Castagnary, "Salon de 1873," *Le Siècle*, 10 May 1873; "Salon de 1872," in Castagnary, *Salons* (Paris, Charpentier, 1892), II: 4.

38 [Burty] "Le Salon de 1873: IV," *La République française*, 15 May 1873; [Burty] "La Salon de 1874," *La République française*, 20 June 1874; [Burty] "Le Salon de 1873: VI," *La République française*, 25 May 1873; Pelletan, "Le Salon," *Le Rappel*, 20 May 1872; Pelletan, "Le Salon," *Le Rappel*, 18 May 1872.

39 Pelletan, "Le Salon," *Le Rappel*, 27 May 1872; "Salon de 1872," in Castagnary, *Salons*, II: 21.

40 "Salon de 1872," in Castagnary, *Salons*, II: 31; [Burty] "Le Salon de 1874: VIII," *La République française*, 9 June 1874.

41 "Salon de 1873," in Castagnary, *Salons*, II: 60–1.

42 "Salon de 1872," in Castagnary, *Salons*, II: 7.

43 Duranty, "Le Salon de 1872," *Paris-Journal*, 11 May 1872.

44 Astruc, "Salon de 1872: le Jury," *Le Peuple souverain*, 25 May 1872, cited in Sharon Flescher, *Zacharie Astruc, Critic, Artist, and Japoniste (1833–1907)* (New York, Garland, 1978), pp. 211–12.

45 Duranty, "Le Salon de 1872," *Paris-Journal*, 15 June 1872; "Salon de 1872," in Castagnary, *Salons*, II: 7.

46 Castagnary, "Salon de 1873," *Le Siècle*, 14 June 1873; "Salon de 1873," in Castagnary, *Salons*, II: 79.

47 Roos, *Early Impressionism*, p. 190; for the original French, see p. 271 n.33.

48 Albert, *Histoire de la presse politique*, vol. 1, p. 339; Alexis, "Paris qui travaille: III," *L'Avenir national*, 5 May 1873; "Une lettre de M. Claude Monet," *L'Avenir national*, 12 May 1873.

49 Georges Rivière, *Renoir et ses amis* (Paris, H. Floury, 1921), pp. 43–4; Roos, *Early Impressionism*, p. 194.

50 Roos (*Early Impressionism*) discusses in illuminating detail the political context which framed the first exhibition of the new painting.

51 [Burty] "Chronique du jour," *La République française*, 16 April 1874; Castagnary as cited in J. Renoir, *Renoir*, p. 147; and Roos, *Early Impressionism*, p. 217.

52 Duranty, "The New Painting," reprinted in Charles S. Moffett *et al.*, *The New Painting: Impressionism 1874–1886*, exhibition catalogue, National Gallery of Art (Geneva, 1986), p. 40; G.R., "Aux femmes," *L'Impressionniste*, 21 April 1877; Vollard, *Renoir*, p. 43; Stephen Eisenman, "The Intransigent Artist or How the Impressionists Got Their Name," in Moffett *et al.*, *The New Painting*, p. 57.

53 Rouart, ed. *Morisot*, 111; G.R., "A M. le rédacteur du Figaro," *L'Impressionniste*, 6 April 1877; Emile Blémont, "Les Impressionnistes," *Le Rappel*, 9 April 1876; *Le Moniteur universel*, 8 April 1876, cited in Eisenman, "The Intransigent Artist," p. 53.

54 Letter from Robert Cassatt to Alexander Cassatt, 4 October 1878, in Mathews, ed. *Cassatt*, p. 140.

55 François Daulte, *Auguste Renoir, catalogue raisonné de l'oeuvre peint* (Lausanne, Durand-Ruel, 1971), vol. 1, p. 44.

56 Archives de la Préfecture de Police, Paris (APP), B/a 1274, dossier Spuller, reports of 9 and 11 (?) October 1877.

57 Manet at about the same time also did a marine of Rochefort's escape from New Caledonia.

58 Anne Distel, *Impressionism: The First Collectors*, trans. Barbara Perroud-Benson (New York, Harry N. Abrams, 1990), p. 143.

59 Bailly-Herzberg, "Marcellin Desboutin and His World," *Apollo*, 95 (June 1972): 500.

60. Cachin, Moffett, *et al.*, *Manet*, pp. 347–8; APP, B/a 988, dossier Nina de Callias, reports of 13 August 1872 and 14 August 1876.

61 Reff, *The Notebooks of Edgar Degas* (New York, Hacker Art Books, 1985), vol. 1, p. 130; Léon Lyon-Caen, *Souvenirs du jeune âge* (Paris, Herbin, 1912), pp. 199–202; "Liste générale des membres de l'Alliance universelle," *Bulletin de L'Alliance israélite universelle* (January 1865), ix. Franck, who also sat on the board of the Jewish consistory, soon resigned from the Alliance, judging simultaneous membership in the two organizations incompatible. Nord, *The Republican Moment, Struggles for Democracy in Nineteenth-Century France* (Cambridge, MA, Harvard University Press, 1995), p. 73.

62 Loyrette, *Degas*, pp. 359–61, 742 n.181.
63 "Adhésions," *Bulletin de l'Alliance israélite universelle* (2e semestre 1868): 120.
64 Reff, *Manet and Modern Paris*, 56; Moreau-Nélaton, *Manet raconté*, vol. 2, p. 62.
65 Colin B. Bailey, "Portrait of the Artist as a Portrait Painter," in Bailey, ed. *Renoir's Portraits: Impressions of an Age*, exhibition catalog, Art Institute of Chicago (New Haven, 1997), pp. 6, 8, 178; Distel, *Impressionism*, pp. 164–5.
66 Hollis Clayson, *Painted Love: Prostitution in French Art of the Impressionist Era* (New Haven, CT, Yale University Press, 1991).
67 Bailey, "Portrait of the Artist," p. 4; Julia Sargaves, "The Street," in Distel *et al.*, *Gustave Caillebotte, Urban Impressionist*, exhibition catalog, Art Institute of Chicago (New York, 1995), p. 98; Paul Hayes Tucker, *Monet at Argenteuil* (New Haven, CT, Yale University Press, 1982); Richard Thomson, *Camille Pissarro: Impressionism, Landscape and Rural Labour* (London, Herbert Press, 1990); Anne Dumas, "The Public Face of Landscape," in House, ed. *Impressions*, pp. 35–6.
68 Pollock, *Cassatt*; Anne Higonnet, *Berthe Morisot's Images of Women* (Cambridge, MA, Harvard University Press, 1992).
69 Burty, *Grave Imprudence* (Paris, Charpentier, 1880), p. 135; Stéphane Mallarmé, "The Impressionists and Edouard Manet," reprinted in Moffett *et al.*, *The New Painting*, p. 30
70 Rivière, "L'Exposition des impressionnistes," *L'Impressionniste*, 6 April 1877.
71 As cited in Bailey, "Portrait of the Artist," p. 44 n.21. My translation.
72 Castagnary, "Salon de 1873," *Le Siècle*, 10 May 1873.
73 [Edmond Lepelletier], "Les Impressionnistes," *Le Radical*, 8 April 1877; Marius Chaumelin from *La Gazette [des étrangers]*, 8 April 1876, as cited in Moffett *et al.*, *The New Painting*, p. 171; Nord, "Manet and Radical Politics," *Journal of Interdisciplinary History*, 19 (Winter 1989): 475.
74 Douglas W. Druick and Peter Zegers, "Scientific Realism: 1873–1881," in Jean Sutherland Boggs *et al.*, *Degas*, exhibition catalogue, Metropolitan Museum of Art (New York, 1988), p. 198ff; Loyrette, *Degas*, p. 401; Norma Broude, *Impressionism: a Feminist Reading: the Gendering of Art, Science, and Nature in the Nineteenth Century* (New York, Rizzoli, 1991), p. 124.
75 "Salon de 1875," in Castagnary, *Salons*, II: 149; Burty, "Les Paysages de M. Claude Monet," *La République française*, 27 March 1883. The circumstances under which the Burty article was written are not without interest. The Durand-Ruel gallery had at the time mounted a one-man show of Monet's work. The painter talked to Burty about writing a piece on the exhibition and later sent the critic a canvas in appreciation for all that he had done over the years on behalf of impressionist art. It was just a few days afterward that the Burty essay cited above appeared. Letter from Monet to Burty, 22 March 1883, in Wildenstein, *Claude Monet, Biographie et catalogue raisonné* (Lausanne, Bibliothèque des Arts, 1979), vol. 2, p. 228.
76 Duret, "Les Peintres impressionnistes," (May 1878), reprinted in Duret, *Histoire des peintres impressionnistes* (Paris, Bernheim-Jeune, 1922), 3rd edn, p. 175. See also Castagnary, "Salon de 1876," in *Salons*, II: 214; Rivière, "L'Exposition des impressionnistes," *L'Impressionniste*, 14 April 1877.
77 Castagnary, "Salon de 1875," *Le Siècle*, 29 May 1875; Burty, "Exposition des impressionistes [sic]," *La République française*, 25 April 1877.

78 Mantz on Morisot, Huysmans on Cassatt, cited in Tamar Garb, *Women Impressionists* (New York, Rizzoli, 1988), 12, 32; Burty, "Exposition des artistes indépendants," *La République française*, 16 April 1879.

79 Mantz on Morisot, as cited in Garb, *Women Impressionists*, p. 12; Duret, "Les Peintres impressionnistes," (May 1878), reprinted in idem., *Histoire des peintres impressionnistes*, p. 178.

80 [Burty], "Chronique du jour," *La République française*, 16 April 1874.

81 House, "Framing the Landscape," in idem., *Impressions*, p. 27; Joel Isaacson, *The Crisis of Impressionism, 1878–1882*, exhibition catalogue, University of Michigan Museum of Art (Ann Arbor, 1980), p. 11; Ward, "Impressionist Installations and Private Exhibitions," *Art Bulletin*, 73 (December 1991): 610–11.

82 See Distel, *Impressionism*, passim.

83 Distel, *Impressionism*, p. 71; Fiaux, *La Marseillaise, son histoire dans L'histoire des français depuis 1792* (Paris, Fasquelle, 1918), p. 250.

84 Gachet, *Deux Amis*, pp. 72, 147, Distel, *Impressionism*, p. 109.

85 Yvon Bizardel, "Théodore Duret: An Early Friend of the Impressionists," *Apollo*, 100 (August 1974): 152; APP, B/a 1268, dossier Sernuschi (sic), report of 16 July 1877 and clipping from *Le Figaro*, 12 May 1896; Duret, *Renoir*, trans. Madeleine Boyd (New York, Crown Publishers, 1937), pp. 45–6.

86 Burty, *La République française*, 11 May 1885, cited in Gabriel Weisberg, *The Independent Critic: Philippe Burty and the Visual Arts of Mid-Nineteenth Century France* (New York, P. Lang, 1993), p. 200; Jacques-Emile Blanche, *Propos de peintre, de Gauguin à la Revue Nègre* (Paris, Emile-Paul Frères, 1928), 3rd edn, p. 132.

87 Bailey, *Renoir's Portraits*, pp. 161, 296 n.13; Bazire, *Manet* (Paris, A. Quantin, 1884), p. 142; Moreau-Nélaton, *Manet raconté*, vol. 2, p. 97.

88 Pierre Vaisse, *La Troisième République et les peintres: recherches sur les rapports des pouvoirs publics et de la peinture en France de 1870 à 1914* (Doctorat d'Etat, University of Paris IV, 1980), vol. 1, p. 83; Distel, *Impressionism*, p. 75; Eugène Blot, *Histoire d'une collection de tableaux modernes* (Paris, Editions d'Art, 1934), p. 105.

89 Vaisse, *La Troisième République et les peintres*, vol. 4, p. 737.

90 Proust, *Edouard Manet*, p. 137; Vaisse, *La Troisième République et les peintres*, vol. 3, p. 724; Nord, *Republican Moment*, p. 188.

91 Bibliothèque nationale, Nouvelles Acquisitions Françaises (NAF) 10316, Zola Papers, research notes for *L'Oeuvre*, pp. 377–8; Burty, "Salon de 1881," *La République française*, 2 May 1881.

3 THE CRISIS OF IMPRESSIONISM

1 See *Monet's Years at Giverny: Beyond Impressionism*, exhibition catalogue, Metropolitan Museum of Art (New York, 1978); Richard Kendall, *Degas, Beyond Impressionism* (New Haven, CT, Yale University Press, 1996); and Richard Shiff, *Cézanne and the End of Impressionism, A Study of the Theory, Technique, and Critical Evaluation of Modern Art* (Chicago, IL, University of Chicago Press, 1984).

2 Joel Isaacson, *The Crisis of Impressionism, 1878–1882*, exhibition catalogue, University of Michigan Museum of Art (Ann Arbor, 1980), pp. xii, 2–43.

3 See Paul Hayes Tucker, *Monet in the '90s, The Series Paintings* (New Haven, CT, Yale University Press, 1989); and Shiff, *Cézanne and the End of Impressionism*.

4 Patricia Mainardi, *The End of the Salon: Art and the State in the Early Third Republic* (New York, Cambridge University Press, 1993); Harrison C. White and Cynthia A. White, *Canvases and Careers, Institutional Change in the French Painting World* (New York, University of Chicago Press, 1993 [orig. 1965]); Martha Ward, *Pissarro, Neo-Impressionism, and the Spaces of the Avant-Garde* (Chicago, IL, University of Chicago Press, 1996), p. 7.

5 *Renoir*, exhibition catalogue, Hayward Gallery (London, 1985), p. 300.

6 Manet had won an honorable mention at the Salon of 1861 but nothing in the twenty years after that.

7 Isaacson, *The Crisis of Impressionism*, p. 6.

8 The other four were Caillebotte, Gauguin, Guillaumin, and Vignon.

9 Maurice Malingue, *La Vie prodigieuse de Paul Gauguin* (Paris, Buchet/Chastel, 1987), p. 78.

10 P.A. Lemoisne, *Degas et son oeuvre* (Paris, Paul Brame and C.M. De Hauke, 1946), vol. 1, p. 141.

11 Ralph E. Shikes and Paula Harper, *Pissarro, His Life and Work* (London, Quartet Books, 1980), pp. 219, 220, 273.

12 The Petit show was in fact a joint exhibition, mounted by Monet in conjunction with the sculptor Auguste Rodin.

13 Georges Rivière, *Renoir et ses amis* (Paris, H. Floury, 1921), p. 203.

14 Letter from Monet to Durand-Ruel, 7 March 1883, in Lionello Venturi, *Les Archives de l'Impressionnisme* (Paris, Durand-Ruel, 1939), vol. 1, p. 251.

15 Ward writes of "the privatization of impressionism." Ward, *Pissarro*, p. 54.

16 So profound was Degas's withdrawal that he ceased exhibiting his current work altogether between 1886 and 1991. See Gary Tinterow, "The 1880s: Synthesis and Change," in Jean Sutherland Boggs *et al.*, *Degas*, exhibition catalogue, Metropolitan Museum of Art (New York, 1988), p. 372.

17 Letter from Degas to Lerolle, 21 August 1884, in Marcel Guérin, ed. *Degas Letters*, trans. Marguerite Kay (Oxford, B. Cassirer, 1948), p. 81.

18 Joan Ungersma Halperin, *Félix Fénéon, Aesthete and Anarchist in Fin-de-Siècle Paris* (New Haven, CT, Yale University Press, 1988), p. 100; John G. Hutton, *Neo-Impressionism and the Search for Solid Ground: Art, Science, and Anarchism in Fin-de-Siècle France* (Baton Rouge, Louisiana State University Press, 1994), pp. 18, 34; Ward, *Pissarro*, p. 9.

19 Malingue, *La Vie prodigieuse*, p. 78.

20 Letter from Gauguin to Emile Schuffenecker, 14 August 1888, in Malingue, ed. *Lettres de Gauguin à sa femme et à ses amis* (Paris, B. Grasset, 1946), p. 134.

21 Letter from Pissarro to son Lucien, 13 May 1891, Janine Bailly-Herzberg, ed. *Correspondance de Pissarro* (Paris, Editions de Valhermeil, 1988), vol. 3, p. 82.

22 Tucker, *Monet in the '90s*, pp. 9–23.

23 A penetrating discussion of Renoir's bather paintings is to be found in John House, "Renoir's *Baigneuses* of 1887 and the Politics of Escapism," *Burlington Magazine*, 134 (September 1992): 578–85.

24 See Degas' comments to George Moore as cited in P.A. Lemoisne, *Degas et son oeuvre*, vol. 1, p. 118.

25 Boggs *et al.*, *Degas*, p. 516.

26 Entry of 28 September 1897, Julie Manet, *Journal (1893–1899)* (Paris, C. Klincksieck, 1979), p. 133; Ambroise Vollard, *Renoir, An Intimate Record*, trans. Harold L. Van Doren and Ralph T. Weaver (New York, Dover, 1990), pp. 19, 112.

27 Interview with Moreau-Nélaton and reminiscence to Vollard, cited in Françoise Sevin, "Degas à travers ses mots," *La Gazette des beaux-arts*, 6, 86 (July–August 1975): 45, 46; entry of 28 September 1897, Manet, *Journal*, p. 133; Vollard, *Renoir*, p. 98.

28 Letter from Cézanne to Paule Conil, 1 September 1902, John Rewald, ed. *Paul Cézanne, Letters* (New York, Hacker Art Books, 1984), p. 285; Cézanne cited in *Joachim Gasquet's Cézanne, A Memoir with Conversations*, trans. Christopher Pemberton (London, Thames & Hudson, 1991), p. 39.

29 Maurice, Talmeyr, *Souvenirs de la comédie humaine* (Paris, Perrin & Cie, 1929), p. 136; Vollard, *Degas, An Intimate Portrait*, trans. Randolph T. Weaver (New York, Crown Publishers, 1937), p. 91; idem., *En Ecoutant Cézanne, Degas, Renoir* (Paris, B. Grasset, 1938), p. 105.

30 Letter from Pissarro to Alice and Esther Isaacson and letter from Pissarro to son Lucien, end of December 1889 and 3 March 1886, in Bailly-Herzberg, ed. *Corrsepondance de Pissarro* (Paris, Editions de Valhermeil, 1986), vol. 2, pp. 314–5, 30; Hutton, *Neo-Impressionism*, pp. 67–8. For Renoir's remark, see entry of 28 September 1897, Manet, *Journal*, p. 133.

31 Anne Dumas, "The Public Face of Landscape," in House, ed. *Impressions of France: Monet, Renoir, Pissarro, and Their Rivals*, exhibition catalogue, Museum of Fine Arts (Boston, 1995), pp. 35–6; Tucker, *Claude Monet, Life and Art* (New Haven, CT, Yale University Press, 1995), pp. 141–4.

32 Richard Thomson, *Camille Pissarro: Impressionism, Landscape and Rural Labor* (London, Herbert Press, 1990), p. 56ff.

33 Léo Larguier, *Le Dimanche avec Paul Cézanne* (Paris, L'Edition, 1925), p. 37; Edmond Jaloux, *Les Saisons littéraires, 1896–1903* (Fribourg, Librairie de l'Université, 1942), p. 72

34 Letter from Cézanne to Henri Gasquet, 3 June 1899, *Cézanne, Letters*, p. 268; *Joachim Gasquet's Cézanne*, pp. 152–3.

35 See *Cézanne*, exhibition catalogue, Philadelphia Museum of Art (Paris, Réunion des Musées Nationaux, 1995), p. 561; letter from Paul Cézanne *fils* to Ambroise Vollard, 7 March 1906, *Cézanne, Letters*, p. 315.

36 Emile Bernard, *Souvenirs sur Paul Cézanne* (Paris, R.G. Michel, 1925), p. 87.

37 Letter from Cézanne to Bernard, 15 April 1904, *Cézanne, Letters*, p. 296.

38 Bernard, *Souvenirs*, pp. 101, 125.

39 *Joachim Gasquet's Cézanne*, p. 150.

40 Letter from Pissarro to his son Lucien, 3 March 1886, in Bailly-Herzberg, ed. *Correspondance de Pissarro* (Paris, Presses Universitaires de France), vol. 1, p. 30, as cited in Hutton, *Neo-Impressionism*, p. 25.

41 Vollard, *Renoir*, p. 112.

42 Thomson, *Camille Pissarro*, p. 114.

43 *Joachim Gasquet's Cézanne*, p. 166.

44 House, "Renoir's Worlds," in *Renoir*, pp. 12–13 and 18n.; Venturi, *Les Archives de l'impressionnisme*, vol. 1, pp. 127–9; Vollard, *Renoir*, p. 99.

45 It is hard to find an adequate translation for Cézanne's slanging exclamation which, Vollard makes clear, was articulated in the accents of the region: "ce

sont tous des salauds, des châtrés, des j.f...; ils n'ont rien dans le venntrre!" Vollard, *En Ecoutant*, p. 48.

46 Jean Renoir, *Renoir* (Ottawa, Cercle du Livre de France, 1963), pp. 262–3.

47 See the entry in Jean Maître, ed. *Dictionnaire biographique du mouvement ouvrier français, 1871–1914* (Paris, Editions Ouvrières, 1975), vol. 13, p. 69.

48 Pierre Michel and Jean-François Nivet, eds., *Octave Mirbeau, Correspondance avec Claude Monet* (Tusson, Du Lerrot, 1990), pp. 18 and 190n.6; Eugenia W. Herbert, *The Artist and Social Reform: France and Belgium, 1886–1998* (New York, Books for Libraries Press, 1980 [orig. 1961]), p. 176; entry of 23 December 1897, Manet, *Journal*, p. 146.

49 Entry of 28 July 1899, Manet, *Journal*, p. 246; Vollard, *Renoir*, p. 98.

50 Letter of 8 April 1888 in response to an *enquête* on feminism, in François Daulte, *Auguste Renoir, catalogue raisonné de l'oeuvre peint* (Lausanne, Durand-Ruel, 1971), p. 53; Vollard, *Renoir*, p. 79.

51 The statement ends with a vulgar flourish: " ... and when they wipe their baby's behind themselves." Cited in Tamar Garb, "Renoir and the Natural Woman," in Norma Broude and Mary D. Garrard, eds., *The Expanding Discourse: Feminism and Art History* (New York, Icon Editions, 1992), pp. 300–1. See also House, "Baigneuses," pp. 584–5.

52 Much has been written on the subject by art historians. Norma Broude is inclined to a generous assessment. See Broude, "Degas's 'Misogyny',", in Broude and Garrard, eds., *Feminism and Art History: Questioning the Litany* (New York, Harper & Row, 1982), 247–69. Carol Armstrong, Charles Bernheimer, Hollis Clayson, and Eunice Lipton offer a more mixed, darker view of the artist's relationship to women. See Armstrong, *Odd Man Out: Readings of the Work and Reputation of Edgar Degas* (Chicago, IL, University of Chicago Press, 1991); Bernheimer, *Figures of Ill Repute: Representing Prostitution in Nineteenth-Century France* (Cambridge, MA, Harvard University Press, 1989); Clayson, *Painted Love: Prostitution in French Art of the Impressionist Era* (New Haven, CT, Yale University Press, 1991); Lipton, *Looking into Degas, Uneasy Images of Women and Modern Life* (Berkeley, University of California Press, 1986).

53 Gustave Geffroy, *La Vie artistique*, 3rd series (Paris, E. Dentu, 1894), pp. 169–70.

54 Lemoisne, *Degas et son oeuvre*, vol. 1, p. 118.

55 Thadée Natanson, *Peints à leur tour* (Paris, A. Michel, 1948), p. 16; entry of 26 October 1888, Daniel Halévy, *Degas Parle* (Paris, La Palatine, 1960), p. 27; entry of 28 October 1897, Manet, *Journal*, p. 138; letter from Cassatt to Havemeyer, 15 February 1914, cited in Boggs *et al.*, *Degas*, p. 606.

56 Letter from Renoir to Charles Deudon, 19 February 1882, cited in Colin B. Bailey, "Portrait of the Artist as a Portrait Painter," Bailey, ed. *Renoir's Portraits: Impressions of an Age* (New Haven, CT, Yale University Press, 1997), p. 40; letter from Renoir to Durand-Ruel, 26 February 1882, Venturi, *Les Archives de l'impressionnisme*, vol. 1, p. 122.

57 Letter from Degas to Albert Bartholomé, August 1897, Guérin, ed. *Lettres de Degas* (Paris, B. Grasset, 1931), p. 213.

58 Jeanne Fevre, *Mon Oncle Degas* (Geneva, P. Cailler, 1949), frontispiece and p. 140.

59 Entry of 28 October 1897, Manet, *Journal*, p. 138.

60 Letter from Pissarro to his son Lucien, 25 July 1883, *Correspondance de Pissarro*, vol. 1, p. 225.

61 Letters from Monet to Alice Hoschedé, 18 and 28 October 1886, and from Monet to Alice Monet, 30 March 1895, in Daniel Wildenstein, ed. *Claude Monet, biographie et catalogue raisonné* (Lausanne, Bibliothèque des Arts, 1979), vol. 2, p. 282 and vol. 3, p. 285. Ibsen elicited the most extreme reactions from the former new painters and their friends. Forain hated his work. See entry of 10 December 1923, René Gimpel, *Diary of an Art Dealer, 1918–1939*, trans. John Rosenberg (New York, Universe Books, 1987), p. 252. Clemenceau on the other hand was spotted applauding with admiration at the 1894 Paris premier of the playwright's *Enemy of the People*. Entry of 26 December [1894], in Rewald, "Extraits du journal inédit de Paul Signac, I, 1894–1895," *La Gazette des beaux-arts*, 6, 36 (July–September 1949): 113.

62 Letters from Monet to Alice Hoschedé, 22 February and 13 April 1884, in *Claude Monet, biographie et catalogue raisonné*, vol. 2, pp. 240, 251.

63 Letter from Monet to his wife Alice, 25 February 1901, in Daniel Wildenstein, ed. *Claude Monet, biographie et catalogue raisonné* (Lausanne, Bibliothèque des Arts, 1991), vol. 5, p. 211. See also Monet's letter to Alice, 26 February 1900, in Richard Kendall, ed. *Monet by Himself* (Boston, Little Brown, 1990), p. 188.

64 Letter from Pissarro to Lazare, 13 September 1896, Bailly-Herzberg, ed. *Correspondance de Pissarro* (Paris, Editions de Valhermeil, 1989), vol. 4, p. 254. See also the letter from Pissarro to his son Lucien, 9 December 1897, ibid., vol. 4, p. 417. On Lazare, see Michael Marrus, *Les Juifs de France à l'époque de l'affaire Dreyfus* (Paris, Calmann-Lévy, 1972), pp. 204–10.

65 Letter from Pissarro to his son Lucien, 8 October 1896, *Correspondance de Pissarro*, vol. 4, p. 271. Degas too had little liking for fin-de-siècle phoniness, although he was more inclined to target aestheticizing poets than painters. The salon, he complained, had become overpopulated with "geniuses," young men of exquisite sophistication who dressed in long frock coats and bantered with the ladies a lily in hand. "So much taste," he told a friend, "can only lead to jail," a bon mot he first retailed when Liberty's of London opened a branch store in Paris and then trotted out again in 1895 at the time of Oscar Wilde's imprisonment for homosexual offenses. Degas' views are characterized in a letter from Pissarro to Paul Signac, 25 July 1891, *Correspondance de Pissarro*, vol. 3, p. 113. See also the entry of 10 February 1897, Manet, *Journal*, p. 124; and the entries of 2 January 1896 and 20 February 1897, in Halévy, *Degas parle*, pp. 95, 109.

66 Letters from Pissarro to his son Lucien, 28 December 1883 and 13 May 1891, in Bailly-Herzberg, ed. *Correspondance de Pissarro*, vol. 1, p. 267 and vol. 3, p. 82.

67 Rewald, *Cézanne, Geffroy et Gasquet* (Paris, Quatre-Chemins-Editart, 1960), p. 14.

68 As reported in entry of 6 June 1890, Halévy, *Degas parle*, p. 40.

69 On Cézanne's declaration of classicist principle, see Bernard, *Souvenirs*, pp. 38, 87. See also Vollard, *En Ecoutant*, pp. 49–50; and Larguier, *Le Dimanche*, pp. 39–40.

70 *Joachim Gasquet's Cézanne*, p. 173.

71 Letter from Pissarro to his niece Esther Isaacson, 12 December 1885, letter from Pissarro to his son Lucien, 5 July 1883, in *Correspondance de Pissarro*, vol. 1, p. 362, 227.

72 Pissarro to Mirbeau, cited in Hutton, *Neo-Impressionism*, p. 66.

73 Letters from Pissarro to his son Lucien, 30 July and 1 August 1894, *Correspondance de Pissarro*, vol. 3: pp. 469–72. See also Robert L. and Eugenia W. Herbert, "Artists and Anarchism: Unpublished Letters of Pissarro, Signac and Others, I," *Burlington Magazine*, 102 (November, 1960): 473–7; idem., "Artists and Anarchism: Unpublished Letters of Pissarro, Signac and Others, II," *Burlington Magazine*, 102 (December 1960): 517; Shikes, "Pissarro's Political Philosophy and His Art," in Christopher Lloyd, ed. *Studies on Camille Pissarro* (London and New York, Routledge & Kegan Paul, 1986), p. 51; Hutton, *Neo-Impressionism*, p. 101.

74 Vollard, *En Ecoutant*, pp. 58, 61, 63.

75 Rewald, *Cézanne, Geffroy, Gasquet*, p. 14. See also John Rewald's preface and the translator's introduction to *Joachim Gasquet's Cézanne*, pp. 8–13, 26.

76 Jaloux, *Les Saisons littéraires*, p. 66.

77 Henri Loyrette, *Degas* (Paris, Fayard, 1991), p. 503.

78 The election was invalidated.

79 Letter from Degas to Bartholomé, 24 August (1890), in *Degas Letters*, p. 148.

80 Loyrette, *Degas*, p. 480.

81 Letter from Monet to Geffroy, 17 February 1891, *Monet, biographie et catalogue raisonné*, vol. 5, p. 196. For a full discussion of the Monet/Clemenceau friendship, see André Wormser, "Clemenceau et Claude Monet: une singulière amitié," in *Georges Clemenceau à son ami Claude Monet, Correspondance* (Paris, Réunion des Musées Nationaux, 1993), pp. 27–59.

82 Nancy Mowll Mathews, *Mary Cassatt, A Life* (New York, Villard Books, 1994), pp. 207, 250–1, 302ff.

83 Dreyfus was found guilty a second time at Rennes. The President of the Republic, however, granted him a pardon. He was exonerated altogether in 1906 and reinstated in the military.

84 Letter from Pissarro to Zola, 14 January 1898, *Correspondance de Pissarro*, vol. 4, p. 432. See also letter from Pissarro to Lucien, 14 November 1897, ibid., vol. 4, p. 403; and Shikes and Harper, *Pissarro*, p. 306.

85 Letters from Pissarro to Lucien, 19, 21 and 27 January 1898, *Correspondance de Pissarro*, vol. 4, pp. 434–5, 436–7, 441; and letter from Pissarro to Lucien, 22 January 1899, Bailly-Herzberg, ed. *Correspondance de Pissarro* (Saint-Ouen-l'Aumône, Editions de Valhermeil, 1991), vol. 5, p. 10.

86 Letters from Monet to Zola, 3 December 1897, 14 January and 24 February 1898, *Monet, biographie et catalogue raisonné*, vol. 3, p. 296.

87 Letter from Monet to Geffroy, 15 February 1898, *Monet, biographie et catalogue raisonné*, vol. 3, p. 296; letter from Mirbeau to Monet, 22 February 1898, *Mirbeau, Correspondance*, p. 194.

88 Letters from Monet to Geffroy, 15 December 1899 and 30 December 1899, Wildenstein, ed. *Claude Monet, biographie et catalogue raisonné* (Lausanne, Bibliothèque des Arts, 1985), vol. 4, pp. 339–40.

89 For what follows, see Christophe Charle, *Naissance des "intellectuels", 1880–1900* (Paris, Editions de Minuit, 1990), pp. 143, 173; entry of 17 January 1898, in Rewald, "Extraits du journal inédit de Paul Signac, II, 1897–1898," *La Gazette des beaux-arts*, 6, 39 (April 1952): 275; telegram from Mallarmé to Zola, 23 February 1898, in Henri Mondor and Lloyd James Austin, eds., *Stéphane Mallarmé, Correspondance* (Paris, Gallimard, 1984), vol. 10, p. 108; *Correspondance de Pissarro*, vol. 4, pp. 451 and 451 n.2; Alfred

Bruneau, *A l'Ombre d'un grand coeur, souvenirs d'une collaboration* (Paris, Fasquelle, 1932), p. 132ff.

90 Havemeyer, *Sixteen to Sixty, Memoirs of a Collector* (New York, Ursus Press, 1993 [orig. 1961]), p. 277.

91 Entries of 5 December 1897, 20 and 30 January 1898, 2 August 1899, in Manet, *Journal*, pp. 143, 150, 151, 247. See also Rivière, *Renoir*, p. 72.

92 Entry of 15 January 1898, Manet, *Journal*, p. 148.

93 Jean-Paul Crespelle, *Degas et son monde* (Paris, Presses de la Cité, 1972), p. 210.

94 Entry of 1 February 1919, Gimpel, *Diary*, pp. 89–90. Gimpel claims to have gotten the story from Durand-Ruel.

95 Entry of 20 January 1898, Manet, *Journal*, p. 150. See also Natanson, *Peints à leur tour*, p. 51.

96 Entries of 30 January 1898 and 23 February 1899, Manet, *Journal*, pp. 151, 219.

97 Entry of 11 February 1898, Rewald, "Extraits du journal inédit de Paul Signac, II," p. 276; Loyrette, *Degas*, pp. 638–9.

98 Rewald, *Cézanne, A Biography* (New York, Harry N. Abrams, 1986), pp. 174–84.

99 Entry of 6 January 1899, Rewald, "Extraits du journal inédit de Paul Signac, III, 1898–1899," *La Gazette des beaux-arts*, 6, 42 (July–August 1953): 38; Loyrette, *Degas*, p. 644.

100 See the masthead of the 15 April 1901 edition of *Annales de la Patrie Française*.

101 Entry of 20 August 1899, Halévy, *Degas parle*, p. 131; entry of 7 December 1898, Manet, *Journal*, p. 206.

102 Havemeyer, *Sixteen to Sixty*, pp. 275–6.

103 *Mirbeau, Correspondance*, p. 20; Loyrette, *Degas*, p. 645.

Select bibliography

Adams, Steven. *The Barbizon School and the Origins of Impressionism*, London, Phaidon, 1994.

Adler, Kathleen. *Unknown Impressionists*, Oxford, Phaidon, 1988.

Armstrong, Carol. *Odd Man Out: Readings of the Work and Reputation of Edgar Degas*, Chicago, IL, University of Chicago Press, 1991.

Athanassoglou-Kallmyer, Nina. "An Artistic and Political Manifesto for Cézanne," *Art Bulletin*, 72 (September 1990): 482–92.

Bachelard, Patrice, ed. *De Manet à Caillebotte. Les Impressionnistes à Gennevilliers*, Paris, Editions Plume, 1993.

Bailey, Colin B., ed. *Renoir's Portraits: Impressions of an Age*, exhibition catalogue, Art Institute of Chicago, New Haven, CT, Yale University Press, 1997.

Bailly-Herzberg, Janine. "Marcellin Desboutin and His World," *Apollo*, 95 (June 1972): 496–500.

—— *L'Eau-forte de peintre au XIXe Siècle: La Société des aquafortistes 1862–1867*, 2 vols., Paris, L. Laget, 1972.

Bernheimer, Charles. *Figures of Ill Repute: Representing Prostitution in Nineteenth-Century France*, Cambridge, MA, Harvard University Press, 1989.

Bizardel, Yvon. "Théodore Duret: An Early Friend of the Impressionists," *Apollo*, 100 (August 1974): 146–55.

Boggs, Jean Sutherland, *et al. Degas*, exhibition catalogue, Metropolitan Museum of Art, New York, 1988.

Boime, Albert. *Art and the French Commune, Imagining Paris after War and Revolution*, Princeton, NJ, Princeton University Press, 1995.

Bouillon, Jean-Paul. "'A Gauche': note sur la Société du Jing-Lar et sa significa-tion," *La Gazette des beaux-arts*, série 6, 91 (March 1978): 107–18.

Bouret, Jean. *L'Ecole de Barbizon et le paysage français au XIXe siècle*, Neuchâtel, Ides et Calendes, 1972.

Broude, Norma. *Impressionism: a Feminist Reading: the Gendering of Art, Science, and Nature in the Nineteenth Century*, New York, Rizzoli, 1991.

Broude, Norma, and Garrard, Mary D. (eds.) *The Expanding Discourse: Feminism and Art History*, New York, Icon Editions, 1992.

—— (eds.) *Feminism and Art History: Questioning the Litany*, New York, Harper & Row, 1982.

Cachin, Françoise, Charles Moffett, *et al.*, *Manet, 1832–1883*, exhibition catalogue, Metropolitan Museum of Art, New York, 1983.

Charle, Christophe. *Naissance des "intellectuels," 1880–1900*, Paris, Editions de Minuit, 1990.

Chisaburo, Yamada, ed. *Japonisme in Art: An International Symposium*, Tokyo, Committee for the Year 2001, 1980.

Clark, Timothy J. *Image of the People, Gustave Courbet and the Second French Republic 1848–1851*, Greenwich, CT, New York Graphic Society, 1973.

—— *Farewell to an Idea: Episodes from a History of Modernism*, New Haven, CT, Yale University Press, 1999.

—— *The Painting of Modern Life, Paris in the Art of Manet and His Followers*, New York, Alfred A. Knopf, 1985.

Clayson, Hollis. *Painted Love: Prostitution in French Art of the Impressionist Era*, New Haven, CT, Yale University Press, 1991.

Crapo, Paul. "Courbet, La Rochenoire et les réformes du Salon en 1870," *Les Amis de Gustave Courbet, Bulletin* (1990): np.

Daulte, François. *Auguste Renoir, catalogue raisonné de l'oeuvre peint*, vol. 1. Lausanne, Durand-Ruel, 1971.

de Forges, Marie-Thérèse. *Barbizon et l'Ecole de Barbizon*, Paris, Editions du Temps, 1971.

Distel, Anne. *Impressionism: The First Collectors*, trans. Barbara Perroud-Benson, New York, Harry N. Abrams, 1990.

—— *et al. Gustave Caillebotte, Urban Impressionist*, exhibition catalogue, Art Institute of Chicago, New York, 1995.

Druick, Douglas, and Michel Hoog. *Fantin-Latour*, exhibition catalogue, National Gallery of Canada. Ottawa, 1983.

Dunlop, Ian. *Degas*, London, Thames & Hudson, 1979.

Fidell-Beaufort, Madeleine. *Daubigny*, Paris, Geoffroy-Dechaume, 1975.

Flescher, Sharon. *Zacharie Astruc, Critic, Artist, and Japoniste (1833–1907)*, New York, Garland, 1978.

Garb, Tamar. *Women Impressionists*, New York, Rizzoli, 1988.

Halperin, Joan Ungersma. *Félix Fénéon, Aesthete and Anarchist in Fin-de-Siècle Paris*, New Haven, CT, Yale University Press, 1988.

Hamilton, George Heard. *Manet and His Critics*, New Haven, CT, Yale University Press, 1986.

Hanson, Anne Coffin. *Manet and the Modern Tradition*, New Haven, CT, Yale University Press, 1979.

Herbert, Eugenia W. *The Artist and Social Reform: France and Belgium, 1886–1998*, New York, Books for Libraries Press, 1980 (original Yale University Press, 1961).

Herbert, Robert. *Barbizon Revisited*, New York, Clarke & Way, 1962.

—— *Impressionism: Art, Leisure, and Parisian Society*, New Haven, CT, Yale University Press, 1988.

Higonnet, Anne. *Berthe Morisot's Images of Women*, Cambridge, MA, Harvard University Press, 1992.

House, John, ed. *Impressions of France: Monet, Renoir, Pissarro, and Their Rivals*, exhibition catalogue, Museum of Fine Arts, Boston, 1995.

—— "Renoir's *Baigneuses* of 1887 and the Politics of Escapism," *Burlington Magazine*, 134 (September 1992): 578–85.

Hutton, John G. *Neo-Impressionism and the Search for Solid Ground: Art, Science, and Anarchism in Fin-de-Siècle France*, Baton Rouge, Louisiana State University Press, 1994.

Isaacson, Joel. *The Crisis of Impressionism, 1878–1882*, exhibition catalogue, University of Michigan Museum of Art, Ann Arbor, 1980.

Jensen, Robert. *Marketing Modernism in Fin-de-Siècle Europe*, Princeton, NJ, Princeton University Press, 1994.

Kendall, Richard. *Degas, Beyond Impressionism*, New Haven, CT, Yale University Press, 1996.

Lemoisne, Paul A. *Degas et son oeuvre*, vol. 1, Paris, Paul Brame and C.M. De Hauke, 1946.

Lipton, Eunice. *Looking into Degas, Uneasy Images of Women and Modern Life*, Berkeley, University of California Press, 1986.

Loyrette, Henri. *Degas*, Paris, Fayard, 1991.

Mainardi, Patricia. *The End of the Salon, Art and the State in the Early Third Republic*, New York, Cambridge University Press, 1993.

Malingue, Maurice. *La Vie prodigieuse de Paul Gauguin*, Paris, Buchet/Chastel, 1987.

Marrus, Michael. *Les Juifs de France à l'époque de l'affaire Dreyfus*, Paris, Calmann-Lévy, 1972.

Mathews, Nancy Mowll. *Mary Cassatt, A Life*, New York, Villard Books, 1994.

McMullen, Roy. *Degas: His Life, Times, and Work*, London, Secker & Warburg, 1985.

Moffett, Charles S., *et al*. *The New Painting: Impressionism 1874–1886*, exhibition catalogue, National Gallery of Art, Geneva, 1986.

Monet's Years at Giverny: Beyond Impressionism, exhibition catalogue, Metropolitan Museum of Art, New York, 1978.

Nochlin, Linda. "Degas and the Dreyfus Affair: A Portrait of the Artist as an Anti-Semite," in Norman L. Kleeblatt, ed. *The Dreyfus Affair: Art, Truth, and Justice*, Berkeley and Los Angeles, University of California Press, pp. 96–116.

Nord, Philip. "Manet and Radical Politics," *Journal of Interdisciplinary History*, 19 (Winter 1989): 447–80.

—— "The Party of Conciliation and the Paris Commune," *French Historical Studies*, 15 (Spring 1987): 1–35.

—— *The Republican Moment, Struggles for Democracy in Nineteenth-Century France*, Cambridge, MA, Harvard University Press, 1995.

Parinaud, André. *Les Peintres et leur école Barbizon: les origines de l'impressionnisme*, Paris, A. Biro, 1994.

Pollock, Griselda. *Mary Cassatt*, New York, Harper & Row, 1980.

Rebeyrol, Philippe. "Art Historians and Art Critics – I: Théophile Thoré," *Burlington Magazine*, 94 (July 1952): 196–200.

Reff, Theodore. *Manet and Modern Paris*, Chicago, IL, University of Chicago Press, 1982.

Renoir. Exhibition catalogue, Hayward Gallery, London, Arts Council of Great Britain, 1985.

Rewald, John. *Cézanne, A Biography*, New York, Harry N. Abrams, 1986.

—— *Cézanne, Geffroy et Gasquet*, Paris, Quatre-Chemins-Editart, 1960.

—— *Histoire de l'impressionnisme*, 2 vols., Paris, Albin Michel, 1976 (original *The History of Impressionism*, New York, Museum of Modern Art, 1946).

Roos, Jane Mayo. *Early Impressionism and the French State (1866–1874)*, New York, Cambridge University Press, 1996.

Ruggiero, Marianne. "Manet and the Image of War and Revolution: 1851–1871," in *Edouard Manet and the "Execution of Maximilian"*, exhibition catalogue, Brown University (Providence, 1981): pp. 22–38.

Sandblad, Nils. *Manet, Three Studies in Artistic Conception*, Lund, C.W.K. Gleerup, 1954.

Shiff, Richard. *Cézanne and the End of Impressionism, A Study of the Theory, Technique, and Critical Evaluation of Modern Art*, Chicago, IL, University of Chicago Press, 1984.

Shikes, Ralph E. "Pissarro's Political Philosophy and His Art," in Christopher Lloyd, ed. *Studies on Camille Pissarro*, London and New York, Routledge & Kegan Paul, 1986: pp. 35–54.

Shikes, Ralph E., and Paula Harper. *Pissarro, His Life and Work*, London, Quartet Books, 1980.

Thomson, Richard. *Camille Pissarro: Impressionism, Landscape and Rural Labour*, London, Herbert Press, 1990.

Tinterow, Gary, and Henri Loyrette. *Origins of Impressionism*, exhibition catalogue, Metropolitan Museum of Art, New York, 1994.

Tucker, Paul Hayes. *Claude Monet, Life and Art*, New Haven, CT, Yale University Press, 1995.

—— *Monet at Argenteuil*, New Haven, CT, Yale Univeristy Press, 1982.

—— *Monet in the '90s, The Series Paintings*, New Haven, Yale Univeristy Press, 1989.

Vaisse, Pierre. *La Troisième République et les peintres: recherches sur les rapports des pouvoirs publics et de la peinture en France de 1870 à 1914*, 4 vols., Doctorat d'Etat, University of Paris IV, 1980.

—— *La Troisième République et les peintres*, Paris, Flammarion, 1995.

Ward, Martha. "Impressionist Installations and Private Exhibitions," *Art Bulletin*, 73 (December 1991): 599–622.

—— *Pissarro, Neo-Impressionism, and the Spaces of the Avant-Garde*, Chicago, IL, University of Chicago Press, 1996.

Weisberg, Gabriel. *The Independent Critic: Philippe Burty and the Visual Arts of Mid-Nineteenth Century France*, New York, P. Lang, 1993.

——, ed. *Japonisme: Japanese Influence on French Art, 1854–1910*, exhibition catalogue, Cleveland Museum of Art, Cleveland, 1975.

White, Harrison C., and Cynthia A. White. *Canvases and Careers, Institutional Change in the French Painting World*, New York, University of Chicago Press, 1993 (original Wiley, 1965).

Wilson-Bareau, Juliet, John House, and Douglas Johnson. *Manet: The Execution of Maximilian. Painting, Politics and Censorship*, Princeton, NJ, Princeton University Press, 1992.

Wormser, André. "Clemenceau et Claude Monet: une singulière amitié," in *Georges Clemenceau à son ami Claude Monet, Correspondance*, Paris, Réunion des Musées Nationaux, 1993, pp. 27–59.

Index